PRAISE FOR HAL GLATZER'S FIRST KATY GREEN BOOK—

Too Dead To Swing

"Glatzer's atmospherics effectively evoke the swing era. …
a lively jitterbug down memory lane."
—*Kirkus Reviews*

"Glatzer knows the music of the period, and re-creates to perfection the
camaraderie and pent-up frustrations of life on the road—not to men-
tion the magic… If the somewhat worldly but still charming Katy
Green is ever involved in another case, or if her first brush with solving
crime is told, I'll be among the first in line to read it."
—*Historical Novels Review*

"Hal Glatzer's *Too Dead To Swing* is a strong debut."
—*Publishers Weekly*

"Glatzer does a marvelous job of re-creating the verge of the U.S. entry
into World War II… For anybody who loves 1940s band music, *Too
Dead To Swing* is going to be an everlasting delight… There's enough
color and excitement for this to make a pretty good movie…"
—Ron Miller, author of *Mystery! A Celebration*

"The simple, easy-going style, catty dialog, changing scenery, and
nostalgic fodder for Forties music fans recommend this…"
—*Library Journal*

"Katy makes a tenacious protagonist…
It will be interesting to see what her next gig will be."
—*Cozies, Capers, and Crimes*

As an audio-play, *Too Dead To Swing* won
Publishers Weekly's Listen Up Award
and the Audio Publishers Association's Audie Award.

www.toodeadtoswing.com

A Fugue in Hell's Kitchen

MYSTERY FICTION BY HAL GLATZER

The Trapdoor
Kamehameha County
Massively Parallel Murder

THE KATY GREEN SERIES
 Too Dead To Swing
 A Fugue in Hell's Kitchen

A Fugue in Hell's Kitchen

A KATY GREEN MYSTERY

Hal Glatzer

2004 · PALO ALTO–MCKINLEYVILLE, CALIFORNIA
PERSEVERANCE PRESS–JOHN DANIEL & COMPANY

Copyright © 2004 by Hal Glatzer
All rights reserved
Printed in the United States of America

A PERSEVERANCE PRESS BOOK
Published by John Daniel & Company
A division of Daniel & Daniel, Publishers, Inc.
Post Office Box 2790
McKinleyville, California 95519
www.danielpublishing.com/perseverance

Book design by Eric Larson, Studio E Books, Santa Barbara
www.studio-e-books.com

Cover illustration by Dean Gustafson; conceived by Hal Glatzer

10 9 8 7 6 5 4 3 2 1

LIBRARY OF CONGRESS CATALOGING-IN-PUBLICATION DATA
Glatzer, Hal.
 A Fugue in Hell's Kitchen : a Katy Green mystery / by Hal Glatzer.
 p. cm.
 ISBN 1-880284-70-7 (alk. paper)
 1. Hell's Kitchen (New York, N.Y.)—Fiction. 2. Women musicians—Fiction.
3. Swing (Music)—Fiction. I. Title.
 PS3607.L38F84 2004
 813'.6—dc21
 2003008155

*Reading Nancy Drew books in their youth inspired
many if not most of the mystery authors
who subsequently created plucky heroines.
Thus, this one's for the late
Mildred Wirt Benson.*

Cast of Characters

Katy Green By helping a friend out of a jam at the Meyers Conservatory, Katy hopes to find work playing classical violin. If only it were that easy!

Am Lee (Amalia) Chen Katy's friend, a cellist, has never been in trouble, but she's scared to death now.

Joseph Meyers When his sister, Iris, died, Joe inherited his family's music school. He doesn't want it.

Nina Rovere The librarian at the Meyers Conservatory knows everything that goes on there—with one glaring exception.

Theo Levant Why are the local hoodlums making trouble for this opera buff who owns the corner luncheonette?

Guy Carson This handsome, up-and-coming violinist will do *anything* to land an audition.

Susie Pierce An aspiring viola player, Susie would rather be an impresario, no matter what it costs.

Ed Pierce Susie's brother wants to bring more classical music to Hell's Kitchen. But he's an architect—what's in it for him?

Rebecca Tharp A gifted guitarist living in New York City to study, although her heart and soul are back in Tennessee.

Hermione Wellfleet Charming and elderly, yet the conservatory's percussionist has all the hep moves of a jitterbug.

Madeline Roark A reporter for *The Etude* classical music magazine, she loves rubbing elbows—and more—with celebrities.

Roger Winkler The senior appraiser at Beechum's Art & Auction Gallery was more than professionally attracted to the late Iris Meyers.

Josh Forman A reporter for the *Daily Mirror*, Josh doesn't see eye-to-eye with his editor, but he'd like to see more of Katy.

Tilda Kowalczyk She's a tough policewoman in a rough precinct.

Frank Bond This veteran cop could be getting too close to the gangs.

Hoy-Hung (Howard) Chen Is Amalia's father really the helpless refugee he claims to be?

Soo-Ling (Sue) Chen If there's something Amalia won't tell Katy, will her mother reveal it?

Bill Wilson A "forgotten man" who remembers things…like where to hide and not be found.

Michael Cornelius Maybe this patron of the music school is dealing in more than just back-date books.

Erik DeReuter From his office way up in the Empire State Building, he looks down (and down his nose) at Hell's Kitchen.

The Hudson Dusters These young hoodlums, high on "happy dust," are the most dangerous gang in New York's most dangerous neighborhood.

Foreword

As Hannah Dobryn's literary executor, I'm pleased to present another book in her Katy Green mystery series. These novels were written after World War II, but they take place in the years leading up to the war. Katy, Hannah's heroine, is a working musician, and each story is set in a different musical milieu.

A Fugue in Hell's Kitchen is the second book in the series to be published, but Hannah probably wrote it before the first book, *Too Dead To Swing*, since it's set a year earlier (in 1939), and in *Too Dead To Swing* there is a reference to Katy having previously helped a cellist friend out of a jam.

In *A Fugue in Hell's Kitchen*, Katy has returned to New York City from a strenuous year playing swing on the road, seeking quiet comfort in the traditionally subdued, formal, and insular world of classical music. But by 1939, that world—like the world at large—is no longer a restful place.

Hannah called this adventure a "fugue": a word (and a venerable form of music) that may be unfamiliar to some readers. So it was foresighted of Hannah to incorporate explanatory passages about fugues, taken from reference books of the 1930s and '40s, as epigraphs for her chapter-heads. Succinctly, and in plain language, they set out the form of musical composition known as the fugue. But—and I'm certain Hannah recognized this—they also clearly set out the form of literary composition known as the mystery.

A Fugue in Hell's Kitchen

𝄡 It's hard to make a living playing classical music, even in New York City, where it's always on the radio, and so many people will pay to hear it. A woman who plays the longhair classics has an especially hard time getting work, unless she plays harp—which I don't. Besides, the last time I tried to pick up a classical gig, I almost *did* wind up playing harp. Like an angel. Dead.

Counterpoint is the very essence of the fugue, with a fixed number of melodic strands called "voices"—the form being obviously, in its origin, a choral one. At the outset, these voices enter in turn with a scrap of melody, called "subject," until, at last, all are singing—if we may use that term.

—The Oxford Companion to Music

1. A Scrap of Melody

𝄢 I'd had plenty of work in 1938, playing swing violin and doubling on alto saxophone. Swing or sweet—even corn—I can play anything that's written down, and improvise if it isn't. So I was in a dozen dance bands, on a circuit of high school proms and college varsity drags. I took practically every one-night stand and occasional gig that came my way, from roadhouses to society parties. I spent three weeks in the orchestra pit of *Pins and Needles*, the Ladies' Garment Workers' Union revue. And for two weeks, I played solo violin for a half-naked "modern" dance troupe. I went from down-on-my-luck, fiddling for coins on a sidewalk in New Orleans, to all-the-way-up-again, in a Kansas City nightclub where the tips were extra-high because they ran a casino behind the bandstand.

But by the end of the year—almost a whole year on the road—it was time to return to New York, to Manhattan, where I've lived for almost ten years. And as long as I was moving back, I felt I needed

to make a change in what I did for a living. I wanted to play whole-some *classical* music again.

So I brought my listings up to date at Local 802 of the American Federation of Musicians, checked the bulletin board at the union hall on Sixth Avenue every day, and asked everyone I met if they knew of any longhair gigs. I did my homework, too: I went out to all the concert halls to hear who was playing what, nowadays. And I buffed up my technique with a couple of hours' practice every day.

I got a few nights' work, now and then, but I couldn't live on so little. I've been a professional music-maker for more than twelve years; I have a college degree, plus a diploma from the Rochester Conservatory. But I couldn't impress the impresarios. I approached the manager of every chamber ensemble, every professional orchestra, even a few of the *semi*-professional orchestras, where they pay only their first chairs—the best players in each section. I covered the whole city and half the suburbs, but everybody told me the same thing: for full-timers, they hire only men. Women, they said, can't make it to rehearsals and performances, what with kids to feed, or husbands to keep house for. I don't have either, yet I couldn't find steady work at union scale.

Finally resigned to the inevitable, I phoned my former students. Two of them came back, and the others recommended me to friends. Eventually, I had seventeen violin pupils, a dozen of whom took lessons in any given week. They were all at least six or seven years into their studies and—with only one exception—took their pursuit of the instrument seriously. And I still got occasional work, though (of course) mainly in swing or novelty bands, and typically only on weekends.

By April of 1939, I'd settled into a routine that was boring but painless; and while I was frustrated, musically, I had no trouble making my rent and food. I was saving money, too, so I could move to a larger apartment, or at least, to a quieter place. Where I

lived, and had to teach, was a furnished room over a candy store on
Columbus Avenue at 74th Street, facing the elevated trains.

≕

April 14th was a Wednesday, and my ten-o'clock student was that
"exception"; she was also chronically late. I didn't mind waiting, be-
cause it meant I could tune in to a Mutual Network radio program
at ten, the "Quarter-Hour Concert Hall," and hear quite a few of
those fifteen minutes.

"Quartermain Shoes invites you to spend a quarter hour with
great musicians and fine music. And remember," intoned the an-
nouncer, "just a quarter hour in Quartermain Shoes will convince
you!"

A cello started playing, and after a moment, the announcer con-
tinued: "Today's broadcast is coming to you, *live*, from the Meyers
Conservatory of Music in Manhattan. And we've come here to
meet cellist Amalia Chen—"

Now, *that* made me grin. Amalia's a friend of mine; we'd been
classmates at the Rochester Conservatory. And I was pleased to hear
the announcer say "Am-ah-*lee*-uh" correctly. I turned up the volume.

"Miss Chen was a child prodigy. She was born in China, but
she's lived and studied in America for fifteen years, and hopes to be-
come an American citizen one day." (An audience applauded.)
"She was recently reunited with her parents, who fled war-torn
China, taking with them only the clothes on their backs. The tal-
ented Miss Chen was offered a teaching position at San Francisco
State University, but—"

An El train rumbled by.

If you've ever lived next to an El you know that when a train's
passing, you get to play a game with the radio. If music is on, you
tap your toe and see if you're still on the beat after the train's passed.
If somebody's talking, you try to figure out what they said.

"—on the faculty here at the Meyers Conservatory, which is
famous among music scholars for—"

Another train went by, going the other way. I'd heard of Meyers, but I didn't know it was famous for something. I scratched around in my pocketbook for a nickel, so that I could call Amalia after the program.

"—in America. Here's Miss Chen now. Tell us about this piece you've selected to play today. You're playing from a manuscript, I see. Tell us about that, Miss Chen."

"I wish I could convey how excited I am." That was Amalia's voice, along with a sound like papers being shuffled. "This is a treasure. He actually wrote down these very notes! I'm so—"

Train again. By the time it passed there was music on the air: a string quartet—but I didn't recognize it. I heard the cello, and the viola, and the violin…but there was a guitar, instead of a second violin. That's rare: only a few quartets are arranged that way. And they were playing in the key of…(Could that be right? I fingered my violin, just to be sure.)…B major. Wow. B is a difficult key for stringed instruments; hardly any quartets are written in B. Now I was sorry I'd missed the introduction. I have a pretty good memory for tunes, but I still didn't recognize the piece.

The cello had some solo lines, but the other instruments had more. That was so like Amalia! Here she had been singled out for attention, interviewed on the radio, and yet, when it came to performing, she'd selected a piece in which she was *not* the featured soloist.

My student arrived before the first movement ended, and I thought about making her wait, so I could hear it through and learn the title. But I had an eleven-o'clock-student coming next, and didn't want to push his time back. So it was past twelve before I could go downstairs to the pay-phone in the candy store. I looked up the Meyers Conservatory number, and asked the woman who answered if Amalia was available.

After a minute, Amalia came on and said, "Oh, Katy! How nice of you to call. I didn't think anybody was listening."

"They were begging me for an encore at Carnegie Hall, but

I said, 'No, I have to listen to my friend Amalia do her turn on the radio.'"

"Did you hear? My parents got out of China. They're staying with me, on Pell Street, now!"

"That's wonderful. What was that quartet you played? The one with the guitar."

"Uhh, I'm sorry. I...I can't talk about that just now." The pitch of her voice had dropped a whole octave. Something was wrong— she'd tumbled into a dark mood—and it didn't sound as though she were sick, or hadn't played well.

"What's the matter?" I asked.

"Nothing... Really."

"Are you someplace where you can't talk?"

"That's right."

"Want to call me back?"

"No. Hold the line a second, please." I heard the sound of a door closing. "Katy," she whispered, "it's awful: The quartet is gone."

"They're probably having a drink someplace."

"Out of my case!"

"Huh? Back up, will you? You're a couple of measures ahead of me."

"The *manuscript* is gone."

"What manuscript?"

"For the quartet we played. I think somebody stole it."

"Call the police."

"The dean mustn't know it's missing. Not yet, anyway."

I said, "I wish there was something I could do," though I couldn't imagine what. It was just instinctive: anybody would say that to a friend.

"Wow! Would you? Can you come over and...I don't know. Do *something*. Help me, please."

"I'll—I'll be right there."

I couldn't say no: I owed her a favor. Amalia was responsible for getting me four whole weeks of longhair work last winter, just when I'd come back to New York and needed it most. She'd invited me to play first violin with her in a string quartet, inside Best's department store on Fifth Avenue, every afternoon between Thanksgiving and Christmas. The pay wasn't especially high, but they gave us their employees' discount on merchandise, too, so I could afford to send French scarves to Mother and Gramma, and a Norwegian ski sweater to my brother, Tim.

Besides, if I went down to Meyers Conservatory, somebody might give me a lead on a longhair gig—a *paying* gig. So I dressed up, in a brown wool suit with a cardigan jacket, and a felt fedora hat with a rakish red feather.

I walked to the 72nd Street station, and took the El down Ninth Avenue to 50th Street. The stop is right behind Madison Square Garden, but there wasn't a prizefight or a six-day bicycle race on, so there weren't any crowds under the El tracks. Which can be a problem for a woman, because you come down off the El in a very rough neighborhood.

Everything west of Eighth Avenue, from about 60th Street down to 30th Street, is what New Yorkers call Hell's Kitchen. Most of the buildings were constructed right after the Civil War, and they're about as healthy-looking, today, as a reunion of Grand Army veterans. Some of the four-story brownstones are still family homes; others were cut up into rooming houses before I was born. There are a lot of five- and six-story walk-up apartment houses, too, which are mostly overcrowded, and smoky from so many cook-stoves. Also there are gas-houses, warehouses, and slaughterhouses. And that'd be okay, too, except that a lot of the city's hoodlums and holdup men call Hell's Kitchen home. Even the cops there go two-by-two.

Mind you, I'm not a 'fraidy-cat. My brother and I learned *jujitsu* out of a book when we were kids. *Ju-jitsu* is the Japanese

"gentle art" of self-defense. I live alone, and considering all the wolves I meet in the music business, it's a real comfort to know I can throw a guy flat onto his back, even if he weighs more than I do. But just the same, when I'm in Hell's Kitchen, I always walk looking straight ahead.

So I almost didn't see Amalia waiting for me, beside one of the El's black iron struts, when I came down the stairs. She's barely five feet tall—comes up only to my neck—but the way she stood there, it was like she was trying to shrink down to nothing. And she was all in black. Well, that's what classical performers wear for recitals. But it made her look even smaller. And there were worry lines across her brow that I'd never seen before.

I opened my arms to give her a warm hug and a peck on the cheek, but Amalia only extended a bony hand, so I shook it. She'd always been on the shy side, but her touch today seemed downright timid. Sliding my hand under her arm as we walked south, down Ninth Avenue, I started off lightly. "Tell me about that quartet. I didn't recognize it."

"I'm not surprised. It's almost never performed."

"So, who—"

"Paganini."

Ahhh. Niccolò Paganini died about a hundred years ago, and in case you never heard of him, he was probably the greatest violinist who ever lived. He was such a virtuoso that people all over Europe swore he'd sold his soul to the devil—and Paganini encouraged the legend: it helped to pack the house, wherever he played. He's not so well-known or appreciated as a composer, though, because he was a real show-off. Some of his solo pieces, like *Moto Perpetuo*—Perpetual Motion—only the best violinists can play at full speed. (Don't ask. I've seen Yehudi Menuhin do it, and even *he* breaks out in a sweat.)

"It was the guitar that threw me," I said.

"Six of Paganini's quartets have a guitar instead of a second violin."

"And you picked the one in *B*?"

"Quartet Number Eleven, in B Major. Yes. Meyers students play at a very high level. And we had Paganini's autograph manuscript, right there, to study from! Except we don't, anymore. One minute, it was in my cello case, and the next minute it was gone."

I patted her arm. "How old is it?"

"The date on it is eighteen-eighteen."

"That *is* old. Is it the whole score, with all four parts written out together?"

"Yes."

"How's it bound? In a book?"

"It's not bound. There are thirty-four sheets of paper, tied with a ribbon. I can't find *any* of those pages, Katy. Not even the ribbon!"

"What happened, do you think?"

"I don't know. But I'm in trouble if I can't return it. The school has an incredibly valuable collection of manuscripts."

"Do they keep them in a vault?"

"No. In the library."

"And anybody can just check them out?"

"Well, you couldn't walk in off the street and do it. But the students and the teachers are allowed to take them away. They trust us. At Meyers, they've always trusted everybody. That's been the tradition since they founded the school."

"When was that?"

"Eighteen seventy-five. They were a family of music teachers, back in Vienna. But they were Jews, so they couldn't get a permit to open a school. They emigrated to America, and took their manuscripts with them. They were collecting before anybody thought music manuscripts were *worth* collecting; so they bought up whole trunkfuls, when old estates were being sold off. They've got a manuscript by Tartini, one by Schubert, two by Mendelssohn. There's a handwritten Brahms sonata, inscribed to Clara Schumann, and a—"

"I get the idea. And I know the feeling you get from handling an old manuscript. It's like you're right there, watching it being composed; or like the composer's writing the piece just for you."

"And what an inspiration *that* is, to good students!"

"It's an admirable tradition they have there, at Meyers, but a little risky nowadays, don't you think?"

We'd reached 48th Street. Amalia said, "The school's right down the block, but let's get a cup of coffee here first, and keep talking." She steered me to a corner luncheonette that had THEO's painted across the window. "The booths are quiet. And Theo is a music buff."

I looked through the doorway. A skinny man with a thick head of hair-oil was reading the afternoon *World-Telegram* in a booth. I pointed to him. "Is that Theo?"

"No. Theo's behind the counter."

Inside, the walls were festooned with concert and recital posters from all over the city: Carnegie Hall, Aeolian Hall, the Juilliard School, the Mannes College, and more. And there were opera posters from the Academy of Music, the Brooklyn Academy, and the Metropolitan, as well as autographed photos of a dozen singers.

Theo waved us toward a booth, and when he came around to take our order, Amalia introduced us. He was trim and muscular, with pale skin that was smooth, even around his gray eyes. He had all his own hair, but silver threads greatly outnumbered the black, so I guessed he was nearer fifty than forty. He pointed to a bright orange Bakelite radio on a shelf above the deep-fryer, and said, "I had you on today, Miss Chen. Did you work up an appetite, playing in B?"

"Haven't had enough of your coffee, yet!" she bantered back.

"Need a menu, Miss Green?"

"Just coffee for me, too, please."

He poured, and I smiled. But his java tasted like it had been percolating for a week; I needed two lumps of sugar instead of one.

When he'd gone to poison the other customer, I said, "Why isn't the Meyers collection in a museum?"

"I think it ought to be, but Dean Meyers believed in carrying on her family's tradition."

"Doesn't she believe it anymore?"

"She…she's dead."

"I'm sorry."

"Iris Meyers was her name—the founders' daughter. Didn't you see the newspapers?"

"When?"

"January."

I chuckled. "Thanks to our Christmas gig at Best's, I could afford to take a couple of weeks *off* in January. I stayed with my mother in Syracuse. What happened?"

Amalia leaned closer to me. "She was found dead, at her desk in the library, but she—"

A rustling noise interrupted her. We looked around. The fellow with the slick pompadour, in the next booth, had turned the pages of his *World-Telegram* and shaken them straight. But when he saw us looking at him, he said, "Sorry," refolded it, stood up, tucking the paper under his arm, and walked over to sit at the counter and talk with Theo.

"It's spooky," Amalia went on. "I mean: people do just drop dead. They have heart failure, or a stroke. But she wasn't ill. Nobody knows why she died."

"Well, this is Hell's Kitchen. Maybe some hoodlum snuck in and killed her."

"You still go for that lurid stuff, don't you, Katy? You always did."

Actually, I *was* more intrigued by what might have killed Iris Meyers than in finding Paganini's manuscript. Mother says I have a "morbid curiosity," because things like…well, things like *that* have always piqued my interest. She insists I inherited it from Dad, who

was a doctor, and gave me first-aid training. But first-aid wouldn't do Iris Meyers any good.

"Who's the dean now?"

"Her brother, Joseph, but—" she leaned over again and whispered, "—a lot of us on the faculty are worried about him."

"Why?"

"He's never had administrative responsibility before. He was just one of the instructors; he still teaches theory and composition. It was his sister who ran the school. Now that *he's* the dean, nobody knows what he'll do. After this spring term ends, he might even close it down."

The bulb in the wall sconce lent Amalia's face an unflattering color, making her look paler, even, than she looked outside, in the cold, bright April sun. She'd always been slender, too, but here she looked underfed. Her brown eyes didn't flick about as much as they had last Christmas time, either. And frown-lines creased her cheeks, which had seemed so round then. I caught myself staring, so I touched her arm. "You'll land on your feet."

"Not if I don't bring back the manuscript! It was *my* responsibility. I signed it out of the library. I gave it to each of the other three players to copy out their parts, and they each gave it back as soon as they were done. I had it with me at the broadcast. I showed it to the announcer."

"Yes. He mentioned that, on the air. What did you do with it afterward?"

"I put it in my cello case—that's where I always keep music sheets: in the zipper pouch of the canvas case-cover."

"But that's on the outside; so somebody could have...picked your pocket."

She stared down at her coffee cup. "Katy, would you look around at Meyers? Maybe you can see something that I can't. Remember how you found my bow?"

Aha! Amalia's favorite story about me. When we were at Rochester

together, her best cello bow disappeared one day, and I happened
to catch a glimpse of it on the instrument repair bench. One of the
luthiers had coveted it, stolen it, and as the expression goes, he hid
it in plain sight. I pretended I wanted to learn how to make repairs,
and while he was away getting supplies, I took the bow off his
workbench and brought it back to Amalia. Ever since, she's regard-
ed me as the love-child of Philo Vance and Mata Hari.

"If I don't return it," she said quietly, "my parents will be
mortified."

I *knew* something deeper than just a misplaced manuscript was
troubling her. Chinese people are very sensitive about bringing
shame on their families. I laid my hand on hers, but except for "I'll
do whatever I can," I couldn't think of a comforting word.

Still, she put her other hand over mine, and gave it a squeeze.
She left two dimes on the table for our coffees, and waved to Theo
as we headed out the door.

We were just turning west into 48th Street when three young
men passed us. One bumped into me. I mumbled some kind of
apology and took a few more steps.

K-chuff! Something whizzed past my ear, like a wasp in a hurry.
I spun around.

One of the boys yelled, "Son of a bitch!" He reached between
the buttons of his plaid shirt, down to his belt, and took out some-
thing wrapped in black tape. I didn't wait to see what it was.

K-chuff! K-chuff!

I ducked, yanked Amalia's sleeve, and tumbled with her onto
the pavement. We rolled over one another, down to the curb, where
I grabbed the tire of a green Buick sedan. Amalia wriggled in panic,
and my mouth got pushed up against the wheel, smearing the
white sidewall with my lipstick.

K-chuff K-chuff! K-chuff! More of...whatever-they-were zipped
around us, from two directions. Then glass shattered, and the
Buick's horn honked twice.

One of the boys sprang right over our heads and jumped onto the running board behind us. The engine raced. The gears engaged. The wheel began to turn. I let it go just in time. The sedan jumped the traffic light, dodged the El supports, and took off down Ninth Avenue.

<p style="text-align:center">⊨</p>

I let out a little of the air I'd been holding in, but I'd waited too long, and gasped to catch my breath. I choked, and thought I was going to throw up. Finally, my chest took over my breathing for me, pumping hard, until I was back in rhythm.

My wool suit-jacket felt wet at the shoulder—Amalia was crying on it—but even wetter inside, where I'd perspired through my cotton blouse. I let myself shiver a little, which pulled my skin away from the damp cloth, and allowed me to imagine that I was shaking the fear out, too.

"When we fell," she whimpered, "I thought you'd been—"

"Actually, I know how to fall and roll, and not get hurt. You learn that with *ju-jitsu.*"

Theo ran out of his door, shaking a fist at the car. All that was left of his window was a single painted shard.

"Call the cops," I said.

"I did, already. You okay? One went through your hat."

"One *what?*" I pulled off my hat; it was gashed across the crown. "I didn't hear guns."

"They were homemade slingshot guns, Miss Green, that shoot *those* things—" He pointed down. Triangular slices of red linoleum, an inch or two long, littered the sidewalk. He crouched, and picked one up. "Look at that edge: it's like a knife. Slice through your neck, hit an artery, you could bleed to death. Goddamn *Dusters!*"

So, *that's* who those boys were! The Hudson Dusters.

New York is famous for its neighborhood gangs. You've probably heard about Little Italy, where Sicilian gangs kill people who

break their code of honor. Up in Harlem, Negro gangs kill to control the punchboard and numbers rackets. In Chinatown, tong gangs kill for territory and tribute. And on the Lower East Side, you can pay the Jewish gangs to kill somebody *for you.*

But in Hell's Kitchen, there's a bunch of Irish hoodlums who are young and crazy. They call themselves the Hudson Dusters, because they get hopped up sniffing "happy dust"—that's cocaine— before they go out on a spree. They've been known to beat people up who just wandered down a street and looked at them the wrong way. So, evidently, on West 48th Street, there were lines in the sand that nobody but the Dusters could see.

A police car drove down Ninth. We looked at it gratefully, ready to tell the cops what happened. But they weren't in a hurry, and they didn't stop.

Theo shrugged. "I'm not surprised." He wrapped dishtowels around his hands, picked up the glass shards from the sidewalk, and dropped them into an ashcan. I tossed in my slashed hat.

Back inside, the customer with the pomaded pompadour had vanished. I wanted to vanish, too; but Amalia motioned me into the ladies' room. We washed off the dirt from the street, and brushed out our hair. I pinned mine up, now that I was without a hat.

When we came out, Theo said, "How about a little more coffee? It's on the house."

"I'm too jittery for java." (That was diplomatic.) "Can I have some milk?"

"Tea, please," said Amalia.

He set them down in mugs, then took a broom to the glass fragments on the floor. With the heat from the grill and the fryer, and the wind gusting through the shattered window, my clothes began to dry. But the police never showed up.

Amalia sipped her tea. "Those—the Dusters—" she tipped her head toward the window "—I see them every day."

"Where?"

"They sit on the stoop of a house across from Meyers. They're there when I come to work in the morning, and they're still there when I go home at night."

"Have they ever threatened you?"

"Not exactly. They—" she closed her eyes "—they make rude noises and disgusting suggestions to the girls. They taunt the boys, too—they call them sissies. And they call me a 'Jap,' which is *doubly* insulting!"

"Aww, 'sticks and stones,' you know."

"Of course. But it's unsettling, when you're trying to concentrate on your music."

"Do you suppose they broke in, the night Miss Meyers died, and—?"

"Forget about her, Katy. I need you to find the manuscript."

"Of course. How long did you have it?"

"Since Sunday night. Each of us copied out our own parts. I did the cello first; then I gave it to the viola player, because she works slowly. She gave it back to me Monday night. Then the first violin got it: he's faster, and he gave it back before noon on Tuesday. So I gave it to the guitarist; she had it overnight, last night, and gave it back to me this morning. We all checked our copies against the original, around nine-thirty, half an hour before we went on the air."

"When did you see it, last?"

"After the broadcast. On the air, we had only enough time for the first movement. We played the rest of the quartet after they signed off. I would have returned it to the library after the broadcast, but the library was closed; everybody was still down in the parlor, where the recital was held. I put my cello back in its case, so it wouldn't get bumped around during the reception, zipped the manuscript into the outer pocket of the canvas case-cover, and carried it upstairs, to my desk, for safekeeping. I went up again later, only about twenty minutes later, to put the manuscript in my desk

drawer, but when I unzipped the pocket, it was gone. I hurried
back down, to ask the radio crew if they'd seen it, but then people
came over to talk to me, and I didn't want anyone to hear me ask
them."

"Did you get a chance, later?"

"No. Everybody was hovering around me. And then you tele-
phoned. So I took the call up in the dean's office."

"Okay." I swallowed the rest of my milk. "Let's go over to the
school. No. Wait. Who am *I*?"

"Huh?"

"I can't just be your old conservatory classmate. Why would I be
asking questions about the manuscript, which nobody's supposed
to know is missing?"

She froze—like a deer in your garden, when you flick on the
porch lamp. "Maybe you're a...a manuscript dealer."

"No. I don't know anything about them. Besides, I need the
subject to just...*come up* in conversation."

She was wiping the rim of her mug with a paper napkin. "A
paper! I could say you're a reporter. From *The Etude*."

That's the national magazine for longhair musicians and teach-
ers. "My name isn't in it."

"Come on, Katy. Nobody reads the *bylines*!"

"All right. It's not a bad idea. And I do know *The Etude*'s New
York reporter. I'll go over to her office later, and tell her I want to
write an article about you. Oh! You know her, too: Madeline
Roark. She was at Rochester with us."

"I remember her. She was kind of snooty toward me. I don't
think she likes Chinese people."

"She's had her picture taken with Madame Chiang Kai-shek!
But then, she likes kissing up to celebrities. She fawns over practi-
cally every soloist who plays Carnegie Hall. And she once had a
torrid love-affair with—"

"I'm not a celebrity."

"You're a radio star, now!"

"Are you sure you can carry this off?"

"I'll make it up as I go. When you've played swing and jazz as long as I have, you learn to fake it."

"Just don't go jumping to conclusions, the minute somebody tells you something."

"You asked me to help you!" We both stayed quiet for a long couple of seconds; then I added, "I'm sorry. Nobody's been shooting at me, lately."

Amalia said, "I'm sorry about your hat," but she giggled, and a moment later, I did, too.

Then I stood up and said, "Let's get started."

She hung back. "Maybe I should just tell the dean I've lost the manuscript, accept the responsibility, and let him fire me."

"Don't you dare! What would your parents say? They sent you to study in America; they encouraged your career. They risked their lives getting out from under the bombing of Nanking. And for what? So you could take the blame for something that isn't your fault?" I was on a riff. I didn't know where it was coming from, but I knew how mad I'd get, if what happened to her had happened to me.

Amalia nodded. "You're right."

"And we'll tell the dean that I'm with *The Etude*."

"What if Madeline doesn't play along?"

I flinched. Madeline's not exactly a friend of mine. But I didn't want Amalia to think I couldn't help, not after giving her such a pep talk. "I'll trade with her for something."

"I can't let you *pay* her!"

"No. I have a scoop I can pass along, about a certain conductor. Besides, she's written articles for *Colliers*, too. If this turns into 'The Mystery of the Missing Manuscript,' she can have *that* story."

"I don't know, Katy. I'm scared."

"Amalia," I said right into her face, "I'm happy to help you out

of a jam. But finding lost music is not what I do for a living. Don't take this wrong, but the best thing that could happen is that my trip down here was completely unnecessary."

☲

Meyers Conservatory was just west of Theo's corner, on the north side of 48th Street. I'd imagined it as a regular school building. But it was actually three ordinary neighborhood buildings in a row, which had been cut through and connected on their insides. The first two were old five-story tenement walk-ups, that had "1882"— the year they were built—carved into the stone parapets around their roofs. Amalia led me into the building closest to the corner, which contained the dormitory rooms, a kitchen, and a small dining room. Then we crossed through into the next building, which had all the classrooms and practice rooms.

The third building, the one farthest west, was different: a four-story brownstone that was originally the Meyers family home. The parlor on the main floor, with its rosewood paneling, still had a few dozen folding chairs out from the recital and broadcast. Up the stairs, the entire second floor had been turned into a library. The third floor was divided up with cheap bookshelves and screens, to make office cubicles for the faculty. And the top floor—originally servants' rooms, in old houses like these—was the dean's apartment. The bedrooms, I guessed, were at the back, while the front room, facing 48th Street, served as the dean's office. A large skylight made up for the low ceiling.

"I'm glad you're back, Miss Chen," said a man at a desk by the window. "There's—oh! Excuse me." He stood up. "How do you do? I'm Joseph Meyers."

I put my hand out, and said, "Katy Green. I write for *The Etude* magazine."

When he grinned, his teeth were yellow. He was about forty-five, or a little past, and chubby enough—probably from leading a sedentary life—that I wondered if he could actually button the

front of his black tailcoat. Glancing at Amalia, he said, "I didn't know I was going to be interviewed again."

"I heard Miss Chen on the air this morning, and thought: There's a great story in that girl. And sure enough, now that I've met her, it's a cinch! Give me your handshake on this deal."

"What's the deal?"

"I want to follow her around for a day or two; talk to her pupils, the people she plays with—"

"I wouldn't want the other faculty to be jealous of the attention."

"I'll talk to as many people as I can! What d'you say, Dean?"

"I'm new at this. Perhaps you've heard? I've only recently become dean here."

"Yes. And I'm sorry about the circumstances. But you got some good publicity, today, on the 'Quarter-Hour Concert Hall.'"

"That was my late sister's idea. She approached the show's sponsor, Mr. Quartermain, last year."

"There's nothing wrong with promotion! And I can help you on that score. The radio deal might've opened a few people's eyes, but at ten A.M. on a Wednesday, how many people heard it? A write-up in *The Etude*, though, *that'll* get people talking, and really put this place on the map."

"It's already on *somebody's* map."

I waited for more, then said, "I don't understand."

His upper lip twitched a little. "I'm sorry. Bad joke. Forget it. You've made your point, Miss Green. Would you excuse us for a moment?"

"Oh. Do you two want to talk it over? Sure thing. I'll just wait in the hall."

I closed the door behind me. Amalia would tell me whatever he said to her. With any kind of luck, the whole manuscript business might've already been settled; maybe he'd found the bundle down in the parlor, or somewhere.

In the stairwell, there was a portrait of a young woman, illuminated by a small lamp over the frame. It was painted about thirty
years ago, to judge by her gown. She had the same eyes and mouth
that Joseph had, and sure enough, the tarnished brass plate on the
bottom of the frame said IRIS MEYERS.

Amalia opened the office door and said, "He thinks your story
would be good for the school."

"Great!" I popped my head back in the dean's doorway. "I'll
head over to the office and get my note pad. Back in two shakes. I
want to talk to you—"

"Can we do it tomorrow morning? Just come right up when you
get here. No appointment necessary."

"I'll do that."

On the way downstairs, I whispered to Amalia, "Did you tell
him it was missing?"

"No."

"What about the librarian?"

"No. Do you think I should?"

"Not yet. Let me talk with her before you do."

"I'll introduce you now."

"Later. I better go join the staff of *The Etude*."

<div align="center">⊨</div>

The Etude's New York office was in the Paramount Building on
Times Square—the one with the big clock and globe that light up
at night. But getting there was tricky. The city was building a new
subway line underneath Eighth Avenue—and under Sixth Avenue,
too, in front of the musicians' union hall. But no matter what Mayor LaGuardia promised, there was no way the Eighth Avenue line
would open before the World's Fair: not with a hole that big up the
middle of the road.

I got across Eighth, finally; walked through Times Square, past
the Trans-Lux newsreel theater and Minsky's burlesque house to
the Paramount Building, and took the elevator up.

Madeline Roark is my age—thirty-two—but with more padding on top and bottom. And she's much prettier, besides, with marcelled blond hair, and a round little mouth like the ones you see in lipstick ads. She smokes expensive Régie cigarettes in a holder that's longer than President Roosevelt's. And she affects a brusque little wave of her hand when she's had enough food, or enough drink—or enough of *you*.

"Hello, Madeline."

"Katy!" She stood up, and leaned in toward my face. I expected a peck, and heard her pucker, but her lips stopped short of actually touching my cheek.

"Been in Europe?" I asked.

"On the trail of a great story. What brings you here, darling?"

"I know you like to be up on the rising stars."

She waved me into a chair. "Who've you got for me?"

"The hottest cellist in New York. She was all over the radio, this morning."

"Do tell!"

"Remember Amalia Chen?"

"Uhh…is that the little Chinky who was at Rochester with us?"

"The war in China's been in the news lately. So that makes Chinese *people* hot, too. Like Madame Chiang. If I were to write something about Amalia, could I show it to you? Maybe you'd publish it."

She leaned back in her chair. "Are you her press-agent?"

"Just a friend."

"I don't think we'd run a story about her." She made her dismissive wave.

"I can give you a real scoop, in exchange. The *Times* doesn't have it, yet."

"What's your scoop?"

"I know where Leopold Stokowski is, right now."

"The conductor? Is he missing?"

"He's in Hollywood, cooking up a deal with Walt Disney, to score a cartoon with classical music."

"That's a dumb idea!"

"Okay. Thanks anyway. The *Times* is right around the corner on Forty-third, and they have a Sunday music section that—"

"No! Don't take it to the *Times*! Cigarette?"

I shook my head. While she lit one, I said, "You really ought to write a story about Amalia, anyway. It'll only take you a couple of days—and it'll be fun. She's right nearby, at the Meyers Conservatory. You could pal around with her, meet her students, talk to her colleagues on the faculty. And you'd write a much better story than I ever could."

"Actually, Katy, I don't have a lot of time this week. I told you I was overseas. It's a really *important* story. Fogarty and Cornelius—you know: the booksellers, downtown—they are buying Breitkopf and Härtel, the big European music publisher. God knows where they're getting the money to do that! But apparently, they're going to move the whole operation here, to New Y—"

"Suppose I just do the *research* for you, at Meyers. You can write it next week."

"Katy, I'll be busy following Mr. Cornelius around next week. I won't have time to write *anything* about Miss Chen and her fiddle."

I stopped myself from saying *cello*. "So, it'd be okay with you, maybe, if *I* wrote something up?"

She sighed a smoky breath. "There's no guarantee we'd publish it. You'd be writing on speculation."

"I'll take the chance."

"And I'll have to edit it."

"I'll bring it to you on Monday."

"No. Monday I'll be down at the bookseller's. Give it to me on Saturday; I'll take it with me to Long Island, over the weekend, and read it there. If it's good, I'll show it to my editor on Monday.

Where the heck is Meyers Conservatory, anyway? Somewhere near here, you said?"

"Uh-huh. Forty-eighth Street, between Ninth Avenue and Tenth."

"Really? I garage my Packard in the next block, on Forty-ninth. Tell you what: I'll stop in at the school and pick up the story from you on Saturday evening, before I drive out to Long Island. Let's say six o'clock. You're smart, Katy. I'm sure you'll have it all done by then. Typed, of course—two copies. And do use *fresh* carbon paper." She gave me her little wave.

I said, "Thanks. See you then," and got back into the elevator. Now, I had until Saturday night to find the Paganini manuscript… or learn to type.

*The word "fugue" (*fuga *in Italian) means "flight." Each voice, as it enters, chases the preceding one, which flies before it.*

—*The Oxford Companion to Music*

2. Chasing Voices

At the back of the narrow hall that served as a lobby for the classroom building at Meyers, two boys were sprawled on a worn sofa, talking through oboe and clarinet reeds in their mouths. Another was reading *The Etude*; I asked him for Amalia, and he pointed to a makeshift phone booth—a closet under the stairs. While I waited for her, I checked a bulletin board on the wall for posted gigs (there weren't any), and picked up a flyer for student recitals, which I slid into my pocketbook.

Amalia finished her call; she beckoned me over and whispered, "The radio crew didn't see it."

"Could one of *them* have taken it?"

"I don't think so. They were all busy packing up their equipment after the recital; and besides, my cello case wasn't anywhere near them."

"I'd like to talk to the students who played the quartet with you."

She took me through the archway that had been cut to connect the classroom building with the adjacent dormitory building. The floorboards didn't quite line up, and the white plaster in the near hallway was a different shade of chalk from its counterpart on the other side of the wall. "Let's see if Susie Pierce is in the town lounge."

"The what?"

"The dormitory is for students who don't live in the city. The town lounge is for students who do. They can rest up, do their homework, stow their instrument cases."

"And Susie?"

"She's the viola player—" Amalia opened the door "—and here she is. Hello, Miss Pierce. I'd like you to meet Miss Green, who writes for *The Etude.*"

"Hi!" Susie was a slender, chocolate-brown girl in her early twenties, with big eyes and a pile of sleek black hair. In Cuban heels, she stood just a bit taller than I; but her tailored green wool suit and pink silk blouse looked as though they cost more than the average conservatory student could afford.

"Miss Green is writing an article about, uh…"

"It's about Miss Chen, actually, but I want to use that quartet you played as a reference point—I want to lead off the article with it. Tell me about yourself."

"Sure! I'm studying theory and composition with Mr. Meyers— Dean Meyers. Frankly, the school is sorely lacking in viola faculty. It has other shortcomings, too—oh, don't look at me like that, Miss Chen. You know I'm right. The school's chronically short of money, and *The Etude* might as well print the truth about it. Anyhow, Miss Green, I still take *private* viola lessons from my old teacher—" she checked her wrist watch "—and I've got to leave soon. He's coming to give me a lesson at home, tonight, after supper."

"Uh-huh. Where's home?"

She smiled. "A-hundred-and-thirty-ninth."

(Which explained the price of her clothes, and her attitude. In Harlem, that block is known as "Strivers' Row," because rich Negroes own townhouses there; and some of them can be as snobbish as any lily-white Park Avenue nabob.)

"That number you played on the air today—that Paganini quartet—Miss Chen tells me that the four of you copied your parts from a manuscript. Is that right?"

"It's an autograph score, handwritten by Paganini himself."

"Really? Would you show it to me?"

Her wide brown eyes shot over toward Amalia. "I gave it to you Monday night. Don't you have it? Or is it back in the library already?"

Amalia said, "Yes," a little too quickly.

Susie smiled. "Well then, you can sign it out again, and show it to Miss Green yourself."

"Of course."

"I'd be happy to talk further with you about your article, Miss Green, but I can't, just now. I've got to go home."

We watched her leave. Amalia led me out of the town lounge and up the main stairs. The rooms on each landing had brass numerals nailed to their doors. Just as we reached the fourth floor, a woman stepped out of the room marked "4B," and closed the door behind her. She saw Amalia, and gave her a nod and a smile.

"Oh, what a coincidence!" Amalia said. "I was going to introduce you two later, but I'll do it now. Nina Rovere—this is Katherine Green. Miss Green is a writer for *The Etude*. Miss Rovere is an accomplished cellist, and also the school librarian."

"Nice to meet you," I said.

She put her hand out, and we shook. By the worry-lines around her mouth, I guessed she was nearer the end of her thirties than the start. But she also had the kind of thick, black hair and round, dark eyes that make talent agents put pictures of Spanish girls like her on

top of the pile. Not that she'd have turned heads in a chorus line: she was long-waisted, with hips more fleshed-out than her bust. And though she was good-looking, she didn't dress to advantage: her gray skirt was too long and her yellow blouse too loose to show much of a figure.

"It was a wonderful recital you gave this morning, Miss Chen. But I'd like to return the Paganini to its place in the archive now. Would you drop it off at my desk?"

"I'll bring it in tomorrow," Amalia replied, with more poise than I'd expected.

Nina's nostrils flared. "I'm always a little anxious when anything so valuable is checked out."

"I understand."

"Speaking of manuscripts," I said, "Miss Chen tells me the school has quite a collection."

"Yes," Amalia piped up. "I wonder, Miss Rovere, if you'd show some of them to Miss Green."

"Come in tomorrow. I open the library at seven-thirty." She tacked on a "Good-bye," and went on down the stairs.

Amalia led me over to 4B. "This is Guy's room," she said. "Guy Carson. He's in his third year of study. He was the violin in the quartet, and he's...uh..."

"Yes?"

"Well, you'll see."

She knocked, and when the door opened, I saw. He looked like the Arrow Shirt and Collar man in the magazine ads: slicked blond hair, narrow face, very tall, no hips....

"I'm Katy Green," I announced through my gape.

He sponged me with gray eyes before he shook my hand.

"Miss Green is writing an article for *The Etude*," said Amalia, "and wants to talk with us about the quartet."

"I'd also like to know how the classical music students of to-day are preparing for the future. You're the next generation of

musicians—what do you think the nineteen-forties will hold
for you?"

(Pretty good, huh? I'd thought that up on the walk back from
Times Square. It sounded like a real reporter's question, and it was
so vague I could use it as a lever to pry out almost anything else.)

He smiled. Straight teeth. "Do you want a short answer or a
long answer?"

(Oh, how I wanted a long, long answer.) "Whatever you want
to say. But I need a fresh note pad. I'll come back. I just wanted
Miss Chen to introduce me to the ensemble. And I'd like to see the
sheet music that you copied your parts from. The radio announcer
said it's an old edition."

"It's a manuscript. Miss Chen has it, or else it's back in the li-
brary."

"What's the best time to catch hold of you, Guy?" (Oops! I
couldn't take back the pun.)

"What're you doing for dinner tonight?" He gave me a big
smile, and I could feel a tingle; but I pretended I didn't, and just
shrugged. "Could you go for a hamburger?"

(So, he wasn't going to spring for the Astor Roof. Oh, well.) I
said, "Sure," and looked at my wrist watch. "I could meet you at
eight o'clock."

"Here?"

(It was tempting.) "How about the hamburger stand?"

"Fine. It's called Theo's—it's right at the corner of Ninth Ave-
nue."

"I know it. I was there, earlier, but…it might be closed to-
night."

"Then we'll just meet on the corner, and go to the Automat on
Times Square."

"Okay."

Guy watched our backs until we had taken the first steps down
the stairs, then he closed his door.

Heading down the stairs one flight, Amalia said, "Rebecca Tharp is the guitarist. She's right below Guy, in room 3B."

Amalia knocked at the door.

"What? Who is it?"

"It's Amalia Chen and—"

"Whoo! Hang on a second, will ya?"

"All right." Amalia turned to me and gestured toward the door. "This is Rebecca's first year here. She's from Tennessee."

We heard a door slam inside, and a noise like tapping feet. Bad dancing, though: no rhythm. Then something that sounded like coughing.

Amalia leaned closer to the door. "Are you all right, Miss Tharp?"

"I'll be right there." (Actually, what she said was: "Ah'll be rat they-yer." She was from Tennessee, sure enough.)

The door stayed shut, and the coughing got louder.

Amalia called, "Rebecca?"

"Wait! You can't come in!" The tapping and the coughing went on for a few more seconds, then they stopped. We knocked again.

"Not yet!" was the reply. From somewhere—but not nearby— we heard something like glass break with a scattering crash.

I twisted the knob and pushed. The door was unlocked, but it opened only a quarter-inch. Leaning my shoulder against it, I could peep through the crack at the latch-hook that kept it shut.

"Rebecca?" I called.

More coughing.

One time, in Atlantic City, there was a horn player who'd have drunk herself to death if I hadn't defeated the same kind of latch on her door. What I did then was worth trying now. I dug my tuning fork out of my pocketbook. (Fiddle players need to keep a fork handy: catgut strings are always going taut or slack with the weather.) Pushing as hard as I could against the door, to make the crack as wide as possible, I slid the U-shaped fork around both sides of

the L-shaped hook, and urged it up. When it sprang out of its eye-bolt, the door popped open.

There were wisps of smoke by the open window. Rebecca was crouched below the sill, against the radiator. Her right hand was jammed hard into her mouth, trying—but failing—to hold back a throat-racking cough.

We urged her up and—hands under her arms—helped her over to the cot. I unbuttoned the neck of her white blouse and looked in her mouth. She wasn't choking; she didn't need first-aid.

"I'm okay now," she said, after a moment.

A little taller—and a lot thinner—than I…late teens, was my guess for age. Her light brown hair needed a perm to give it some shape; but when I brushed the bangs away from her face, they were brittle; some hair crumbled in my fingers and smelled burnt. I stood up; Amalia continued to hold her hand.

On the floor was a black spot. That wasn't tap-dancing I'd heard, it was stomping. "Did you have a fire in here?"

"Who're you?" Her voice was hoarse.

"I'm with Miss Chen. What happened?"

"I'm so ashamed! I lit up a cigarette and set my hair on fire. You won't tell, will you?" ("Cigareet" was obviously "cigarette." But it took me an extra second to translate "set ma hay-er on far" and "you won' tail.")

"Who would I tell?"

"We're not 'sposed to smoke in our room here at Meyers." She coughed in Amalia's face. "Sorry. I know I shouldn't, but I've got the habit."

She sure did. The inside edges of her first two fingers, on both hands, were stained yellow-brown from tobacco. "Smoking cuts your wind," I said.

Amalia fluffed up her pillow; Rebecca closed her eyes, lay back, and took deep breaths. "I don' play a wind instrument. I play guit-tar."

A black, hard-shell guitar case leaning up against her closet door held it shut. Over her dresser, two photographs were stuck into the edges of the mirror frame. The smaller one was of a smiling young man in a sailor's cap and pea-coat—a beau, most likely. The other was a publicity shot of a family band—*her* family—standing in front of a radio station. Rebecca was in the center, with a guitar hanging by a neck-strap. Her mother wore an accordion; her father held up a double-bass. Like them, Rebecca had a dour, serious expression. But a small boy—a kid brother, probably—had a grin as wide as the banner they'd unfurled at their feet, which read: THANK THE LORD FOR THE GOSPELAIRES. WXP—DAYTON, TENN.

If Rebecca wore makeup or hairpins or jewelry, she didn't keep them on her dresser. It was topped with books that she'd piled up flat, the way people do who've never owned a bookcase, or even bookends. There was Siegmeister's *Concert Goer's Companion*, the *Musical Heritage Dictionary*, the Stratton biography of Paganini, Goldberg's *Music For Everyman*, the *Encyclopedia of Music and Musicians*, a WPA guidebook to New York City, and three Bibles—none of them from Gideon.

"D'you have tuberculosis?" I asked, "'Cause if you do, you shouldn't smoke."

She opened her eyes. "I do not have TB! An' I can sit up by myself. You can let go of me now, Miss Chen."

Amalia blinked, and released her hand.

Rebecca smiled—though it seemed forced—and said, "I'm sorry. I just don't want to get in trouble."

"I understand," said Amalia. "I won't tell anybody you had a smoke. Give me your pack. I'll ditch it."

"I already did. I threw it out the window. The ashtray, too."

The window faced a deep airshaft. The ashtray must have been the glass we'd heard shattering. I said, "Good going," as I glanced down through the window, but the angle wasn't right; I couldn't see the bottom.

"I was wondering, Rebecca," Amalia said softly and slowly, "did you happen to see where th—"

"Say! I better introduce myself: I'm Katy Green." I gave Rebecca the *Etude* story, and closed with, "Do they call you Becky back home?"

"Oh, no! That is, they used to, when I was little. But since I got saved, I go by Rebecca, like in the Bible."

"Miss Chen told me that it was you, this morning, playing guitar with her and the others."

"Yes, ma'am, it was. Did you like the quartet?"

"Paganini wrote great music for guitar."

"I was readin' in that there book, by Mr. Stratton—" she pointed to the biography "—that Paganini was a good guit-tar player his-self."

"Uh-huh. And Miss Chen says you copied your part from his very own manuscript." I let my eyes roam around the room. "Can I see what a hundred-and-twenty-year-old piece of music looks like?"

Rebecca looked at Amalia. "I gave it back to you this mornin', didn't I?"

"Yes. I believe you did."

I stepped right in. "Well, Beck—I mean Rebecca—you better rest."

"Yes, ma'am."

"And quit those cigarettes."

"I'll try. Thank you."

We left and headed down the stairs. As we reached the hall on the first floor, I touched Amalia's elbow. "Do you think Rebecca might be a lung-er?"

"A what?"

"TB. When I was helping her sit up, I had a funny sensation, as though we were in a hospital, or a sanatorium."

"From the coughing, I suppose. And how skinny she is."

"Did she return the manuscript, after all?"

"She must have, because I had it for the broadcast. Oh, Katy, I felt so good right after that. I was on top of the world. My parents were here—oh, goodness! I was supposed to telephone them. What time is it?"

I looked at my watch. "Ten after eight."

"I'd better phone," Amalia said. "I'll meet you in the library. Go on up without me."

"I told Guy I'd have supper with him at Theo's, at eight. I'll meet you in the library in an hour."

"Okay. 'Bye." She gave my arm a squeeze and walked away.

All the way out, down the stoop and onto the sidewalk, heading for Theo's on the corner, I was thinking about Paganini—though perhaps a bit more about Guy Carson. So I didn't watch where I was walking, and I bumped smack into a "forgotten man." He was bigger than I, but he stumbled. I grabbed the sleeve of his tattered overcoat and kept him upright.

"Thank you, miss. You haven't by any chance got a nickel, have you? It would help keep an honest fellow on an even keel."

That was a nice pitch: it wasn't desperate, and he only wanted a nickel! Most down-and-outers have asked for more since that "Brother, Can You Spare a Dime" song came out. He needed a haircut and a shave, but he didn't smell from booze or anything else. So I fished a nickel out of my pocketbook and put it in his hand. He touched the brim of his floppy cap—the kind that newsboys wear—turned away, and headed west.

<p style="text-align:center">♯</p>

Five wide boards were nailed up over Theo's shattered window. But he'd tacked on a handwritten sign that read: OPEN ANYWAY— PLEASE COME IN.

Guy was already in a booth, motioning for me to sit alongside him on the banquette, so I did. He'd changed into brown corduroy slacks and a V-neck sweater with no shirt underneath—a collegiate

style that made him look even more boyish. We ordered hamburger sandwiches, and Theo asked what we wanted on top. Guy asked for pickles. I took mine plain. (I would have had onions, but not tonight.)

"What did you say you were writing about?" Guy asked me.

"What do young musicians think about the future?"

"I'm not so young. I'm twenty-four." He said it with a look that declared he wasn't *too* young. Which was true: I don't mind flirting with men who are younger than I—it makes me feel pretty.

"What do you think the nineteen-forties will bring?"

"That's rather a stupid thing to ask about, these days. We'll all be dead! The boys, anyway. A whole generation of us. You watch. Practically every man in this country's going to be drafted. My father was called up for the last 'World War,' and got himself killed."

I said, "I'm sorry" automatically, but the war was more than twenty years ago. "How come you're still in music school? You could join the army right now, and by the time war breaks out you'd be an officer."

"If there's a bullet with my name on it, what does it matter if I've got stripes or not? Did you ever read Rupert Brooke? He was a poet: killed only a couple of days before the Armistice. If I'm killed, I want the world to know they lost a great violinist. I'm *this close* to getting a job."

"There aren't a lot of longhair gigs out there, even for men."

"What do you know about getting work as a musician?"

I bit my lip for a second, then I said, "I know that it's not the only life for somebody with talent. I have a friend who's a violinist—she's a conservatory graduate, too, and she gets a few jobs playing chamber music, especially around Christmas time. But the only steady gigs she can pick up, nowadays, are playing *swing* fiddle. She's done club dates, and—"

"Swing isn't music!"

"Like hell it isn't!"

"Are you asking me or telling me?"

"Sorry. But swing is the most popular music in America right now."

"Meyers graduates aren't looking to be 'popular.' They get chairs in the leading orchestras—"

"The women don't."

"—so a good violinist should aim for the top," he went on. "That's what I'm aiming for, anyway."

"You could be a teacher."

"No thank you. My mother and stepfather are teachers."

"Violin?"

"Piano."

"Where?"

"Up in Boston. And have they got a great gimmick! For pupils, they take only rich kids, from families who want their brats to be young ladies and gentlemen. Believe me, those kids have no interest in music: they only *pretend* to practice. But their parents see them sitting at the piano, so they keep on buying lessons. It's been very profitable for my family. I think Iris Meyers took the same approach with some of the students here."

"So, you want to be a soloist."

"That, or play first-desk violin in a major orchestra."

"I bet the army band would take you."

He grinned. "If I'm going to *lower* myself, I might as well put on overalls, move to Tennessee, and be a hillbilly fiddler. Have you met the guitar player, Rebecca Tharp?"

"Not everyone with a Southern accent is a hillbilly. And from what I heard on the radio, she's a fine guitarist."

"She's no *singer*, though! Her room's right below mine—I can hear her through the floor, screeching out hymns. At least they *were* hymns, before she strangled them. Guitar or no guitar, if you ask me, a year from now, she'll be plunking away on the 'Grand Ole Opry'!"

"She has to be—" I almost said "as good as you," but I said "*good*—good enough to get into Meyers."

"I've been trying to tell you: the school's lowered its standards."

"Don't be sarcastic."

"I mean it literally. In the three years I've been here, they've accepted students who would never have gotten in before. There's a boy who thinks he's a piano prodigy, though nobody else does. And there's a clarinet player and a oboist who do nothing but sit around the town lounge with their reeds in their mouths."

"I've seen them there."

"Well, you'll never see them in the practice rooms. And that Negress who played viola with us today—"

"Susie Pierce?"

"It's all she can do to keep up. She's played one piece by Paganini, and now she thinks she's ready for *Harold in Italy*. That's the—"

"Yes, I know. It's the viola showpiece that Paganini commissioned from Hector Berlioz."

He looked down his straight Boston nose for a second, then he gave me a smile. Perhaps I was up in his league, after all.

"That quartet you played on the radio," I said quickly, "I'm dying to see the score. My gramma says you can learn a lot about someone from their handwriting."

"It's back at school." He lowered his voice. "Would you like me to show it to you?"

I looked right into his eyes. "Let me guess: it's up in your room, with your etchings."

He laughed, but he also moved in closer. "No. But I can bring it to my room, if you like. You could take all the time you want, to look at it there."

I smiled. The prospect was appealing. But then Theo brought our hamburgers, which were a lot better than his coffee, although the grease quickly softened the white bread slices, and I had to grip

the entire sandwich with both hands to keep the meat from falling through.

"Are you really interested in old manuscripts?" Guy asked after he took a bite. "I know you write for *The Etude*, but can you even read music?"

"Did you ever meet a girl who hadn't taken piano lessons?"

He smiled, realizing—again—that I might actually understand what he'd be showing me.

Finally I said, "Why did you say Susie Pierce is untalented?"

"I didn't! She tries very hard, and she's competent. But even if she were the greatest violist in the world, she'd still be up against the color bar. As you said, there's no professional orchestra that'll give a chair to a woman. All right: where is the white orchestra that'll hire a colored man—much less a *woman*? My guess is: she'll wind up forming a chamber ensemble in Harlem, and give subscription recitals for her own people. She's lucky, of course: her family has money. She won't have to *abase* herself by taking in students."

I started to burn, but I couldn't let him see it. Criticizing his snob-kissing parents—that I understood. Lording it over lazy players isn't rare in the music business, either. But ragging those of us who have to teach to make the rent—*that* hit too close. I took a couple of bites in a row, and chewed slowly, just to keep myself quiet.

He broke the silence. "I'll sign out the manuscript from the library. If you like. Do you really want to see it?"

"Oh, yes!"

We ate up, and left our quarters on the counter. Dutch treat. I insisted.

From Theo's door, I glanced nervously up Ninth Avenue and along 48th Street, to satisfy myself that the Hudson Dusters weren't around. An El train went by overhead. I did notice, though, that my "forgotten man" in the tattered overcoat and newsboy cap had

stationed himself on the corner. Whenever a car stopped at the
intersection for a red light, he would walk over, carrying a rag and a
bucket, and wash its windshield for small change.

Guy played the gentleman, holding open the big oak door of
the Meyers house, to let me pass and step inside.

"Don't they lock it up?"

"Only after eleven."

We walked upstairs to the library, and through the French doors
that divided it from the hall. Nina Rovere looked up from her desk,
acknowledging us with a soft "Mr. Carson. Miss Green."

"I guess I got here a little sooner than I thought," I said lightly.

Guy motioned me over to a big rosewood cabinet. It had lead-
ed-glass doors, mostly clear, but highlighted by segments forming
pink rosettes and green leaves. He scanned the stacks of brown and
black leather music folders that lay inside on deep shelves, then
turned back toward the desk. "Excuse me, Miss Rovere. May I
show my friend here the Paganini quartet?"

Nina flinched, but slightly: as if only a very small spider had
dropped onto her book. She looked up at him and said, "It's out. If
you're looking for violin works in manuscript, there's a sonata by
Tartini; it's a bit older. Would you like to see that?" She was asking
Guy—not me.

"Anything else by Paganini?" I asked.

"No other manuscript. Though we do have a rarity in published
sheet-music: the British first-edition of Paganini's *Le Streghe*. Would
you like to see it?"

"If it's in," he replied.

She ran her fingers through a box of catalog cards, extracted
one, and set it down on her desk. Guy stepped aside as she ap-
proached the rosewood cabinet, took a key ring out of her jacket
pocket, and unlocked the glass door.

"It's from eighteen twenty-nine: originally a composition for

violin and orchestra," Guy explained to me, "but this is what's known as a 'reduction' for just violin and piano. 'Lay stray-gay' means 'the witches' in Italian."

I said "Oh?" wide-eyed, but I knew the piece quite well. Like most violinists nowadays, I'd learned *Le Streghe* from Fritz Kreisler's arrangement, which was published in nineteen-thirty. But the edition that Nina handed us was a hundred years older, and it was a treasure all right.

I'd always thought that Tin Pan Alley publishers invented the idea of printing vivid, colorful covers on their songs, to help sell them in crowded, noisy music stores. But the situation must have been the same a century ago. For this edition, the title had been exaggerated into "Paganini's Dream: The Dance of the Witches." And the artist apparently took his inspiration from that translation, because the cover—a hand-colored etching—showed a caricature of Paganini himself playing the violin under a tree, while witches and goblins danced all around him. And a little monkey-devil sat on Paganini's lap, pointing to the fingerboard, as if he were giving him a lesson.

I was going to check the inside pages, to see how this old arrangement differed from Kreisler's, when Dean Meyers opened the French doors and stepped into the library, saying, "Miss Rovere, may we have a word with you?"

By "we" he meant Amalia, who was right behind him. She looked away from me, as the dean gave me a grin—not a smile—of acknowledgment.

Nina said, "Certainly."

"In my office, please."

"How're your parents, Miss Chen? Did you phone them?" I asked casually, hoping to be included, somehow, in whatever she and the dean and the librarian had to discuss.

"They're very well, thank you."

"Mr. Carson, why don't you show Miss Green the *rest* of the library?" said Nina, taking *Le Streghe* out of my fingers and locking it away. She returned the catalog card to its box, too, before following the others upstairs.

Guy shrugged. "There are some fabulous manuscripts in there; I'm sorry I can't show them to you right now."

"I hope everything's all right," I blurted, then caught myself. "Amalia's parents are refugees, you know. Still adjusting to life in America."

He snorted. "There's too many Chinamen in the world, already. And they want *us* to fight *their* war against the Japs. That means I could get myself killed, so a million little yellow men can bow down to Chiang Kai-shek instead of Hirohito!"

He was entitled to be an Isolationist, but I didn't like that crack about "little yellow men." I glanced away, toward Nina's desk. She'd been reading *Gone With the Wind.*

Guy followed my eyes to the cover. "I've heard of that. It's a *girls'* book, isn't it?"

"They're making a movie of it. I'm sure they'll let *boys* into the theater."

"When I see a movie, I want to be uplifted, not distracted. Are you going to wait here for Miss Chen?"

"Yes. Why? Are you leaving?"

"We could go back to my room for a drink."

A school that didn't let students smoke in their rooms probably didn't let them drink, either; though the idea of being alone with his slender physique and a bottle deserved serious consideration. After I'd found the manuscript. "Not tonight. Thanks."

But he gave me a look that suggested he wanted to come to my door to borrow a cup of sugar. Anyhow, he said the right words over the recipe: "I'd like to talk with you some more. Maybe we could have coffee at Theo's, tomorrow."

"I'll look you up."

He glanced around the library. "I guess it's all right if I leave you here alone."

"Don't worry. I won't play any music."

"No. I meant, in case anybody—"

"I can take care of myself."

"I'm sure you can!" he chuckled, added, "See you tomorrow," and went out through the French doors.

I'd been hoping he would leave me alone before Nina came back. When most people read a book with a dust jacket, they use the end-flaps to hold their place. But she'd used a catalog card, like the one for *Le Streghe*, for a bookmark. And the top inch of it was exposed. It read:

COMPOSER: PAGANINI, Niccolò
TITLE: Quartetto n. II, in Si maggiore
 Dedicato a L.G. Germi (M.S. 38)

I knew that "Si maggiore" was Italian for "B major," and after a moment, I remembered what "M.S. 38" meant: it was number 38 in the official Moretti Sorrento catalog of Paganini's compositions. I was intrigued by the dedication, too; but I was more puzzled by Nina's use of the card as a bookmark. On her desk, there was a pile of *real* bookmarks—the kind that clerks slip into a book when you buy it—from Slomer's, Blackmun Sons, and Fogarty & Cornelius.

So I opened her novel to the page she'd stopped at (Ashley had just come back from the war), and read the typewritten catalog card:

COMPOSER: PAGANINI, Niccolò
TITLE: Quartetto n. II, in Si maggiore
 Dedicato a L.G. Germi (M.S. 38)
DATE ACCESSIONED: 23 November, 1920; gift of I. Meyers

PROVENANCE:

Iris Meyers, New York, 1920–

Gallerie de la Musique, rue Faubourg St. Honoré,
Paris, 1908–1920

Geo. Withers & Co. (trustee), London, 1886–1908

Sir Robt. Withers, Bart., Sussex, 1854–1886

Luigi Guglielmo Germi, Advocat, Genoa, 1820–1854

AUTHENTICATION: R. Winkler, Beechum's, New York

CONDITION: Good–Excellent.

VALUATION: $20,000

It wasn't the usual library's catalog card. It was more like the record
an antique dealer might keep, of who'd bought a painting or a piece
of furniture, over the years. Which made sense. Under "Authenti-
cation," it credited somebody at Beechum's—the big auction house
on Madison Avenue, on the Upper East Side. If I was reading the
card correctly, Iris Meyers had bought it at a Paris gallery, in 1920,
though it belonged to two generations of an English family before
that. And the first owner was an *advocat*, a lawyer, named Luigi
Guglielmo Germi: undoubtedly the "L. G. Germi" to whom Paga-
nini had dedicated the quartet.

I turned the card over. It had two neat rows of date-stamps and
names—people who'd checked the manuscript out of the Meyers
library—going back to 1935. The latest entry had been made last
Sunday, April 11th; and beside it, "A. Chen" was handwritten.

Slipping it back into *Gone With the Wind*, I looked around the
top of Nina's desk. Besides the bookmarks, she had a box of tissues,
several stamps and ink pads, and—

The doors opened all of a sudden. I spun around, hoping Nina
hadn't seen me being nosy. But it was Amalia, and she was alone.

"Is anybody around?" She looked from side to side.

"Nope. Just me."

"Oh, Katy, it's terrible! They know it's missing now. They gave me until Sunday to find it, or I'll be fired."

I don't know why I said, "We'll find it; don't worry," except that I didn't want her to start crying.

"Dean Meyers asked me for the manuscript, and I didn't know what to say, so I said I thought Nina had it. That's when he brought me downstairs."

"I can picture what happened next. Nina told him it wasn't in the library, and that you were responsible for it. What did the dean say then?"

"He asked me where I saw it last? And was I sure the other players had returned it after the performance? And did I look everywhere?"

"Did you?"

"Where do you think I've been all evening, Katy? I've been at my desk upstairs, emptying every drawer. I checked all the bookcases. I even looked in people's wastebaskets."

"Who else knows it's missing?"

"No one. Only the dean and Nina, you, and me."

"Plus whoever's got it."

She let her head droop. "I better take one more look around my desk."

"Okay. You go up and do that. I can't do anything more tonight. I'm going to go home and get some sleep. I'll come back first thing in the morning. Okay?"

"Thank you, Katy. I have to give lessons, starting at eight o'clock. Meet me at my desk at ten, will you?"

"I'll be there."

I smiled, and watched her go upstairs. Then I walked past the librarian's desk to the old music cabinet. The doors were yoked by a simple lock that any child could pick with a hairpin. I was actually thinking about trying that, when I heard the French doors open.

It was Nina. She looked at me the way an exterminator looks at a bug. "It's late, and the library is closing."

"I was just leaving."

"We don't get many reporters coming here. We're not used to having the press take any notice of our school."

"Have you been here a long time? This is a very well-kept library."

She seemed to thaw a little. "I've been in charge for the past three years; I taught here for seven years before that."

"Amalia said you play cello."

"That's right."

"Ever play *The Swan*, by Saint-Saëns?"

She actually smiled. "It's a favorite of mine. I used to end my recitals with it, or use it for an encore. I'm glad you like it."

"It always makes me think of the ugly duckling in the fairy tale, who's really a swan inside, only nobody knows it. I feel that way, too, sometimes. Know what I mean?"

"Yes." Then she was quiet for a moment.

"Have you got *The Swan* in a manuscript, too?" I glanced back at the cabinet.

"No, I'm sorry, we don't. But we do have many other interesting old pieces."

"I'd like to see them."

"Well, it's late. And we close the library early on Wednesdays. I—that is, Dean Meyers and I will be happy to answer any questions you may have. Please come back tomorrow."

"Thanks. I will. Good night."

I closed the French doors behind me and went to the stairwell. If I'd thought I could find the Paganini by a lucky guess, I was sure, now, that I couldn't. And I wasn't likely to stumble on it just by poking around. I needed to organize my thoughts and make a plan.

Going down to the parlor floor, I got distracted by an old photograph in a gilded frame, that hung from the wall over the

landing, half a flight down. It must have been taken before the turn
of the century, judging by the people's clothes, and the fact that
there weren't any cars on the street. But the El had been built—its
iron struts and bracings loomed over the scene. The view was to the
west, across the intersection of Ninth Avenue and 48th Street.
What was now Theo's restaurant was an eating-place then, too—it
had a BAKERY & LUNCH ROOM sign over the entry—but there was
a dentist's office upstairs, so I guess you could get cavities and get
them filled, all in one place! Looking left, down 48th Street, you
could see the two walk-up buildings and the brownstone house
that made up Meyers Conservatory. And looking right, up the ave-
nue toward 49th Street, the shop next to the corner eatery had a
sign painted in the window advertising PIANOS.

I was leaning closer to see if I could read any other signs, when I
heard footsteps coming downstairs. "We're locking up, Miss
Green," said Nina. "You'll have to leave the building now."

"I see this corner of Hell's Kitchen has been a musical site for a
long time."

"We're proud to be part of the tradition."

"It must be hard for you—for all of you—with Miss Meyers
gone. Are things different now? Now that her brother's the dean?"

Nina let a moment go by, then she said, "No. We're all keeping
her memory alive; carrying on as she would have done, with every-
thing that she began."

"Such as today's broadcast. Was that the first time someone
from the school had been on the 'Quarter-Hour Concert Hall'?"

"No. Two years ago, we had a violin prodigy studying here.
They put her on the air, performing the Tartini sonata."

"The one from your collection?" (Oops! I shouldn't have
opened that can of worms.)

"Yes. Why do you ask?"

"Oh, I'm just trying to get some background for my story. The
radio's a good way to get publicity. There aren't many private music

schools like this left anymore, since the Depression hit." I touched her hand sympathetically. "You're all very lucky, to work here."

"I do have to close up now," she said, and motioned—politely—that I was to go on down the stairs. She followed me down, and closed the front door behind me. I heard the latch click and lock.

<p style="text-align:center">⊨</p>

The police must have responded to Theo's call sometime, because Thursday's *Daily Mirror* ran a small story under the headline DUSTERS DUST-UP. I read it that morning on the El, heading down to Meyers:

> A rivalry within the Hudson Dusters' gang flared up in Hell's Kitchen yesterday. No one was injured, but the front window was broken at Theo's, a luncheonette belonging to Theodore Levant, at 702 Ninth Ave.
>
> The damage was caused by a hail of dagger-shaped pieces of linoleum. They are fired from homemade weapons, like slingshots, with thick rubber bands cut from an automobile tire's inner tube and taped to a pistol-shaped block of wood. These weapons can be as lethal as any firearm, and because they are cheap, accurate, and silent, they are increasingly popular among gangs such as the Dusters. There have been similar incidents in Hell's Kitchen almost every week for the past three months.

As I said before, and notwithstanding its musical heritage, this wasn't a neighborhood I relished visiting.

A glazier's truck was parked in front of Theo's. One man was bracing a big sheet of plate glass in the frame while his assistant spatula'd putty around the edge. I stopped to look, and Theo called, "We're open!" to me, from inside.

"I'll come by later."

"Nice dress!"

"One of my favorites." It was, too: a thick, dark green rayon, with a pleated yoke and skirt-front, that looked like something from Bergdorf Goodman, but which I'd actually bought at S. Klein, on Union Square, for two dollars and a quarter.

I turned the corner into 48th Street. Susie Pierce was just getting out of a blue Chevrolet coupé, carrying her viola case. She made a come-on-over gesture when she saw me, and beckoned the driver out of the car, too.

"I want you to meet my brother. Ed Pierce—Katherine Green."

His grip was politely gentle, but I could tell that under his pin-striped three-piece suit, there were muscles. He was a couple of years older, much heavier, and slightly darker than his sister, with thick black hair conked straight.

"Susie says you're writing an article about Meyers Conservatory." Like her, he spoke with a private-school accent. "Are you looking at the rest of the neighborhood, too? There's a lot to like here."

"Hell's Kitchen isn't the sort of place I'd encourage people to walk around in."

"Maybe not today, Miss Green, but soon."

"Soon?"

"Thirty years ago, nobody went to Times Square; but after the theaters moved in, the audience moved right along with them. Now, everybody goes there."

I nodded politely, but I hadn't caught his drift.

"There's a vacant building around the corner on Ninth Avenue." He pointed in that direction.

"Was it a piano showroom? I saw a photo in the Meyers stairwell—"

"That's the one! It'd make a fine recital hall. On a small scale, of course."

"Ed's an architect. He's been remodeling old buildings, which gave us the idea about re-doing that one. I think it could be a rental, for musicians," Susie added, "to take whenever they needed performance space. There could be subscription concerts, too."

Now I got it: they wanted publicity for the idea, to attract investors. I said, "Oh," and looked at my watch, hoping that would imply I'd heard enough.

But Susie kept rolling the hoop. "That parlor was much too small yesterday. Meyers will never generate a substantial audience, unless the students and faculty can play for a hundred or two hundred people."

"And only two blocks east of here," Ed continued, "you have Broadway and Times Square. The audience is practically in the neighborhood already."

A song parody popped into my head, fully versed, and I chirped it out:

> *"Only forty-five bullets from Broadway,*
> *Come hear the tunes you adore.*
> *'Neath the roar of the El, in the Kitchen of Hell,*
> *Where the Dusters and gangsters make wa-a-r-r...."*

Susie tried not to, but she giggled. "Very clever!"

Ed nodded. "You're quick on the trigger, Miss Green. But seriously: the neighborhood *is* going to change, some day." He pulled a pack of Luckies from his vest pocket, offered me a smoke, which I declined, and lit up his own with a gold lighter. It had the same college crest on it as his red necktie.

"Did you study architecture at Cornell?"

He looked blank for a moment, then glanced at what I was looking at, and smiled. "Yes. I was accepted in the School of Drama, but there's not much call for Negro actors. So I switched to something that pays better."

I wasn't about to ask how much call there was for Negro architects, but I had to say something. "Do you own that building around the corner?"

"No. It's in probate."

"What does that mean?"

"The owner died without disposing of it in his will. The executor is considering offers, and I've made one. It's been empty for years, and it needs work, of course. But as Susie said, I've been doing a lot of renovation projects lately. In fact, I'm about to start on the Meyers buildings."

"Do they need work, too?"

"Do they!" He raised his arm and used the Lucky for a pointer, top to bottom. "The roof needs new tar and gravel; the skylight over the dean's office is sagging. The parapet wall, and all the bricks down the street side, here, need repointing. The coal-chute in the sidewalk—" he pointed toward an old-fashioned sheet-metal hatch "—is rusting out. And that's just on the outside. Inside, I need to run all new electric wiring. And some of the walls... *Whew!* It's only the plaster that's holding them up."

(What could I say?) "Sounds like a lot of work."

"I estimate about two and a half months, once my crew gets started."

"And after that's done," said Susie, "we can launch *our* project. What do you think, Miss Green? Will it fly?"

I had no idea. I asked what I figured a real reporter would ask: "How much is your recital hall project going to cost?"

Ed glanced at Susie, then said, "I estimate about twenty-five, maybe thirty thousand, all totaled. But we can get the money!" (I guessed it would come from their parents and friends, up on Strivers' Row.)

Susie smiled. "Do you think your editor would like a story about it?"

"I'll ask."

"Great! Thanks. Well, I've got a compositional exercise to finish for Dean Meyers. 'Bye!" She hoisted her viola case and trotted up the stoop.

"Susie wants to be the impresario: book the acts and manage the recital hall," her brother said proudly. "She's got a good head for it. And of course, she wants a place where she and her friends can perform."

"I don't know about the economics," I said, "but are New Yorkers ready to run the gantlet of Hudson Dusters, and come this far west for longhair music?"

He smiled. But when he said, "The thirty thousand also covers details like that," I felt myself shudder. Musicians focus on sounds, and the timbre of his voice had changed. His tailored clothes, upper-class manners, Ivy League education, and erudite accent had lulled me into thinking he was naïve. I'd forgotten about his muscles. And I'd ignored the dues he'd have paid—not just *money* dues—to become an architect in New York City. I actually backed away from him slightly, but covered it by lifting my arm and looking at my watch. He looked at his watch, too, so he must have felt the chill.

"I think you may be on to a good thing," I said at last. "But would you excuse me? I'm supposed to interview somebody inside."

"Be seeing you." He got into his Chevrolet and started the engine. Then he called out, "Any ink you can give us in your magazine—we'd be really grateful," and drove away.

⊨

"Good morning, Miss Rovere," I said, as I walked through the French doors.

She nodded in the way librarians have of reminding you that there's *No talking in the library.*

"I wanted to hear that Paganini quartet. Have you got it on a record?"

"There's never been a recording. It's quite obscure." The way she

said it tamped down any notion of mine that we could pick up our conversation where we'd left off last night.

"Maybe the radio crew made a transcription, yesterday, back at the studio."

"I don't know. Would you like me to telephone them and ask?"

"Yes. Would you?"

"Certainly. Anything else?"

"Nope." I thanked her and headed upstairs.

A sheet of paper, thumb-tacked to the wall on the third-floor landing, diagrammed the maze of faculty desks. In pencil, the teachers had labeled whose desk was whose. I oriented myself, and started picking my way through waist-high piles of books and papers that weren't on the map.

The canvas cover for Amalia's cello case lay neatly folded on her desk, but I didn't see the cello or *her*, there. A gray-haired woman was sitting at the next desk, grading papers. She smiled when I asked, "Is Miss Chen around?"

"I haven't seen her, dear. Do you have an appointment?"

"Yes, at ten."

"Then just sit in her chair; I'm sure she'll be along soon."

I did that, told her my name, and gave her the *Etude* line.

"I'm Hermione Wellfleet. It's nice to meet you."

I guessed it was Mrs. Wellfleet from her wedding band. She was sixty-plus, but sturdy, like a lady golfer. A gray cardigan sweater was draped over the shoulders of her beige silk blouse; and before we shook hands, she set down the lorgnette through which she'd been reading. An elderly teacher in a place like this could only play the flute—piccolo, too, of course. I pictured her trilling the solo in "The Stars and Stripes Forever," and was on the verge of whistling it, when she said, "I teach percussion."

"Excuse me?"

"Timpani are my particular forte. But this is a small conservatory, so I teach all the drum students."

"Drums."

"Yes, dear. It's all right. Go ahead and giggle. I'm used to it."

I laughed out loud.

"It's a coincidence you're at *The Etude*, Miss Green. I was just about to open the latest issue." She picked up a copy that had been rolled up and secured with a rubber band. "I try to read it every month, but I don't recall seeing your byline."

(I was prepared for that.) "I'm pretty new there. I used to be at *Band Star*."

"Oh, that's a wonderful magazine!"

"You read that, too?"

"For the same reason I read Walter Winchell in the *Mirror*, and the Broadway columnists in the other papers. I have to keep up-to-date, don't I?"

"Do you?"

"When a pupil says he wants to know how Gene Krupa gets a certain effect, where would I be if I didn't know who the man is and what he sounds like?"

"Krupa has excellent technique." That was safe to say.

"Get hep, Miss Green. He *swings*!" She grabbed a couple of red pencils from a can and rapped a highly ornamented "shave-and-a-haircut" on her desk, hitting the "two bits" with a rim-shot on the inkwell.

I had to say—jitterbug-style—"A-a-ll *reet*!"

"What inspired you to interview Miss Chen?"

"I heard her play yesterday on the radio. And her...her life-story, with everything that's happening in China right now..."

"That's very astute of you."

Amalia hadn't shown up yet, so I said, "It's a shame that I couldn't interview Dean Meyers—Iris Meyers—before she died. She must've been some woman! I heard she hustled the radio people in advance, to broadcast the gig."

"She wouldn't have expressed it that way." After a quiet mo-

ment, she said, "It was a terrible loss. I wish I knew what happened that night."

"Me, too. I was out of town in January. I never saw the papers."

"I have the clipping from the *Herald-Tribune*, and the obituary, too. Would you like to read them?"

"Sure."

She slid them out of the top drawer of her desk. "They were posted on the bulletin board downstairs, but Dean Meyers asked me to remove them, yesterday. He didn't want the radio people to see them."

The clipping wasn't big; Iris Meyers wasn't famous outside of longhair circles. It was dated January 17th. The headline was MUSIC DEAN FOUND DEAD, and all it said was:

> Iris Meyers, dean of the Meyers Conservatory of Music on W. 48th St., was found dead in the school's library yesterday morning.
>
> It is presumed that she died from a sudden heart attack, as no witnesses have come forth to suggest any other cause of death.

Her obituary, dated the 18th, and headlined IRIS D. MEYERS, MUSICOLOGIST AND EDUCATOR, was respectfully longer:

> Iris Deborah Meyers, Dean of the Meyers Conservatory of Music, died Jan. 16 of heart failure. Miss Meyers, 54, was an authority on musical manuscripts of the 18th and 19th centuries. At the time of her death, according to colleagues, she was writing a book about the autograph manuscripts in her school's extensive collection.
>
> "Her provenance is like a guarantee of authenticity," said Roger Winkler, senior appraiser of books and au-

tographs at Beechum's Art & Auction Gallery. "And
she was an expert on the subject of forgeries. Collec-
tors, worldwide, sought her advice."

Miss Meyers was granted an undergraduate degree
in music from Barnard College in 1906, and obtained
a doctoral degree in history from Columbia University
in 1909. She taught music history at both schools until
1918, when her parents succumbed to the influenza ep-
idemic, and she succeeded to the deanship of the fami-
ly's music conservatory on W. 48th St.

Never married, she is survived by her younger
brother, Joseph Abraham Meyers, who has assumed
the position of dean at the school.

"What does this word mean?" I pointed to it on the page—it was
the same word I'd seen in the library, on the catalog card for the
Paganini manuscript.

"*Pro*-ven-ahnce," she said. "It means 'ownership' or the succes-
sion of ownership over the years."

" 'Learn a new word every day'—that's what Mother always told
me."

"Excuse me. Good morning, Mrs. Wellfleet. Katy."

We looked up. Amalia was carrying her cello case through the
clutter.

"Good morning, Miss Chen." She handed Amalia the rolled-up
Etude. "I found this on the floor between our two desks when I
came in this morning. Is it yours?"

"I guess so. Thank you."

Amalia slid it, still rolled, into the outside pouch of the canvas
case-cover on her desk.

The newspaper clipping fluttered in Mrs. Wellfleet's hand, as
she turned back to me. "Speaking of Dean Meyers…it was I who
discovered her."

"You did?"

"Actually, both Miss Rovere *and* I, when we went into the library that morning."

"What did you—"

Amalia started breathing loudly through her mouth.

"Are you ill, dear?"

"No. I'm all right. Thanks. Listen, Katy, we need to go."

"Thank you for the chat, Mrs. Wellfleet."

"Good-bye, then."

I let Amalia lead me out through the labyrinth of desks and bookshelves. In the hall, she said, "Please!" and gripped my arm. "Don't talk about Iris Meyers when I'm around. I get queasy."

"Wouldn't you like to know what happened? *I* would. The newspaper said she was an authority on manuscripts. So maybe there's a connection to—"

"You and your lurid imagination! That's the *Mirror* sticking out of your coat pocket, isn't it?"

"You think I should read the *Times* or the *Herald-Tribune*?"

"They cover China!"

"I know that's important to you, but—"

"Okay. Let's not get off on a tangent, Katy. I need you to focus on the manuscript."

"All right. *Let's*. All four of you still have your copies, don't you? Why don't you play the quartet again, so I can watch."

Amalia looked blank.

"You can learn a lot about people from the way they play."

"Yes. That's true." She gave a little sigh, but said, "All right. Come on."

Rebecca was in the corridor of the classroom building next door. She looked up from a book—it was the Stratton biography—and said, "I've been readin' some more 'bout Paganini."

I nodded. "He's a fascinating character, isn't he?"

"This fella who saw Paganini play a concert, and wrote about

it—he was a famous poet, an' a book-writer besides. Name o'
Go-*ee*-thee?"

Amalia tittered.

"Oh, I knew I wasn't sayin' that right." She turned to me. "I
don't know nothin' but American English, 'cept for the I-talian
words that tell you how fast to play a tune. D'you know how to say
this fella's name, Miss Green?" She pointed to the page and spelled
it out: "G-o-e-t-h-e."

" 'Ger-tuh' is pretty close."

"Thanks. And it says here that 'Ger-tuh' was maybe the smartest
man alive. Is that right?"

"In Europe? A hundred years ago? Uh, yeah. He probably *was*."

"Well, do you know what *he* said about Paganini?"

"Tell her later, Miss Tharp," said Amalia. "Right now, I wonder
if you'd care to play for Miss Green. She'd like to hear the entire
quartet."

"Only the first movement went out over the air," I added.

"Well, I guess it'd be all right to play it again. Want me to ask
Miss Pierce? I think she's in the town lounge."

"I can go," I said.

"I'll unlock practice room five," said Amalia. "Meet us there,
Katy. It's on the second floor."

Susie was, indeed, in the town lounge, writing a piece for Dean
Meyers's composition class in the staves of a music pad with a gold-
filled Cross fountain pen. Previous pages were stacked on a chair,
and, when I gestured that I wanted to look at them, she nodded.

In vividly clear penmanship, she'd made crisp notes, practically
uniform in size and shape. If she'd lived in Paganini's time—before
printers could set music in type—she would have made a good liv-
ing as a copyist. I'm a sight-reader, so I could "play" in my head
what she'd written: it was a trio for clarinet, viola, and piano, *ersatz*
Beethoven in style. Imitation is supposed to be flattering, but she
hadn't come close enough to pat him on the back. For a composi-

tional exercise, it was okay, but I doubted she could get it published or performed.

"Would you mind playing the Paganini quartet again? Miss Tharp and Miss Chen are heading over to practice room five. And I'm on my way upstairs to round up Mr. Carson, too."

"Right now?"

"Are you too busy to jam with them?"

"I'm always happy to be asked to play. But—" she gave a snort "—your slang, Miss Green: it's so *jejeune.*" She capped her pen, straightened her papers into a neat pile, edged them gently into a leather briefcase, snatched up her viola, and headed out the door.

Guy wasn't in his room, but one of the boys with a reed in his mouth told me to try practice room eight, where I found him changing the strings on his violin. He smiled and said yes, when I told him why I'd come; but he made me wait while he looped one last string over the bridge, twisted up the peg to stretch the gut extra-tight, then let the string relax back down into pitch. When I realized that my eyes were running up the pleat in his trousers, and that *his* eyes were on *my* legs, I looked away.

In practice room five, Susie had settled into a chair and was rubbing a cake of rosin along the hairs of her viola bow. Rebecca was running chromatic scales—playing every note—up and down the neck of her guitar. Amalia was just sitting still, eyes closed. I'd seen her do that when we'd played together last Christmas time, at Best's. Just before starting a piece, she'd shut her eyes and have a quiet moment for a couple of seconds. Then, after her meditation, or whatever it was, she'd open her eyes, stretch both arms out in front of her, and adjust the height of the music stand even if she'd already done that before. And that's what she did now.

They all tuned up, then looked at Guy—the first-violinist always nods for the cue—and launched into the quartet. They all had to concentrate hard, because, as I said, the key of B major is a tough key to play on strings. So they didn't see me watching them.

Surprisingly, the one who seemed most nervous was Amalia, though she was by far the most experienced. But the others did exhibit patterns of behavior while playing that I'd seen before in bands and orchestras, and I knew how to interpret them.

Susie was what I call a "never-blinker." Her head moved around a lot, but whenever she came to a particularly difficult passage, she wouldn't close her eyes, even for a second, as though she had to keep reading a few notes ahead, or lose her way entirely. She seemed tense, too, but a viola does take more out of you than a violin does: it's bigger, so your arm and fingers have to stretch farther. But maybe she was feeling…what? Stress, most likely. She clenched her teeth and lips, and tensed her face, and seemed to be fretting the strings with more finger-pressure than necessary, too—which teachers warn you against, because it could give you pains someday. She was perspiring, even after only one movement.

Rebecca was a "toe-tapper," which drives some players nuts if you have to share a stand with one. She wasn't making noise, though: she'd slipped off her Mary Janes, to play in stocking feet. But Rebecca was also a "crowder-inner," which I find much more irritating. A crowder-inner takes up more than half the space, and can block your view of the page that's open on their side. You have to either shoo them away or crowd in yourself. Rebecca sat closer to the stand, even, than most crowder-inners do, which made it hard to watch her face. But if she were anxious about the manuscript, it didn't seem to affect her playing. She conveyed more feeling for the composition than I'd expected, and her intonation—her ability to make each note stand out—was surprisingly good. Nobody had to lower their standards to give Rebecca a place at Meyers.

Guy was a "sitter-upper." His Boston mother would never have to tell *him* not to slouch. He kept his instrument parallel to the floor, although once in a while he'd swoop down and swing back up to make a big bow-stroke. When he did that, his hair flopped down

over his eyes, and he'd toss his head back to flip it away. Guy's terrific posture was the result not only of good instruction, but of a half-moon-shaped shoulder pad, so he didn't have to bend his neck all the way over to hold the violin tight. Most classical violinists pooh-pooh those things, or say they're like cheating on an exam. But I use one, too; it makes playing a lot more comfortable. And Guy did look more comfortable than any of the others.

I thanked them when it was over. Amalia—being a teacher—asked them to critique the performance; and they spent five minutes or so, calling attention to various passages where one or another of them might have played the notes differently. Finally, the students packed up their instruments and left.

Amalia looked at me, waiting for my insight, but I had to shrug. "I wish I could say that I saw something incriminating in someone's face or posture. I did see tension, and narcissism, but mainly…concentration."

"It *is* a difficult piece," she said, sliding her cello into its case. "I think, if Paganini had deliberately set out to make us uncomfortable, he succeeded."

"Yeah! It's hard to play *anything* in B. But that old devil, Paganini! He also forces you to use all four fingers to make those snappy little runs."

"Especially on the lowest strings, where you have the longest stretches."

"There's a jazz piano player I know—he'd call a piece like that a real 'fingerbuster.'"

She smiled, as I handed her the case-cover for the cello. But I didn't have a tight enough grip on it. The canvas slipped out of my hand and fell to the floor. Her copy of *The Etude* slid out; the rubber band around it snagged, then broke.

The magazine opened like a fan, and papers that had been inserted between its pages spilled out.

"Ooh. Sorry!" I bent down to pick them up.

They were the color of weak tea, and felt more like stiff fabric—linen, perhaps—than paper. The staves and notes had been drawn by hand in a dirty gray ink that might have once been black. I stopped collecting them and stared. The key was B major. And at the top of the first page there was a big autograph with fancy flourishes: *Niccolò Paganini.*

In a fugue, everybody gets a chance: each voice has equal
rights and ownership in the theme, each gets his moment
to shine. This whole process is known as the "exposition."

—Elie Siegmeister,
The Music-Lover's Handbook

3. Shining Moments

"I guess I was a little giddy from all the attention. I really
oughtn't to have slid the sheets between the pages, Miss
Rovere. But I must have thought it would protect them. And I...
I forgot they were there."

"They won't last another hundred years, if they get mishandled."

"I'm sorry." Amalia still hadn't looked her in the eye. But it
wasn't from shame. She had to tell the story, and we'd only just con-
cocted it, on the way to the library. We didn't know how the manu-
script got into *The Etude*, or why it had been left beside Amalia's
desk, or by whom.

"I didn't think you were so easily distracted," Nina concluded.

"Miss Chen and I should be getting back to our interview now."

"Yes, of course. Oh—wait, Miss Green. The man from the radio
program said they *did* make a transcription; and they're giving us a
copy of those discs. He'll drop them off this afternoon. Do you still
want to hear them?"

(It wouldn't be right not to, after I'd asked.) "Yes. Thank you."

I made Amalia wait on the stairway landing beside the framed photo of the street corner, while I checked my face in the mirror of my compact, touched up the rouge on my cheeks, and reapplied my lipstick.

Mrs. Wellfleet was coming up the stairs. I said, "Nice to see you again," as I went around her.

But she touched my sleeve. "I was hoping we could chat again, soon. May we exchange telephone numbers?"

"Sure. Mine's an answering service, though. Leave me a message, and I'll call you back."

She ran her fingers along a gold chain that led from a cameo brooch on her blouse down to a pocket in her skirt, and pulled out a mechanical pencil, waiting for me to hand her a piece of paper.

I checked my pocketbook, then looked up at her—she was almost a whole head taller than I. "Sorry. I don't have anything to write on." (And that was dumb! What kind of reporter hasn't got paper? Oh, well. I didn't have to be a reporter any longer.)

But she said, "That's all right, Miss Green. I'll remember the number."

"It's Plaza four, oh-four-three-three."

"Since you used to write for *Band Star*, I'd like to pick your brain about some of the swing players who are hot right now."

"Any time!" I waved good-bye, and went down the stairs with Amalia.

When we had reached the first floor, and were out of earshot, Amalia touched my arm. "Do you think *she* could have slipped the manuscript inside the magazine?"

"*Somebody* did. One of the three students. Or…"

"Who?"

"Nina herself. She knows where your desk is."

"Everybody knows where my desk is. Dean Meyers, too."

I opened the front door. "I don't have any students coming until

Monday. Do you want me to stick around, and try to find out who—?"

"No, Katy. Now that it's back where it belongs, it doesn't matter. And there's no story for *The Etude*, of course. What will you tell Madeline?"

"I'll play it by ear."

"I'm sorry you went out on a limb for me, with her. But thank you again, for all your help." She gave me a big hug. "Let me take you out to lunch on Sunday, in Chinatown. We'll have *dim sum*— little savory pastries."

I hugged her right back, said, "That'll be nice," and trotted down the stairs.

You can't skip more than a day's practice, if you're a professional. I needed to go home and run scales, and check the union hall for work, too. At the bottom of the stoop I turned and waved, called, "So long," and strolled away, toward the Ninth Avenue El.

"Hey, sweetheart! You sellin' kisses?"

I looked around. Four Dusters sat on a stoop across 48th Street. None of them looked old enough to vote, and one—in a plaid shirt—might have been with the kids who'd shot out Theo's window. But I wasn't about to cross the street to see.

I lengthened my stride, even though it made my skirt ride up a little higher—which prompted one of the boys to yell, "Cheesecake!" They stayed on the stoop, making progressively ruder suggestions, the farther I got from them.

At the corner, I realized I was hungry, so I went into Theo's. His Bakelite radio above the deep-fryer was playing the Mendelssohn Octet. The dial was tuned to WNYC, the city's own station, that carries longhair music almost all day and night.

For fifteen cents he served up a lot of potatoes with his fried eggs; but I remembered his hamburger grease and passed on the bacon, which also saved me a nickel. Another man was clearing the tables, and he smiled at me as he carried dishes back behind the

counter. I was glad I'd touched up my makeup, even if the only man it attracted was wearing an apron and needed a shave.

Rebecca Tharp ambled in, and waved when she saw me. Taking the stool next to mine, she ordered "flapjacks," which Theo evidently knew meant pancakes. He poured three puddles of batter onto the griddle, and called over to her, "I enjoyed your guitar work immensely, on the air yesterday. You really have it in your fingers—it's a gift."

She beamed and said, "Thank you, Mr. Levant." Then she turned to me. "And thank *you*, Miss Green, for last night—for not mentionin' my cigarettes, I mean." She took a pack of Luckies from a pocket in her cotton dress, stuck one in her mouth, and lit it with what I call the one-handed matchbook trick: folding a match over the striker-strip, and flicking it with her thumb. Then she turned toward me and fluffed the hair away from her forehead. "I combed out the burnt ends and trimmed 'em up. Does it look all right?"

A little cigarette ash floated down onto my eggs, but she didn't seem to notice. I edged it away with the handle of my fork. "You gave Miss Chen a good scare."

"Well, I am truly sorry. But I've got the habit. We all got the habit, where I come from, on account of everybody *grows* tobacco."

"Do your folks make moonshine liquor, too?"

"Oh, no! Drinkin's a terrible sin. 'sides, where we live—it's even a dry county. I'd *never* touch liquor! I've been *saved*, you know. But anyhow, about scarin' Miss Chen—I told her I was sorry, this mornin', 'fore the rest of you got up to the practice room."

I nodded. "How did you come to study at Meyers? You're a long way from home."

"Oh, I've done some travelin', playin' music of course, so I don't mind bein' away. And comin' to New York—it's a great chance to improve my technique. I've always been real good on the guit-tar. Almost everybody in my family can read music—we're not all ill-lit'rate, y'know, down in Tennessee."

"I didn't say—"

"That Guy Carson says! Always callin' me a *hick*."

"I think you're very talented."

"Thank you. Mr. Levant had it half-right. Ma daddy says it's a gift from God."

"Maybe it is."

"'*Course* it is! See, I can do more than just *read* music. I can look at something—anything—on a music paper, and it just comes right outta my fingers. That's why Mama figured I oughta get a real musical education—classical trainin' is what they call it here at Meyers. 'Course my family, they couldn't afford to send me to the Juilliard School, nor to the Berklee up in Boston, nor the Rochester neither—that's where Miss Chen got her schoolin', y'know?"

"Yes."

"And a couple of the schools I applied to—they didn't even write me back. But Miss Meyers, she wanted me to come, and she didn't mind that I hadn't never been to college, nor took lessons neither."

"You've never taken lessons?"

"Not like they mean here. My uncle Van give me my first guitar, and showed me where all the notes lie. He's better'n me at *pickin'* notes, but he's gone blind, so he can't *read* 'em. He just...plays, y'know?"

"By ear."

"Yes, ma'am."

"He taught you well. You're a very good guitarist. I can see why Miss Meyers wanted you to study here. And why Amalia picked you for the quartet."

"I guess you're a friend of Miss Chen's, huh?"

"Well, I—"

"You called her by her first name."

"Oh. Everybody in New York calls people by their first names, Rebecca." (Which wasn't true, but to cover my *faux pas*, I played

the reporter again.) "What do you think the next decade holds for you, as a musician?"

"I'm surely the wrong person to ask about the future. I don't expect I'll be playin' much music, after I get hitched."

"You're getting married?"

"Yes, ma'am. So, over the next decade, I guess I'll be raisin' kids. That is, I will, dependin' on *him*: on what *he* wants, y'know?"

"Are you...are you engaged?"

She didn't blush, exactly: her skin was naturally pink. But a very tiny spangle of perspiration appeared on her brow, and she took a deliberately slow breath. "We haven't told nobody. We go to the same church, here."

"Oh, he's here in New York! I suppose your parents want you to finish up at Meyers first."

"Well, that, too."

I looked her over. She was long in the limbs and flat in the chest; and her face was slightly puckered, in a way that's considered pretty in the Appalachians. I guessed she'd disappoint a lot of men back home by getting married so soon. Then I thought: Maybe she's already pregnant! And then I thought: I'm jumping to conclusions. (And why am I so intrigued by this country girl's love life, anyway? Is my own so dull?)

Her "flapjacks" came. She poured half a pint of maple syrup over them and cut wedges through the whole stack with her fork, holding it in her fist, like a child does, and then spearing and stuffing each wedge into her mouth.

I went back to my eggs, but my knife slipped and clattered to the floor. "Goddamn it!"

"Hush!"

"What?" I bent down to retrieve it.

"I can't stand to hear the name o' the Lord taken in vain—it's a sin, you know?"

"Sorry." I let a beat go by. "I saw that photo of your family band,

on your dresser. 'The Gospelaires,' is that right? What's it like, play-ing with your folks? Do you play tent-shows and revival meetings?"

"Not so much anymore, since we got a regular spot on the radio in Dayton. That's where my family's livin' now."

"What range do you sing in? Alto? Soprano?"

"Me? I can't sing a note. I just play."

I ate my potatoes and eggs for a moment, and—remembering the sailor's photo—I asked, "Is your fiancé a musician?"

"Can't carry a tune in a bucket. But he knows his Bible. He can recite whole chapters, almost. That's a good sign, don't you think?"

For some reason, I felt I had to ask her, point-blank, "Are you comfortable playing in a quartet with…a Negro woman?"

"Aw, Miss Green!" She giggled. "D'you think we have a lynchin' every Sunday down in Tennessee?"

"No! What I meant was—"

"It's okay. I got no ill will toward Miss Pierce. Nor her brother, neither: he's a real good man. You see, Miss Green, I've met plenty of Negroes, from playin' music and all, and they're mighty fine peo-ple, most of 'em. Mighty fine. Color don't matter to me. You can be white or black—" she pointed to me, and chuckled "—or *Green*."

"What about…'yellow'?"

"You mean Miss Chen? Well, I never did meet a Chinawoman, before. But they're all right, I guess."

"Uh-huh." I ate some more of my potatoes, and she forked in an-other wedge of flapjacks. "So…when do you plan to get married?"

"Well, the fact is, we're gonna wait. His family and mine—they don't have much in common. And we don't know if they'd get along, right away. So we're keepin' it a little secret. I mean: he's got a real education—not like me. And we're gonna need some money of our own, and…well, it wouldn't do for us to move in with his folks, nor with mine, neither."

"I can understand. Times are still hard for a lot of people."

"Oh, it's not that. His folks have money. More'n enough, I'd say,

and a lot more'n mine. It's just that…he says we had better wait a while, till we're both a little more comfortable with the sitchy-ay-shun."

Before I could ask what the situation was—before I could even wonder why I was asking such personal questions—there was a noise from the other end of the counter. I turned and saw a young man with a blue scarf wrapped around his nose and mouth. A plaid shirt. And a black-taped slingshot gun in his hand.

K-chuff! A red sliver struck the radio set, and the music stopped.

K-chuff! Another knocked it into the deep fryer.

"Ahhhhhh!" Theo had been pulling something out of the fryer when the radio hit, splashing hot oil onto his hands.

The man with the gun yelled, "Don' nobody move!" and nobody moved.

A second man, masked by a white kerchief that hung below his neck, knocked the busboy away from the sink, where he was washing dishes, and began swiping bills and change out of Theo's cash register.

Theo was waving his hands around to cool them, fidgeting and whimpering in pain.

The man in the plaid shirt backhanded Theo with a fist, and muttered, "Shut y'r trap, ya mocky kike!" He checked behind him to see that nobody was in his way, nodded to his buddy, and they dashed out the door, where a green Buick had one wheel up on the curb. They dove in. The Buick bounced onto the street, and accelerated down Ninth Avenue.

Theo called out, "Billy!" and ran to the sink. Billy opened the cold-water faucet. Theo thrust his hands in, and took some long breaths as they cooled. He looked around, to see if his customers were okay, and said, "Get me some salve, Billy. It's in the—"

"You gotta get to the hospital!"

Rebecca was open-mouthed. I touched her hand. "You okay?"

Several people had run away as soon as the robbers had gone,

and I suppose I could have fled, too, without paying for my food. But I fished a dime and a nickel out of my pocketbook and left them beside my plate.

Rebecca said, "I'm sorry; I'm scared," left some coins alongside mine, and darted out the door.

People on the sidewalk, gawking, quickly made a crowd. A taxi stopped for the traffic light, and the driver slid right over to the curb side, to see what had happened.

Theo looked dazed. He was sweating, and panting loudly. I motioned to the busboy. We took hold of Theo by his armpits, and led him to the curb, where I grabbed the cab's door handle, flung it open, and told the driver, "Roosevelt Hospital. Quick."

The two old ladies inside were stunned.

"This is an emergency!" I yelled in their faces, pushing Theo into the back seat between them, and hunkering down, myself, behind the front seat.

A dozen car horns were blaring. Billy loomed over the cabbie. "Didn't you hear? It's an emergency!"

The cabbie slid back across, with a backward glance at his passengers. One of the ladies nodded. "Okay," he said, and gunned the engine.

As soon as the cab had lurched into traffic I pulled down the jump-seat, fitted myself into it, and clutched the strap over the door for balance. But I kept my eyes on Theo. The skin on his hands was an ugly red, and drops of blood—like crimson sweat—seeped from the pores where he'd been burned. His eyes were closed; he was rocking back and forth. I worried he might faint.

"Did they get a lot of money?" I asked, as much to keep him awake as to satisfy my own curiosity.

"Fifteen bucks. Maybe a little more."

The woman who'd nodded asked me what happened, and I told her. The other one just looked out the window. I think that seeing Theo's hands made her feel sick. But she was a Good Samaritan:

when we reached the hospital I tried to give her a quarter, toward the fare, but she wouldn't accept it.

The orderlies saw immediately that Theo had been burned. All I had to say was "Cooking oil," and they hoisted him onto a gurney and took him inside.

I know first-aid, so I knew what they'd do for him; and I stayed around until a doctor told me he'd be all right. I started walking north, to go home, but I needed to go to the union hall on Sixth Avenue, to check the bulletin board and the call-sheets, so I turned east. But there were no openings at any of the orchestras, and no gigs that I'd be able to play. So I took the long way home, up Sixth Avenue, where the city was tearing down the El; and into Central Park, where long hedgerows of forsythia flashed bright yellow in the sun.

The day was almost warm, the way April days are sometimes, when Mother Nature seems to say, "Here's a little taste of spring— do you like it?" Unfortunately, she's saving it for dessert, and you have to eat your spinach first: a few more weeks of wintry weather. But on days like this, it's like you get to lick the spoon.

꠸

Back in my room, I stepped out of my dress, took it to the bathroom sink, and scrubbed the inside of the armpits with soap, so my perspiration wouldn't stain, then I hung it over the tub to dry. Changing into a plaid cotton frock, I ambled downstairs to use the phone in the candy store.

In New York, a "candy store" isn't a sweet-shop. They sell penny-candies, but it's more like an old general store, with newspapers, fountain pens, stockings, and a lot of other useful things, including—in my building—a pay-telephone.

I check in with my answering service at least once a day, so I won't miss any gigs that might come along. I dialed the number and gave the girl my name.

"You have three messages, Miss Green."

A pencil dangled from a string beside the phone, but—I dug in my pocketbook—no paper! Only the recital flyer I'd picked up at Meyers. I used the back of it. "Shoot."

"The first one came in at nine twenty-eight this morning. It's from the Copacabana, and it says: 'Can you work saxophone, Saturday night, with Panchito and his Rhumba Orchestra?' The phone number is—"

"I have it. Thank you."

"The second message is from a Madeline Roark, at *The Etude* magazine. She called at twelve-eighteen P.M."

"What'd she say?"

"She says: 'I hope your writing is as good as your palaver. I don't want to spend all weekend editing your story. See you at Meyers on Saturday at six o'clock.' She didn't leave a phone number."

"That's okay. What's the third message?"

"It's from somebody named America Chin."

"Do you mean 'Amalia Chen'?"

"That must be right. The other girl took the call. You know, her *e*'s look just like *i*'s, and her handwriting is—"

"What's the message?"

"Oh. I'll read it. It came in just a few minutes ago, at one fifty-six. It says: 'I am at the Sixteenth Police Precinct on West Forty-seventh Street. Please come right away. I have been arrested.'"

A fugue is said to be "strict" if the laws of fugue are closely adhered to, and "free" if they have been violated. From what has been said, it must be apparent that fugues are of infinite variety.

—Parkhurst and DeBekker,
The Encyclopedia of Music and Musicians

4. Violations of Law

Two white glass globes, each with a black number *16* on them, flanked the entry. A trio of roughnecks—plainclothesmen, for all I knew—were standing on the steps of the precinct house, describing girls who passed by on the sidewalk in words that the girls should be thankful they couldn't hear.

Inside, two unshaven men were having a powwow on a bench along one wall, but if one was a felon and the other his lawyer, I couldn't tell which was which.

A barrel-chested young man with a PRESS card in his hat was chatting up the desk sergeant about the Giants' game at the Polo Grounds. Only after they'd finished dissecting the last strike-out did the cop look over in my direction to say, in a brogue, "And what can we do for you, miss?"

I was glad I'd changed into my gray worsted suit—the one with peaked lapels on the jacket, like a man's. "I want to see a woman you're holding: her name is Amalia Chen."

He looked me over. "You a lady lawyer?"

"Does she have a lawyer yet?"

"You better wait. There's a couple of Chinee fellas in there with her already, and one's a lawyer, so he says. You can sit over there." He pointed to a bench.

"Thanks."

I sat and stewed. That damned manuscript! Nina Rovere and Joe Meyers must have filed charges, after all, even though their precious Paganini had been returned. Why did they want to ruin Amalia's life? What did they—

"You make a big improvement in the scenery, honey."

"Huh?" I looked up. The reporter was smiling at me from across the room, thinking he'd tossed me a compliment. I glared at him.

He turned away, back to the cop. "Anything on the blotter I can put in the paper?"

The sergeant opened the day's log of crimes, and turned it around for the reporter to see. "Got a dead woman."

"Yeah? That's great."

"Old biddy. Gassed herself in her oven."

"Oh." After a second, the reporter decided to write it up anyway and copied the name from the blotter into a note pad. "When was this?"

"About noon."

"Any chance she was murdered? It'd make a better story."

"No idea. The report's still bein' typed up."

"What else you got on the blotter?"

"Holdup at a lunch counter. Seven hundred 'n' two Ninth Avenue, at Forty-eighth."

"That's Theo Levant's place. Lemme see."

I pricked up my ears.

"Anybody hurt?" he asked the cop, pencil to paper.

"Owner got his hands burnt from the deep fryer."

"Where is he now?"

"Roosevelt Hospital."

"Talked to him yet?"

The sergeant glanced at the list. "Hang on." He leaned his chair back and called through a door. "Officer Frank Bond! Got a minute, Frank?"

A patrolman with a puffy, red face came out, a white mug of coffee in his hand. The reporter touched the PRESS card in his hat and asked, "Anything new on that lunch-counter holdup?"

"Nope. They got away."

"Neighborhood kids?"

"The busboy said they wore masks."

"Dusters?"

The cop shrugged.

"No arrests, right?"

He drained his coffee in one long gulp, then looked the reporter in the eye. "Did you hear the Giants on the radio yesterday? That was so-o-ome ball game!"

"I better call the desk," the reporter said, checking his watch. "Got to start my story rolling now, or they won't save me any space." He strolled over to a pay-phone that hung on the wall a few feet from my bench, dropped in a nickel, and twirled the dial without looking at it. "Dingall, it's Forman; I'm at the Sixteenth." After a pause, he said, "Just one so far—not too big. You ready? Okay. Story begins: 'Two masked gunmen staged a daring daylight hold-up Thursday at a lunch counter in Hell's Kitchen period. The escapade netted the robbers...' Uhh, stand by a second." He cupped a hand over the phone and called over, "Hey, Frank! How much did they get?"

The cop shrugged. "We ain't talked to him yet."

"Okay, Dingall. Strike the last sentence. Make it: 'The robbers tortured the owner comma first name Theodore, last name Levant—L-e-v-a-n-t—comma, by plunging his hands into hot cooking oil period. Then they stole an undisclosed sum of money

from the till period. Paragraph. It was on this same streetcorner comma only one day before comma that the restaurant's—apostrophe ess—window was shattered in a—'"

"About fifteen dollars," I said quietly.

"Stand by, Dingall." He cupped the phone again, and whispered to me: "Fifteen bucks? That's all?"

"Maybe a little more."

"And you know this *how*?"

"I was there."

Into the phone, he said, "Lemme call you back, Dingall. Save me an extra—" he looked me up and down "—three inches." I knew he meant newspaper space, not my measurements, so I smiled. He hung up, and put one foot on the bench. But then the gentleman in him surfaced. He took his foot back, closed up his necktie and collar, which had been exposing dark hair at his throat; and took off his hat. His head was conical, wider in the jowls than the temples, and topped with reddish-brown knots that would have been waves if he'd been to a barber lately.

"Josh Forman, *Daily Mirror*."

I put my hand out, and we shook. "Katy Green, daily reader."

"Step outside with me for a minute, would you?"

We stood under one of the big number-*16* globes. He was slightly shorter than I, close-shaven, with a youthful face, though he was at least my age and probably a little older.

"What were you doing at Theo's lunch counter?"

I chuckled. "Eating lunch."

"What'd you see, Miss Green?"

"Burning his hands—that was an accident." I told him some more, and he scratched it all into a spiral-bound note pad, with a well-chewed pencil. "By the time I left the hospital, they'd given him a hypo, and he was sleeping."

"Did Theo say anything else in the cab?"

I thought for a moment. "No."

"What else do you remember about the stickup?"

"Uhh…one of them called Theo a 'kike.'"

"There's a lot of anti-Semitism around." He looked from side to side. "Know what I mean?"

"Not personally. But I'm pretty sure they were the same boys who shot out Theo's window yesterday. At least, they got away in the same car: it's a green Buick sedan with white sidewall tires. Was it you who wrote the story about the window, in today's *Mirror*?"

He opened his arms. "Hell's Kitchen is my beat."

"Well, we waited while a cop car drove by—they must have seen the broken window—but they didn't stop."

His brow wrinkled. "You were there for that, too? What are you? A magnet for trouble?" He grinned, with clean but uneven teeth.

"You asked the cop about the kids. Theo believes they're Hudson Dusters."

"Oh, it's the Dusters, all right. But it's funny: they never used to pull this kind of crime. They always worked the rackets. Like 'the watchman.'"

"What's that?"

"You have to pay a kid to watch your truck while you're unloading, so nobody—nobody *else*—steals your freight. The Dusters loot warehouses, and hijack cargo off the docks, but they usually do those things at night. Making a public nuisance of themselves in the daytime, shooting off their slingshot guns—that started only a few months ago."

"In January, maybe?"

"Uhh…yeah."

"Why is that? What happened in January?"

"I don't know. I'm trying to get a handle on it. I grew up around here. I've known some of those boys all their lives, and a couple of them even trust me. But this is armed robbery in broad daylight. And I can't figure out what's in it for them. Did they ask any customers for watches, or jewelry?"

"No. They just took Theo's money, and drove away. If *I* were a robber, I wouldn't rob a luncheonette at all. There's more money in a bar or a liquor store, and I could grab some merchandise, too."

"Good point, Miss Green! And why didn't they just wait for closing time, when they could take the whole day's receipts? Maybe somebody's using them, to get at Theo."

"*They* could have a grudge against Theo."

"I suppose…but Dusters hang out near that corner. They've got to know he doesn't do much business, and wouldn't have more than a few bucks in the till. I mean: why not just sell him 'protection'? They work *that* racket all the time! But they usually make those threats when there's nobody else around."

"Maybe they were high on cocaine, and not thinking straight?"

"Oh, I'm sure they were high. What is it? Why are you looking at me like that?"

"Something you said before—could somebody *use* them to make trouble?"

He shrugged. "If Theo had a run-in with some other gang, from somewhere else in town, and they wanted to get even—but they didn't want to be seen doing it—they could hire a couple of Dusters to make trouble at his place."

"Why do it two days in a row?"

"Beats me, honey. Is there an 'e' at the end of your name?"

I shook my head. "Green like grass."

He jotted it down. "What kind of work d'you do?"

"I'm between jobs. Would you mind not using my name?"

"What's the problem?"

"I don't need to attract any *more* trouble."

"Is there somebody you don't want seeing your name in the paper? Your husband, maybe?"

"Nothing like that."

"No husband? That's good news." (That wasn't the reporter or the gentleman talking—it was the wolf.)

"Can't you just call me 'a customer', or 'a witness'? Something like that?"

"I could—if you'd do something for *me*."

I didn't like the sound of that, but I said, "Like what?"

"Tell me your phone number."

"I haven't got a phone."

"Where d'you live?"

"Uptown." The dry edge I gave it pushed him back.

Just then, from the station door, Frank the cop beckoned us both inside, where I heard a metallic *clank*, and looked toward the far wall. One of the two barred doors had opened.

"Katy!" It was Amalia. A policewoman with a wrestler's build had a tight grip on her arm.

I trotted over to the desk. "Is she getting out now?"

"I don't know, miss. Just have a seat."

"Is there a penalty for stealing something, even if it gets returned?"

"Huh? What'd you steal?"

"Not me. I was asking because my friend over there's been accused of theft, but what was stolen's been returned. I mean, she didn't steal it! But anyway, it's back now. So, could she—?"

"Hey, Tilda!" the sergeant called to the policewoman. "What's the Chinky in for? She steal somethin'?"

Tilda yelled back, "Naahh."

"Then why was she arrested?" I demanded.

"Her?" Tilda tightened her fingers around Amalia's arm. "Fawgery."

"Forgery, huh?" said Josh. "What did she do? Sign checks?"

"She didn't do it!" I told him, loud enough so they all could hear, but no one was listening.

Tilda snorted. "Naahh. She copied some old ly-berry book."

Josh strode toward Amalia. "Tell me about the library, will you, doll?"

"It was in the magazine. I swear!"

"The magazine was in the library?"

"No! That's not—"

"Hey—no talkin', you!" the policewoman interrupted. Then she turned to Josh. "She's goin' to the House o' Detention. You can see her in court."

I pushed in: "Where's the manuscript she's supposed to have forged?"

"Whazzat?"

"That 'library book.' Is it here in the police station?"

"Naahh. They said at the school it's real expensive. We ain't got no place to keep stolen valu'bles."

"So, where is it?"

"It's over at, oh, what's-it-called? Uhh…Beeton's. *Beechum's*—that's it. There was a guy from Beechum's there, when we pinched the Chinky at Meyers. He signed for the thing, and took it over to Beechum's, on the East Side. Madison, I think. They got a safe. They hold evidence for us there sometimes."

Two middle-aged Chinese men emerged from a side room: one in a blue blazer, with gray worsted slacks; the other in a well-worn black suit. They went over to Amalia and spoke to her quietly; then the men shook hands, and the one in the blazer left the station. Amalia pointed me out to the other man, who came over to the desk where I was standing.

"Miss Green," he said with a nod, "I am Hoy-Hung Chen, the father of Am Lee."

(I knew that Am Lee was Amalia's Chinese name.) "What happened?" I asked.

"Yeah." That was Josh, who tapped the PRESS card in his hat. "What happened?"

"Please don't bother Mr. Chen." Then I turned to him and said, "You don't have to talk to the newspapers."

"He can if he wants to. Are you his interpreter?"

Mr. Chen looked at him coolly. "Miss Green is a friend of our family."

I asked him, "How long before they release Amalia on bail?"

"Tomorrow, or the next day. First, she must be arraigned in Magistrate's Court. We have an attorney—" he indicated the door "—who is going now to the bail bondsman."

When the paperwork was completed, Tilda put handcuffs on Amalia and opened the outside door.

"They didn't believe me!" Amalia cried out to me. "They didn't even give me a chance to—"

The policewoman hustled her out of the precinct house and handed her over to another woman in uniform, who pushed her into a police wagon. The driver put it in gear, and Amalia looked back at us through the rear window, like a kid watching her balloon fly away.

Hoy-Hung Chen walked slowly away from the precinct house.

Josh touched the policewoman's arm. "What happened, Tilda?"

"That's 'Officer Kowalczyk,' to you, Mr. Forman. Just 'cause you got a press card in your hat, it don't give you the privilege—"

"Sorry. If you please, Officer Kowalczyk, would you tell me what happened?"

"Well, it was the dean o' that music school over on Forty-eighth," she said. "He called in the complaint. Him and this other guy—the one from Beechum's—Winkleheimer, Winkleman, I don't remember: it's in my report. Anyhow, they said the Chinky was tryin' to palm off a phony ly-berry book on them, and they wanna press charges." She lowered her voice. "Me, I figure the old man's a big-shot in one o' those tong gangs they got down in Chinatown, you know? The girl steals the goods, an' he fences 'em."

"I'll check it out. Thanks."

She went back inside. Josh wrote something on a page, and tore it off his pad. "Look, Miss Green," he said, "I don't buy everything Tilda said. So, I'm gonna dig a little deeper before I write anything

up. If your friend got a bum rap, I'll see that she gets a square deal from my paper. You seem like an all-right girl. Here's my number at the *Mirror*." He pushed the paper into my hand. "Give me a call later today. Fair enough?"

"Okay."

I caught up with Hoy-Hung Chen a block away, and walked with him over to Broadway, so he could take the subway back to Chinatown. He was shorter than his daughter, but just as slender—too thin, in fact, to properly fill his suit, which made me think that it came to him at second hand, or from a charity that works with new immigrants. His English, however, was very good, since he'd worked in Nanking, where Europeans and Americans do business.

Amalia had told me about her father. He'd been an insurance executive, in charge of his company's branch office. But the Japanese leveled the city with bombs in 1937: "The Rape of Nanking" is what the newsreels called it. The Chens lost their home. They had to turn everything they owned into cash: her mother's jewelry and silk dresses, all of their furniture. Her father was even reduced to collecting scrap paper off the streets, until they had enough money to bribe their way onto a boat and get to Singapore ahead of the Japanese. It took them almost two years to get a visa to America.

"We are very grateful," he said, "that Am Lee has such a good friend as you are. She often speaks of how you found her bow at the Rochester—"

"Oh, please! That was—"

"—and last Christmas time. You played in her quartet. She admires you greatly."

"I'm her friend."

"I am sorry to ask this," he said, turning away slightly and casting his eyes down, "but may we impose further on your friendship? We have no other friends in New York."

"You have an attorney."

"He works for the Society."

"What society?"

"In Chinatown, a Benevolent Society is…oh, like a neighbor-hood Chamber of Commerce, to which our landlord belongs, with the other property owners on Pell Street. If it became known in his Society that Am Lee was arrested, they will say he rents to criminals."

"But she's not!"

"Nevertheless, he may evict her—evict all of us—for bringing trouble. The attorney for the Society can perform legal duties, but no more than that. He can not—he *will* not—pursue the truth."

"You know Amalia didn't forge that manuscript."

"The suspicion, alone, is a threat. Even if a crime is never prov-en, Am Lee is not a citizen. She can be deported, especially if she has lost her home. And, as we have no sponsor, we would be de-ported, also, back to China. No one else can help, but you."

"How can I help?"

"You must save her life."

That drove it home! Pretending to be a reporter, and nosing around at Meyers, was a lark, a harmless distraction from teaching. And yesterday, I'd done it mainly to drum up longhair gigs for my-self. But now Amalia was in the kind of trouble that could send her and her family into war.

I nodded, extended my hand, and said, "I'll try my best." We shook hands.

After he went down into the subway, I found a phone booth and made a call. Then I walked over to Fifth Avenue, got on an uptown double-decker bus, and took a seat outside on top.

Ħ

ROGER WINKLER, SENIOR APPRAISER was stenciled on his door at Beechum's; inside, his office walls were festooned with portraits, in oil, of famous classical musicians. He stood when I walked in, reached across a big mahogany desk to shake my hand, and ges-tured me toward an armchair.

He was short, with fleshy hands and not much of a neck; but his shape was more chunky than fat, as if he'd been carved out of a bar of pink soap. I guessed it had taken at least sixty years for so much forehead to have opened up between his eyebrows and his hairline. As he sat down, his blue double-breasted suit stretched tightly across his chest; but he didn't seem to be the type of man who'd un-button it for comfort, at least, not in his office.

"Thank you for seeing me," I said. "As I mentioned on the phone, I was on my way to the Meyers Conservatory to interview Miss Chen for *The Etude*, when I heard she was arrested. But I've always wanted to write a true-crime story for *Colliers* or the *Saturday Evening Post*, and a story like this could be my big break. You're the most important part of the story now, Mr. Winkler. What you do here—spotting fakes and forgeries among all these antiques— it's…it's like being a detective."

"Yes, it is." With a big smile, he pulled the pocket-square out of his jacket's breast-pocket, took off his steel-rimmed eyeglasses, and wiped them clean.

"What is it about the Paganini manuscript that makes it so valu-able?"

"Well, Paganini was a unique performer, with a technical mas-tery of the instrument unparalleled in Europe. But as a composer… well, there were no copyright laws in those days. So, during his life-time, he never published most of what he wrote, including—in this case—his guitar quartets. For a performance, musicians would copy out their parts from manuscripts, in much the same way that the Meyers students did yesterday. Miss Meyers always liked that, you know. It gave her students a touchstone to the past."

"Were you at the recital?"

"Oh, yes. I'm a patron of the school, and Iris Meyers was my…my closest professional colleague."

"I read that she was an expert on forgeries, too."

"She certainly was, and I'll come back to that in a moment. You

asked what makes this thirty-four-page autograph quartet so valuable. Let me give you its history. It was almost certainly written for Paganini's friend and attorney, Luigi Germi, who was an excellent violinist; so, most likely, Paganini played the guitar part himself. Germi owned the manuscript until his death. It was sold at auction in 1854, along with some of Paganini's letters. There's a copy of the catalog reprinted in Stratton's biography of Paganini; you can look it up."

I nodded. Since I was supposed to be a reporter, I'd been making notes, except I didn't have a little notebook like Josh's, or even any writing paper. I used the back of the Meyers recital flyer again. He didn't notice.

"The manuscript was owned by an English collector for many years, and was put up for sale, through a gallery in Paris, after the War. This was a gallery that had done business with the Meyers family for decades. Several other manuscripts in the school's collection have come from there, as well."

"Could I ask…how much Miss Meyers paid?"

He smiled. "Yes, but I had better put the price into perspective. At the auction in 1854, it sold for four pounds, four shillings—about two hundred dollars in *today's* money. In 1920, Miss Meyers paid just over three thousand dollars for it. She did ask me to appraise it last November, when she started talking to Mr. Quartermain about having it performed on the radio. And my estimate is that it would sell today for between twenty-five and thirty thousand."

"Did she expect to sell it?"

"No! She was always looking to acquire *more* manuscripts. The Paris gallery is an uncertain partner these days, what with another war looming over Europe. So she began working with an antiquarian bookshop down on Fourth Avenue: they searched for manuscripts on her behalf."

"How did you happen to be at Meyers today, when the manuscript—the forgery, I mean—was turned in?"

"Joseph Meyers contacted me last week, saying he wanted a new appraisal for the entire collection."

"Why?"

"You'll have to ask *him*."

I pondered for a moment, then said, "Okay. You knew, right off, that it was a forgery. How did you know? And what made you think Amalia Chen had forged it? If it's had several owners over the past hundred years, maybe one of *them* pulled a switch. Or maybe that Paris gallery didn't know it was a forgery; and Meyers Conservatory has been the proud owner of a fake, all this time."

He was nodding while I talked. "Perfectly reasonable, Miss Green. Things like that do happen. When a collector tells me that he has never, ever, bought a fake, I show him to the door. Every serious collector has been taken in, at some time. But the manuscript Miss Meyers bought in Paris, in 1920, was genuine. I've seen it many times. The manuscript that Miss Chen gave to Dean Meyers today—" he took a leather folder out of his desk drawer and waved it gently "—*this* manuscript, is a forgery."

"But how do you—"

"Feel the paper."

It was stiff, and pale brown in color. "It feels like old paper."

"It *is* old paper. Genuine linen rag paper, made in Italy in the early nineteenth century; it has the proper watermark. This is very much the sort of paper Paganini might have used. And notice: it's been folded enough to make the creases fragile, as they would be, after all this time."

"Are you saying the forger got hold of some hundred-year-old paper?"

"Oh yes. It's not rare, and there's always been a market for it. If you go to a fancy banquet, sometimes they print the menus on old linen rag paper like this, as a souvenir."

"Can you buy it in New York?"

"That bookstore on Fourth Avenue carries it. I'm sure you'd find

more at other shops down there, if you asked around. It costs perhaps ten or fifteen dollars a sheet."

"So, for thirty-four pages, the forger had to invest a few hundred dollars—figuring it'd be worth it, right? Like a counterfeiter printing on real money-paper from the U.S. Treasury."

"Exactly."

"So, was it the handwriting that tipped you off?"

"Actually, the hand is quite skillful, but handwriting is not as important as you might think. Hardly anyone writes exactly the same way twice. And although Paganini learned music from some of the most renowned teachers of his day, the rest of his education was haphazard and limited. Also, he was ill for many years. In my opinion, his is among the easier hands to copy."

"Then, what made you suspicious?"

He lifted the first few pages out of the stack and pointed to where the italic letter *f* was written under a series of notes, in several places, meaning you're supposed to play them *forte*—loud.

"All these *forte*s are practically identical. But remember: I've seen the original, and on that one, the shape of the letter *f* differs a bit, one from another. It takes *days* to copy a manuscript of this length. And Miss Chen is the only person who signed out the manuscript long enough to copy it all—not just one part. I suspect that she simply forgot to pay attention to the source, and neglected to include the *forte*s. When she realized her mistake, she went back and added them, all at once—which is why they all look alike. And Miss Chen was in a hurry to finish, too."

"How do you know that?"

"On the last few pages, the letters are not so wide—implying a lighter touch of the pen, suggesting she was in haste, or possibly distracted."

"I'm impressed, Mr. Winkler. But are those little *f*s enough to send a woman to the House of Detention?"

"Oh, no. As I said before, Paganini's handwriting had enough

variation in it to make graphology a rather unreliable forensic instrument."

"Would you say that in English, please?"

"I didn't base my opinion on the handwriting. It was the ink."

"The ink?"

"A forger wants the paper to look as if it had been *written upon* when it was new. Which, of course, is impossible. Hundred-year-old paper is so dry that it will blot up any ordinary ink, leaving a smear that would be seen immediately as inauthentic. So, you can't use a water-based ink—as Paganini did. You need to mix the ink in a solvent that will evaporate before it can soak too deeply into the paper."

"A solvent that evaporates quickly…like alcohol?"

He grinned. "Since Repeal, forgers have been using alcohol more often. But not in this case. It was either acetone or ether."

"Ether, huh? Same as the anaesthetic?"

"Yes. Although acetone is the better solvent. It's easily available, too. But it's poisonous."

"So, it must be hard to get."

"No. You probably have some at home."

"Really?"

"To remove your nail-polish."

"Oh. Is *that* acetone? It stinks. Did you smell it on the pages?"

"I could have, if the forgery had been done in the past day or so. But after a few days, no matter what solvent you employ, it will evaporate. I can tell from the blotting pattern, though, that it was newly written."

"When, do you think?"

"As I said: at least forty-eight hours ago. Probably longer."

"But not a hundred years? Or even twenty years."

"Correct."

"This is fascinating. You could teach a correspondence course in forgery. Like that—you know—'Famous Artists School,' that advertises in the *Saturday Evening Post*."

He smiled. "The best introduction to the subject is a small book that Miss Meyers wrote; you'll find copies in the school library. Naturally, she took the position that forgery is wrong, and one shouldn't do it." He chuckled at his own joke.

I made myself titter a little. "So, if I were a collector, I could read her book and bone up on making forgeries."

"You'd be a fool not to."

"But, why call attention to the forgery by hiding it for a day? Why not just put it back, quietly, in the library?"

He squinted at me through his spectacles. "On the psychology of the criminal mind, I am *not* an expert!"

"Do you believe Miss Chen is a criminal?"

"I don't know."

"You were there when she was arrested."

"Calling the police…enabled us to avoid embarrassment."

"*She's* embarrassed, though."

"Miss Green, her parents are longtime customers here. They keep us on retainer to act on their behalf, acquiring and disposing of pictures. As a favor to them last year, I wrote a letter recomending their daughter to Miss Meyers. I am genuinely afraid now, however, that Beechum's has been *used*, and that my own reputation may be threatened, if manuscripts I affirm as authentic turn out to be spurious."

"But what's the point of a crime like this? How many people could possibly want to buy it? The real one, I mean."

"Oh…start with the city of Genoa, Italy. Paganini willed his Guarneri violin to the city. It's called 'The Cannon,' because of its…well, 'booming' sound. The city fathers there keep it on display, and invite prominent soloists to perform on it. I'm sure they'd love to have an autograph manuscript. There are private collectors, too, of course, including some of the well-known *virtuosi*, some of whom are not fussy about ethics. I, myself, if I could afford it…as a memento of Iris Meyers." He let a few beats go by,

then looked at his watch. "I'm sorry, but you'll have to excuse me. I have work to do now."

⊨

The sun was going down over Central Park when I rode the bus back downtown to Meyers. From the phone under the stairway, I called Panchito to say I'd play his gig at the Copa, Saturday night. Then I tried Josh at the *Mirror*, but he wasn't in. So I asked for Dingall, the city editor, whom Josh had called earlier. He took down what I told him about Amalia's career as a performer and a teacher, and—to win her some sympathy—I added that she was in danger of being deported. I left my answering service's phone number, and said Josh could call me later, if he needed more info about her.

Then I hiked upstairs, and knocked on Guy's door. It was a long-shot—and I did wonder if there were rules about having someone of the opposite sex visit you alone in your room. But it didn't matter: there was no answer.

I turned to go downstairs again, but I practically bumped into Guy. He was just coming out of the hall bathroom, wearing nothing but a white towel. His hair was wet and his frame was sleek.

" 'If I knew you were coming, I'd have baked a cake,' " he sang.

"Sorry."

"Don't be. Who'd you come to see?"

"You. And I'm seeing more than I expected."

He smiled, and didn't look away from my eyes. Finally, he said, "Give me a minute," and ducked through his door. He popped it back open in less than a minute, having pulled on gray slacks and a sweater and (I was sure) nothing else.

"Want a drink?"

I found myself saying, "Yes," without even asking what he had.

"Hold these." He handed me two mismatched tumblers, then poured an inch of something—it turned out to be peach brandy—from a leather-covered pint flask. We clinked our glasses with a theatrical flourish.

"I guess you've heard about Miss Chen," I said, after a swig.

"I saw the police take her away. More brandy?"

I let him refill my glass. "I liked your playing today." That sounded like applesauce, but he smiled.

"Want me to play something for you now?"

"Do they let you play in your rooms? The walls are probably thin."

"I've got a mute." He clipped one to the bridge of his violin and checked the tuning.

I looked around. Guy's room was right above Rebecca's, and the same size, but there was less space to move around. His window, like hers, opened onto the airshaft; but Guy had pushed a drop-front desk up against the sill. That was dangerous—if the building ever caught fire, he'd have to climb over it and squeeze out through the top of the window. And it'd still be a four-story drop: old buildings like this didn't have to have fire-escapes—just airshafts—for exits.

His closet door was open. All the hangers were the same distance apart. Six pairs of shoes, with wooden trees, were lined up evenly. A leather folder of soft collars lay on his dresser, alongside a lacquered box of stays, cufflinks, and shirt-studs. Pine bookshelves held a few dozen volumes. Three more books lay on his night stand, the one on top being leather-bound, with a torn spine but prominently titled, *The Spurious Manuscript: A Treatise on Distinguishing Improper Copies and Autograph Forgeries*. The author was Iris D. Meyers, Ph.D. I couldn't think of an excuse for opening it; I'd have to find another copy in the library.

Guy was noodling around with double-stop chords, but finally he said, "Do you want to hear more Paganini?"

"Sure."

He ran through the "Air on the G-String," a showpiece that's (you guessed it) played on just the lowest string. The piece is well-known nowadays, but audiences a hundred years ago must have

been stupefied, especially by the trick bowing for it that Paganini also invented.

"Terrific! Really professional," I said when he'd stopped, and I meant it. "You've got good posture, too. But sometimes, you swoop down like a crane—" I pantomimed it, exaggerating to show him what I meant "—when you attack the strings with an up-bow, especially when you're down the fingerboard, in first position. I saw it when you played the quartet, too. It's not a sin, but it'll count against you when you audition for an orchestra."

"It will?"

"For holding your posture, try picturing a flagpole, in your mind." I straightened my back, and extended my arm out all the way, to show him.

"You sound like my teacher!" He gave a little laugh.

I jerked my arm back to my side and said, "Sorry." But it was good advice. For a moment, I felt the way a veteran teacher feels, when a favorite pupil finally outplays her. She introduces him proudly as her discovery and he gets his first important job. Then he starts taking the gigs that *she* ought to be playing! She can't do anything, anymore, except give lessons. "I'm not your teacher!" I said a little too loudly.

"Where'd you pick up that gimmick about the flagpole?"

"I, uh, wrote an article about a violin teacher, once."

"Have another drink."

I held out my glass. "Do you think Amalia is a forger?"

He waited a second. "You called her by her first name yesterday, too. Is she a friend of yours?"

"We went to—" (Damn! I almost said "conservatory." Was the brandy making me careless, or was I thinking too much about Guy's physique?) "We went to Theo's, for coffee, the other day. She *asked* me to call her Amalia. She says she put the manuscript into her cello case-cover, took it upstairs, and the next time she went to get it, it was gone."

"After the radio recital?"

"Yes."

I thought he started to say something, but he hesitated and looked down at the floor.

"What is it?"

"I'm trying to visualize the room, and see who was where. Help yourself to the brandy."

"Are you trying to get me drunk?"

"Should I?"

(Ooh...he was so much smoother than any wolf who'd tried to make me lately.) "No. Are you visualizing the room yet?"

He set his violin down in its case, and stood up, but with his eyes closed. "Okay. I'm shaking hands with the guests: Miss Chen's parents; the dean; the faculty; Mr. Winkler, of course, and Mr. Cornelius—they're the moneybags—the school's biggest patrons. I'm shaking hands with Mr. Quartermain, and his radio crew...."

"Where are you?"

"Uh...I'm...wait." He opened his eyes, took my hands, stood me up, and led me over to the edge of his cot. "Stand here." Then he walked over to the door, turned and started back in my direction. "I'm coming along the line of visitors." His right arm was out, shaking imaginary people's hands. "I get to the second row—" he stopped beside me "—I turn and—" he planted a kiss right on my mouth.

I could have smacked him across the face, or worse. But I didn't. I just stood there and let him kiss me. The second time, I opened my lips a little and felt the tip of his tongue against my teeth. I let him wrap both arms around my shoulders, crook his elbow and take the back of my head in his right hand, pressing our mouths tighter. For the first time that day, my man-tailored suit-jacket felt much too tight. I was tasting the brandy again, and starting to imagine... But I straight-armed him. He took it like a gentleman, and stepped away. There was no point in our going

any further. Certainly not without my pessary from Margaret Sanger's clinic.

<div align="center">⊏</div>

Back in my apartment, undressing alone, I let myself feel sad. It would have been nice to have Guy with me. When you come home, you want a boon companion, a friend in need, a sympathetic ear...all those things that my married friends expected to get when they caught a husband. And some women actually do get a man like that. Others get louts who spill beer on the baby, and won't put on a shirt for company.

Being on the road so much, I don't have—I can't have—what Mother calls a "social life." I do take a lover, occasionally. And I was sure that that's all Guy would ever be to me. But I haven't had a real romance, or even a steady boyfriend, for about two years.

When you're over thirty, and you've never even had a proposal, your married friends stop fixing you up with blind dates and start asking if you'd like to "make four" with their old aunties at Contract Bridge or Mah-Jongg. I don't even tell Mother anymore when I play a wedding gig; her reaction is all too familiar.

Mind you, I'm still pretty, and I've got a decent figure. Mother says I ought to get my hair straightened and tweeze my eyebrows, but I think I look better with my brows thick and my curls tight. It makes me feel exotic. Somebody once thought I was Greek!

After I lay down and switched off the light, I decided it *wasn't* a lack of true love that was making me uncomfortable. There've been men in my life for more than ten years. I wasn't sorry to lose the ones I'd said farewell to, and I didn't miss the ones who'd left *me*.

No, my discomfort was coming from a different kind of frustration. I just couldn't get a grip on what had happened at Meyers. It all seemed like a sort of fugue, where each voice carries a slightly different version of the melody, and you don't grasp what the whole composition is about until it's over.

Except that, with Amalia in trouble, and in jail, I couldn't wait for it to be *over*. I had to do something to make it come out right. And so far, despite all my efforts, I simply wasn't in control of…of the "sitchy-ayshun."

<div align="center">Ⅱ</div>

My jaw hurt when I woke up Friday morning. I'd clenched my teeth all night, and I was so mad at myself for doing it, that I stubbed my toe on the drain while I was in the shower-bath.

I plugged my percolator into the lamp-socket that hung over my table, and bubbled up enough coffee to prop my eyes open. Then I disconnected the percolator and plugged in the one appliance that—in a furnished room with no kitchen—I couldn't live without: my Armstrong Table Stove. It's the deluxe model, that fries bacon on top, poaches eggs on the bottom, and toasts bread in the middle.

Out the window, over the El tracks, the sky was cloudy. I put on my burgundy "wardrobe" suit, with the matching coat and beaver-dyed rabbit collar. By the time I'd eaten my breakfast, and downed a third cup of coffee, I felt okay again.

But I almost blew my top, riding the El downtown, when I opened the *Daily Mirror*. I thought I'd given that editor, Dingall, a good idea of who Amalia was, and what had happened to her. But either he didn't get it straight, or he decided that she was bigger news than Hitler. A photographer had snapped her at the House of Detention, and she was on page three with one handcuffed arm up, to keep the flash out of her eyes, looking like every girl who's ever been picked up in a raid.

The headline said, CHEEKY CHINA DOLL, and the story was even worse:

> Am Lee Chen, 35, of Pell Street, Chinatown, was ar-
> rested yesterday and charged with forgery. The docu-
> ment in question is a music manuscript, a copy of an

antique owned by the Meyers Conservatory of Music on West 48th Street.

Chen claimed to be a refugee, to gain sympathy in pursuit of a teaching position at the conservatory. She denied all knowledge of the crime when she was arrested, but Joseph Meyers, dean of the school, told the *Daily News* that the manuscript is unquestionably a forgery. As a native of China, residing here on a visa, she faces deportation as an undesirable alien.

Exposition in a fugue is always characterized by a sense of cumulative growth, because each voice, after it has completed the subject, continues to weave an independent melody of its own.

—Elie Seigmeister,
The Music-Lover's Handbook

5. Weaving Melodies

I was still fuming when I arrived at the dean's office. "Got a minute?" I said, through my teeth.

"For the press? Any time. Come in, Miss Green." Joe gave me a big smile. "It must be cold outside. Would you like some coffee?"

I said, "Thank you. Black, with one sugar," as calmly as I could.

He poured from an electric percolator, passed me a Delft sugar bowl, waved me to a cushy chair across from his, settled down, and smiled. Today he was wearing a collegiate sweater-vest that was tight around his ample waist. On the shelves behind his desk were dozens of reference books, literary anthologies, and oversize volumes of art prints. Reproduction sculptures of Greek and Roman athletes flanked a small fireplace, and on the marble mantel stood a nine-branched candelabrum with Hebrew letters on the base—which reminded me of the Dusters' epithet, and Josh's concern that anti-Semitism was rising in Hell's Kitchen.

Through the skylight, the clouds were breaking up, allowing the

sun to paint patterns on a big table in the middle of his office. Joe leaned back in his chair, saying, "A beautiful spring day, isn't it?"

"Did you see what the *Mirror* wrote?"

"I take the *Tribune*. Why?"

"Here!" I tossed my copy into his lap. He got his coffee cup out of the way just in time.

Half a minute later he set the paper back down on the table between us and said, "I don't like it."

"Damn right! She didn't do it."

"We'll see about that, at her trial."

"And your sister *invited* her to join the faculty. She didn't get her position here out of 'sympathy.'"

"I'm sure Miss Chen will be the star of the prison orchestra."

"It's possible, you know, that the manuscript wasn't the real thing in the first place. Mr. Winkler told me he hasn't seen it since November. It could have been forged days ago, *months*, even."

"It was the real thing, and one of my sister's favorites in her collection."

"So why are you sitting around? Shouldn't you be looking for whoever left it near Amalia's desk yesterday morning, stuffed inside a magazine?"

"Is that where Miss Chen says she found it?"

"She didn't find it. Mrs. Wellfleet found it."

"I didn't know that."

"Maybe there's more you don't know. What *I* know, is that it's a frame-up. Somebody's making it look as though Amalia—"

"All right, Miss Green. Let's say you're correct, and someone *is* framing her. Who would that be? Who are you accusing? Me?" He sat back, folded his arms, and took a couple of deep breaths. "I get the impression that you didn't just *stumble* into this situation. Are you friends?"

"I…I interviewed her once before, on another assignment. She phoned me on Wednesday, and—"

"Oh! *Now* I understand. She wanted you here, so, if she were arrested, you could rouse sympathy for her, in the pages of *The Etude.* 'Pity the poor, helpless Chinese waif.' Is that right?"

Maybe he was forgetting that *The Etude* wasn't a daily paper, like the *Mirror*: so, weeks would go by before it could print any story at all. But it *was* very influential in longhair circles. Letting him think I had the power of the press behind me gave me leverage over him. I took a sip of coffee, and said, "Suppose you're right: Amalia is a forger and a thief. Why would she risk getting caught by calling attention to the fake?"

"Go ask *her.*"

"What could she do with the original? She couldn't pawn it, like a saxophone; or take it to a fence, like a gold watch."

"Of course not. She'd…just a moment. Is it all right with you if I do as President Roosevelt likes to do, and go 'off-the-record'? Do you know what he means when he tells a reporter that?"

I sang him a couple of bars of "That's Off the Record," from *I'd Rather Be Right.* And when he chuckled, I leaned back in my chair, and said, "I'm not taking notes."

He leaned back, too. "I met her father and mother Wednesday. The Chens are all refugees—that's true. But they're not peasants. Mr. Chen told me that, back in Nanking, he was in the…uh, insurance business, I think."

"Right."

"They're cultivated, they have Western tastes, and they're art collectors. They own paintings by the French Impressionists."

"I'm sure they were well-off, in China. They sent their daughter to study in America. But—"

"I'm coming to the point, Miss Green. The Chinese don't generally trust American banks. Which is reasonable—some banks here are still shaky from the Depression. But now that the Japs have taken over East Asia, and closed all the banks but their own, a man like Mr. Chen needs to invest in something he can sell at short notice,

and if he's lucky, in something that appreciates, too, like gem stones, or real estate, or works of art."

"Or manuscripts? Do you really think Mr. Chen sent his daughter to steal from you, because he's afraid to open a passbook savings account?"

"Perhaps it's Miss Chen herself who needs the money."

I hadn't thought of that. So it took me a moment to ask, "For what? She lives down on Pell Street—not Park Avenue. Or Strivers' Row! She earns a decent salary, doesn't she? And a teaching position here is very prestigious." I opened my arms. "Why would she drop a plum gig like this? She's no dummy."

"Maybe she wants to strike out on her own."

"She could have done that, any time."

"It's easier with a pocket full of cash. Look: the buyer doesn't have to be her father. It could be one of the shadowy tycoons that owns half of Chinatown, or a fence in one of those tong gangs they have down there."

"But—"

"Whatever her reasons, you can't overlook the fact that she signed out the original manuscript, and brought back a forgery."

"You don't *know* it was the original that she signed out."

"All she has to do now is tell us where she hid it," he went on. "And after a couple of nights in the city jail, I think she will."

"You sound like those mothers in the park, who yell at their kids, 'If you don't behave, I'm calling the cops!'"

"Well, I am *that* angry! If anybody's going to sell the Paganini, it had better be me! Uh, we're still off the record, aren't we? This is not exactly a secret, but I don't want what I just said to show up in your story. All right?"

"Sure. But do you want to sell it?"

He poured us both another cupful. "Meyers Conservatory is not richly endowed. We used to have an annuity that gave us a considerable income, but the Depression hit us very hard. Hence, what I

said about American banks. My sister reduced all of the faculty's salaries, including hers and mine. She even relinquished one of our family's oldest assets. We used to own the restaurant on the corner; we sold it to Theodore Levant two years ago. Have you eaten there?"

"You make better coffee."

He laughed. "I know what you mean. Theodore's family came from Vienna, like mine did. And in Vienna, they roast coffee beans until they're almost burnt. I've told him a million times that Americans don't like their coffee so—"

"Is the school in trouble?"

"Yes, it is. Iris did all these things so we could keep the school going and not have to close. She lowered—" he took a sip. I waited. (Was it the standards?) "—the price of tuition, to help students return. She asked several of our faculty to take on extracurricular assignments, which they did. Miss Rovere has been serving as librarian. Our percussionist has been keeping our books. Our piano teacher has been cooking for the dormitory students. These decisions were not easy to make, but they were the right decisions." He sat still for a moment. "I've inherited a difficult situation. Iris had hired Miss Chen last September, to broaden our curriculum in quartet-playing."

"So you know she didn't beg for sympathy."

"Of course. Her credentials are impeccable. The *Mirror* grabbed the wrong end of the stick, on that score. But we haven't resumed charging full tuition. We still need money, not only to pay salaries, but for repairs to the school buildings that we've postponed for years."

"Susie Pierce's brother told me he's been hired to do the work."

"Ed Pierce, yes." He nodded. "He's poked into every corner of our three buildings till he knows every inch of the place, top to bottom. And he says there may be yet more repairs we'll have to make—things he won't be able to see until the walls are opened up.

But if the money's not there, well…" He held out the percolator; I put my cup under the spout.

"Let me guess: the Paganini quartet just happens to be worth what you need to fix the place up."

"Pretty close. And it's a good time to sell. The Paganini is worth more now, since the radio broadcast."

"Yeah. And you should thank Miss Chen for that. There's nothing like air-play for pushing a tune to the top of the charts."

⊐

Theo's building, like many on Ninth Avenue, was what New Yorkers call a "taxpayer," with an apartment upstairs for the proprietor of the business at street level that pays the property tax.

I heard music through his door—Wagner's opera *Die Walküre*, with Kirsten Flagstad singing Brünnhilde—so I knocked loudly. Theo looked through a little peephole, slid the bolt across, and waved me into his apartment with hands wrapped in gauze, from which only his fingertips stuck out.

"Thanks for getting me to the hospital," he said right away, though his mouth didn't move much. Red splatter burns on his face were smeared with white ointment. Pyjamas with a pattern of tiny sailboats peeped out from the collar of his red-and-black silk robe. "I'm sorry—I'm not dressed for company," he added.

"How do you feel today?"

"*Largo.*" (That's the musical term for "slow.") "Can I offer you a beer?" he added, "and the opportunity to open one for *me?*"

I don't usually take a drink this early in the day, but it would take the edge off all the coffee I'd had that morning. So, I said, "Sure." He pointed into the kitchenette, where a bottle-opener dangled from a string on the handle of the icebox door. I pulled out two Rheingolds, and pried off the caps.

"There are straws on the third shelf," he called, inclining his head toward a cupboard, and smiling as broadly as his burns allowed. His pupils were tiny, and I guessed what that meant: the

doctors had given him morphine pills for the pain. I found the straws, slid one into Theo's beer, and placed the bottle carefully into his bandaged hand.

"Will you re-open the restaurant soon?"

He gestured for me to follow him into the living-room, and sit opposite him on the couch. "I wish I could do it today. I'd just hired Billy, to bus tables and wash dishes, and now he's out of work again while I'm closed. The doctor told me to wait till my hands are okay. It'll be a week, at least. They've got to change my dressings a few more times. Meanwhile, I can't afford to hire a cook."

(So, here was *another* man with money troubles!) He brought the bottle up to his face and found his lips with the straw.

The music ended, just as an El train went by outside his window. Theo shrugged apologetically, and gestured with his elbow for me to turn the phonograph records over. *Die Walküre* was one of perhaps two or three hundred opera albums that filled a wall of shelves, across the room. By their binders, I could tell that some of his records dated from before the War. Framed posters of two turn-of-the-century divas—Tetrazzini and Galli-Curci—hung on the wall above his big Philco radio-phonograph console. Signed photos of a dozen more recent sopranos and mezzo-sopranos lined the other walls. Opera books and libretti, and bound volumes of opera scores, spilled out of three enormous bookshelves in his hallway.

"You must have as much about opera, here, as they have in the Meyers library. Do you collect autograph manuscripts, too?"

"I did, once. Wish I could afford it now. I had a page from the second act of *Lohengrin*, but I traded it for two center-orchestra seats for the *Ring*."

I flipped the records over, stacked them on the changer-spindle, and sat back to listen politely, though I don't happen to care for Wagner's *Ring* operas, *Die Walküre* included. I especially don't like

Flagstad's Nazi sympathies. But Theo was apparently one of those fanatics who knows Wagner's works by heart, and doesn't care what the singers do or say outside of the master's music-dramas.

"Do you get to the opera very often?"

"I have a season ticket at the Met. That's how—" He waited while an El passed, going south. "That's how I met Joseph Meyers: he and Miss Rovere had the seats next to mine. It was a couple of years ago. I was a short-order cook who'd always wanted a restaurant of my own, and as it happened, I'd just inherited a few bucks. Joseph and his sister had this building, here, that they wanted to sell. So I bought it."

I didn't know how a reporter would frame the question, so I just said, "Excuse me for asking, and you don't have to tell me if you don't want to, but did you get a good deal on the place? Was the price fair?"

He smiled and said, "I stole it." But when he saw my face fall, he added, "Not literally! They just needed to sell, more urgently than I needed to buy."

The record ended, and the next one dropped onto the turntable. "The school still needs money, I understand."

"You're telling me! If Joseph could get a decent price he'd sell the school buildings tomorrow. He's had an offer. I have, too, for *my* place. Some real estate guy's been after us, to let him handle the sale. He came to see me in, uh…January. Said he had a client who runs a chain of restaurants, and wants a place that's already set up. But they want room to expand, too. So he asked me about the buildings down the street, and I gave him Joseph's name. The agent comes back every few weeks, to see if we've changed our minds. Maybe you saw him—he was in the restaurant the other day, when the Dusters shot out my window. A skinny guy with a slick pompadour: he has an office in the Empire State Building. Gives me his card every time he shows up."

"Can I see it?"

As another El roared past, Theo boosted himself up with his elbows, shuffled over to an open secretary cabinet, pushed the gauze enfolding his right hand against a business card until it stuck between the wrappings, and swung back around. "Keep it."

The name on the card—Erik DeReuter—didn't mean anything to me. "What chain does he represent? Horn and Hardart? Schrafft's?"

"He won't say. But that's no surprise. When Rockefeller was buying up all those blocks to make Rockefeller Center, he used a dozen different names to hide his involvement. The truth is, I wouldn't mind selling. I'd make a profit. But Joseph doesn't think he should sell—that his sister wouldn't have sold, anyway. They grew up in that house, you know. It's always been their home. So, if he doesn't sell, then I won't, either. He came to the hospital yesterday, and we talked. But he's scared to stay, and I am, too. Look out the side window—" he pointed toward 48th "—down the street. Do you see them? The Dusters? They're on a stoop, across from the school."

"Yes."

"Thank God nobody got killed, this week. But what'll happen—" he took a breath "—the next time…if they shoot real bullets? If I were Joseph, I'd sell." (Between the beer and the morphine, Theo was slowing down.) "That school. It's nothing but a big hole in the ground. Swallows up money. Iris ought to have—" he took a breath "—sold it off years ago. My corner. Too. Might as well—" he breathed again "—sell it now."

"What would you do?"

"San Francisco. Nice opera company there. Be a patron. Big fish in a little pond."

"How'd you get interested in opera? Do you sing?"

"Oh, yeah. College. Gilbert 'n' Sullivan."

"What are you? Bass? Baritone?"

"Bari."

"That's wonderful. Of course, you know what they say: 'It's always the tenor that gets the girl!'"

"So?" He was looking at me with a wan smile, and I suddenly realized that "getting the girl" was of no importance to him, whatever. Theo was a...well, there's a lot of slang words for it, and they're a lot nastier than "sissy." The expression I prefer is one I picked up from a Negro friend of mine: he'd have said Theo was a "man-lover." This made no difference to me, personally; I didn't care where Theo found romance. And you meet plenty of man-lovers, working in show business. I blushed at my *faux pas*, but Theo took it in good humor. He jerked his bandaged hand toward the record and said, "Oh, eventually Siegfried gets Brünnhilde, but then he dies!"

The music faded out, and the needle started scratching the label. I got up, plucked the record off, and was about to slip it back into its paper envelope when Theo held his better hand out for it. I laid the record on top of his bandages; he had just enough movement in his thumb to secure it. He waved the record over his head and asked, "What do you think of Flagstad?"

"Not much. Oh, she's got fine pipes. But Hitler thinks she's the greatest soprano in the world, and she thinks Hitler is God!"

He sat back against the arm of the sofa. "As a Jew, I'm embarrassed to say that I agree with Hitler about *anything*. But we both think *Wagner* is God."

Before the edges of my smile had even started to curl up, Theo swung the record down—fast—toward his knee. But he stopped short. "I can't do this! If I smash a record, I'm no better than Hitler, who burns books. What'll you bet he ends up burning the...the men who *write* books, too? If anybody tells you the devil is loose in the world...believe it. His name is Adolf Hitler."

"Do you think we'll enter the war?"

"Of course we will. But first, we'd better whip the bullies right *here*. Goddamn Dusters!"

ㅛ

Riding downtown in the subway, I had nothing to do but think: some "coincidences" *aren't*—but which?

Iris Meyers dies in January, and suddenly a real estate agent makes Joe and Theo an offer. Okay. The agent might read obituaries in the paper, and go to talk to the next-of-kin. Heirs want to dispose of property they can't use, sometimes. Or he might spot a corner restaurant, calculate that it isn't doing great business, and ask the owner about unloading it. But once they've turned him down, why would he keep coming back to pester them?

Was he using the Dusters to *scare* them into selling? Harass the students; rob the lunch-counter… That made sense, though it'd be an awful risk: Theo or Joe could call the cops, and set him up to be arrested, if he ever made an explicit threat. And what chain of restaurants would plant an eatery in the middle of Hell's Kitchen, anyway, right under the El? Wouldn't they prefer a quieter—and safer—location?

Still, if he *were* paying the Dusters to make trouble, he was getting his money's worth. Things were just bad enough to make Theo consider selling, but not so bad that the newspapers would call it a real crime wave. The police didn't hurry to Theo's when his window was broken; and at the Sixteenth Precinct, they didn't act like they expected Mayor LaGuardia to stride in, wave his big hat, and tell them to get cracking.

I couldn't see any connection to the manuscript, either. What would the Dusters do with it? How—and why—would they have stolen it, much less forged it? Maybe this realtor was really a sinister, criminal genius, like in the movie serials. But I couldn't imagine a masked arch-villain muttering, "*Sell*, Mr. Meyers, or I'll reduce the value of your library!"

Then I thought: Maybe it's all an elaborate scheme on Joe's part, to buy back the restaurant and get a chain operation in. Then, when it's a big draw, and real-estate values all around the block go up, Joe could sell all four buildings for a ton of money. It was

possible. The price of land in Hell's Kitchen probably couldn't get much lower.

But suppose somebody were trying to force Joe to sell the school, by stealing the manuscript before he could sell it. It would have to be someone *inside* the school, or at least, someone who knew the extent of the collection. But if that were so, why not just make off with it? Why frame Amalia for the theft? And why leave a forgery behind—especially one that an expert would spot as a phony?

"Iris would have known that!"

Oops! I'd said that out loud. A couple of straphangers looked over at me. I mumbled a few more words, as though I were somebody who *always* talked to herself on the subway. And, as New Yorkers will do, they edged away from me.

Was there even any connection between the forgery and Iris's death? I'd been assuming there was, but I didn't even know how she died. My "morbid curiosity" was niggling at me. I needed to know what happened to her, but I wasn't likely to get anywhere by asking Tilda—*Officer* Kowalczyk. I'd have to ask Josh Forman. And I couldn't do *that* right away, either. Amalia was my first responsibility. What Joe said about her father couldn't possibly be true. Could it?

⊨

A teenaged boy in a black wool suit was on the stoop of the building on Pell Street. He stepped aside, but watched me, as I checked the house-number and pushed open the door.

Amalia lived in the kind of building that's given tenements a bad name. The stairwells and halls reeked of moldy carpet, and of something once edible, now overripe and rotten. All the time I was visiting, I was glad I didn't have to use a toilet.

Her apartment was on the top floor; and from the number of doors I saw on the way, the landlord must have carved up the building into more than thirty individual rooms. Meyers Conser-

vatory had done much the same thing, with a similar building, but at least the school had made an effort to clean and maintain the place, and to lodge only one person in each room. I was sure that Amalia's wasn't the only room with three—or even more—people living inside.

Hoy-Hung greeted me at the door graciously, but with something less than delight. "We are expecting the attorney, from the Society," he said, beckoning me inside. "This is my wife, Soo-Ling."

Like him, she was slender, and very Western in her accent and her clothes, although—like his suit—her checkered skirt and pink blouse didn't appear to have been originally her own. "It's so nice to meet you, Miss Green," she said. "Please call me Sue, with the American spelling."

"Americans like to give nicknames to people whose names they can't pronounce. They call me 'Howard,'" her husband added, with a chuckle. "Would you like tea?"

"Thank you."

Nobody had patched or painted the walls for years. The only window faced an airshaft. Bedrolls, and clothes in old fruit-crates, were stacked in a corner. Two wires were plugged into a bare-bulb ceiling fixture: one led down to a hotplate, on which Sue's teakettle boiled; the other to a radio set on the floor—there was no room for it on the table. Other than that, and a small chest of drawers—probably Amalia's—the only pieces of furniture were the straight-back chairs on which we sat, between which there was barely enough elbow room to open a *Reader's Digest*.

However, leaning against the wall opposite the door were half a dozen flat, rectangular packages, each perhaps two or three feet on a side, bound tightly in brown paper and string.

When you visit someone, you're supposed to compliment the place; but there was nothing to admire. So I said, "Is this your first time in New York?"

"No. We were here twelve years ago. After we visited Am Lee in the conservatory, we came here and stayed at the old Waldorf—it's gone, now: They built the Empire State Building on the site. All together, we have visited America—" he glanced at Sue "—seven times?"

"Yes." She sprinkled tea leaves into a teapot from a box that, according to the picture on the label, also had dried chrysanthemum flowers in it. "But we are strangers here," she added. "None of us is a citizen. And the newspaper today—"

"I saw it. I'm sorry. I'll go visit Amalia in jail, right after I leave here. But tell me: did she need money?"

"Everyone needs money," said Howard.

"Is she...in trouble?"

"What kind of trouble?"

"I—I meant..."

Sue helped me out. "Miss Green is being polite. She is asking: Is Am Lee pregnant?" She poured my tea into a porcelain cup. Howard looked at Sue in dismay, but she shook her head. "No. Not pregnant."

A couple of silent seconds went by. I tipped my chin toward the paper-wrapped flats across the room, took a breath, and said, "I'm sorry to ask: What are those?"

"Our life-savings," said Sue.

"Before we left China, we sold what we owned, closed our bank account, and sent the money to the United States, for safekeeping. The Imperial Japanese Army seized my office, my company, my property...." Howard sat still for a moment. "So we invest in pictures. Paintings."

"The school of the French Impressionists," Sue explained. "Do you know the artists? Degas? Manet? Cassat?"

"Only from museums."

"We buy and sell through Beechum's Gallery. Now we must sell a Pissarro, to pay back the landlord for his bail-bond money, and for the attorney's fee. It will be auctioned tomorrow."

"Shouldn't your paintings be in a vault someplace? Are they safe here?"

"Was there a young man on the stoop, when you arrived?"

"Yes."

"Then they are safe. Protection is another service that the landlord and his Society provide to us—for which yet more money is charged, of course."

<div align="center">⊨</div>

The House of Detention for Women is one of the scariest places in the city—not because of its location, which is on a busy street in Greenwich Village; nor its architecture, which is in the modern, "streamlined" style. No. What makes it scary is, who's inside. The cops throw in all the ex-cons, dipsos, hop-heads, and coke-sniffers that they sweep off the streets every night. Those girls scream a lot, and quite a few of them are certifiably loony. A normal girl who had to stay in a cell with them could go crazy in a hurry, if she didn't get beat up—or worse.

I had to let a matron pat down the pockets of my wardrobe-suit and coat, before she'd let me into the room; she pointed to a chair, for me, that faced a chain-link fence. On the other side, another matron brought Amalia in, sat her down on a bench opposite me, and stood behind her.

"I stopped in to see your parents this morning."

"Thank you. Did my father...has the bail money come through?"

"It hadn't, yet, when I left. I'm sorry." I hesitated for a second, wondering if Roger Winkler authenticated paintings, too. Then I said, "Are you okay in here?"

Amalia shrugged, though it made almost no ripple in her jail dress—an oversized, faded gray shift. "It's never quiet. But if I shut my eyes I can think of a certain sound. I don't know if I've ever told you this before, Katy, but do you know how—just before I play something—I always close my eyes for a minute or so?"

"I've seen you do that. It's some kind of meditation, isn't it?"

"Yes. You think about one single thing, and everything else goes away. After you've practiced it for a few years, you can bring up the feeling in just a few seconds. It's very relaxing."

"Does everybody in China do it?"

"Oh no! It's from India. And I learned it *here*, from an Armenian mystic named Gurdjieff."

I giggled. "They do say, you can find anything in the world in New York! What is it that you think about?"

"It's the minor third of F and A-flat played together. When I hear that, inside my head, my breathing slows down and I get very calm. It helped me a lot last night, believe me. Oh! Before I forget. On your way out, stop at the desk; I've signed a waiver so they'll give you my keys. Would you go to my mailbox at Meyers—it's on the third floor, where the faculty desks are—and pick up my mail?"

"Sure. Look, I need to ask you something. Do your parents collect anything...besides those paintings? Dean Meyers thinks they could be...I don't know—international art thieves."

"What?"

"He says they encouraged you to steal the manuscript, so they could sell it."

"That's crazy! They'd have lost everything if they'd left their money in China. Why shouldn't they invest in fine art? Hardly anything else is safe in the world, anymore. Well, real estate, I suppose. Diamonds. Gold."

"Are they buying real estate, too?"

"I don't think so. I don't know. Why?"

"I'm just trying to follow the melody."

"What?"

"It's like I'm caught inside a fugue, with a dozen voices. Everybody's singing a different tune. The counterpoint's going every which way, and I can't get a handle on the whole structure, until everybody's sung their parts through." I glanced at the matron; she was

eyeing a magazine on a table across the room, probably wishing she could just sit down and read it. "Uh…what was Iris Meyers like?"

"Katy! Are you still—?"

"I'm trying to help you! This may, actually, be important. Just tell me."

"I'm sorry she's dead." I waited for more. She looked down, then back up at me. "Do you mean: What were my feelings toward her? I respected her, professionally, but *only* professionally. Not as a human being. She was condescending. She looked down on everyone whom she regarded as intellectually inferior."

"Not you!"

"No. But several of the students; even a few other faculty members. She had a particular dislike for Hermione Wellfleet, and for Nina Rovere, too, which she didn't bother to conceal."

"Did she criticize them, in front of the students?"

"On the contrary: she gave them the 'silent' treatment."

"Ooh. That can be worse than being yelled at. When did she ask you to perform the quartet?"

"Right after New Year's: a week or two before she died."

"Why did she pick that piece?"

She smiled. "It's ice-cream music!"

I laughed out loud. That was an old conservatory joke: If you have time to play only one piece, make it something flashy, that leaves the audience smiling—like serving ice cream for dessert.

"Is that all?"

"She said she was fond of it, and that she'd never found the occasion to have it performed before. She had already talked to Mr. Quartermain, about broadcasting the 'Quarter-Hour Concert Hall' from the school."

"Why did he wait until April?

"He schedules all the broadcasts months in advance."

"Why did you pick these particular students to play it with you?"

"Well, Guy is quite good, as you heard. I expect he'll rise very quickly as soon as he gets his first job in an orchestra."

"And Rebecca?"

"I'm impressed—aren't you? She has an *innate* talent: she can sight-read anything! But she'll never grow, musically, unless she's challenged. She had no formal training, back in Tennessee." Amalia chuckled. "She'd never even *heard* of Paganini before she came to New York!"

"How about Susie Pierce?"

"There's only one other viola player at school, and Susie is the better of the two. You heard her. What do you think?"

"She's pretty good, but she might not make the final cut in an audition."

"I agree." Amalia stretched her neck from side to side; the matron looked down to make sure she wasn't trying to stand or run. "Moreover, I think she knows that performing is not her strong suit. Why else would she be so keen to open a recital hall on Ninth Avenue?"

"Could she be mad at you, for some reason? Mad enough to—"

"I don't think so. I'm not her teacher, after all. And playing on the air wasn't an audition. Besides, you have pupils, Katy. If you chide them during a lesson, even if your criticism is blunt, they don't make the newspapers slander you, or have you arrested."

I smiled. "Jail hasn't crushed your spirit. That's good."

"I thought I'd be devastated, at first. But there's time to think, in here—when there's no one screaming, anyway. What gets me through it, besides the meditation in my head, is remembering why I wanted to be an educator and not a performer. I get more excited when someone *else* plays well, than when I do. Besides, if you're a soloist, you have to spend more time selling yourself to impresarios than actually performing. I'd rather help other musicians to become…oh, this is so corny!"

"No. Go on."

"I think of myself as a catalyst in a chemical reaction: being in the right place at the right time, to help somebody become great. But now…if I can't prove…I mean, I don't even have to be tried and convicted. They could send me back to China—my parents, too—just for being suspected!"

The light in her eyes had flickered out. She tried to stand, but the matron put a restraining hand on her shoulder. "Help me, Katy!" The matron pressed down harder. Amalia winced. "Don't let them deport us!"

All the voices having made their appearance with the subject, they wander off to the discussion of something else, or (more likely) of some motif or motifs already heard. The passage in which this occurs is called an "episode."

—The Oxford Companion to Music

6. Motifs and Motives

It was the first time I'd ever been in the Empire State Building. For a couple of minutes, I stood in front of the Fifth Avenue entrance, staring up at it, and wondering if I should visit the observation deck, too, now that the skies had cleared. I'd read somewhere that only about half of the offices were rented—that even our former governor, Al Smith, who was the spokesman for the building, couldn't find enough tenants to fill it up. And, sure enough, the directory in the lobby had a lot of blank lines.

But DeReuter & Associates Real Estate was there, in a suite on the eightieth floor. And when I saw the view from their windows, I knew I didn't need to pay for admission to an observation deck that was only seven stories higher. Even the receptionist enjoyed a tycoon's panorama of Manhattan.

"Miss Thornden? I'm Erik DeReuter." He stood in a doorway, one hand on the knob, the other extended toward me.

"Delighted," I said, as I strolled into his office. I'd invented

"Mary Thornden"—an heiress from upstate—while I was back at my apartment, changing into the long black dress I use for orchestra gigs, and my imitation Persian-lamb coat. I also clipped on the rhinestone earrings that looked most like diamonds. "And what a view!" I gushed, although it truly was impressive, overlooking the entire West Side.

Erik had, indeed, been the other customer in Theo's on Wednesday. About thirty, or a little over, he wore a thick tweed suit—not only to look rich but to put some bulk on a practically skeletal frame. An old-fashioned antimacassar protected the top of his leather chair from the pomade that held his blond locks in stiff waves.

"You said on the telephone, Miss Thornden, that you were looking for commercial property. A hotel? Was that right?" He offered mentholated Kools from a desktop cigarette box. I declined. He hesitated, then closed the top without taking one.

"Actually, I'm here on my father's behalf. Perhaps you've heard of him: Henry Thornden? Of Syracuse?"

"Syracuse, eh? 'The Salt City.'"

(Uh-oh. If he knew the Chamber of Commerce's nickname, he might be able to spot me for a phony.) "I'm so glad you're a booster! We are, too, of course, my father and I. Where do you stay, when you visit?"

"Ahh, well, I've done business with Syracusans, here in New York. But I've never actually *been* there."

(That was a lucky break!) I launched into the story I'd concocted on the subway. "Then you must stay at the Onondaga Hotel, when you come. We own it—and it's the biggest in town. But Father wants to extend our—well, as we say—our 'hospitality' beyond the confines of Syracuse, upstate, by—" I gestured toward Erik's windows "—*plunging* into the great metropolis."

I had no idea who owned the Onondaga, but I figured DeReuter wouldn't check, at least not today. And I *am* from Syracuse. "Thornden," however, is the park near our house.

He rolled a fountain pen around his thin fingers, nervously. "Do you mind if I smoke?"

"Of course not! Were you refraining on my account? Please be comfortable."

He snatched up a Kool, and lit it with a silver desk lighter.

"We're prepared to act quickly if there is a property here that meets our needs."

He leaned back, exhaled, and smiled. "I'm sure we'll find the right location for your new venture. What is it, exactly?"

"God! I love it here. You know, once I've settled the business part, I'll need an apartment, perhaps on Park Avenue. Will you be able to help me find that, too?"

"It will be a pleasure." He took a long drag. "What is the, uh, 'business part'?"

"Father has been talking for years about building a new hotel, but you must understand, Mr. DeReuter, from my point of view, Syracuse is *déclassé*. My future is here."

"You're a sophisticated woman, I can tell."

"We belong in Manhattan."

"Of course you do! And this a very good time to buy property." (Did you ever hear a real estate agent say it *isn't*?)

"You do have a fabulous view, Mr. DeReuter."

"Tell you what, Miss Thornden: why don't we take a drive around the city? Let me show you some properties that would make excellent sites for a new hotel."

"Oh, I've already done that. You see, I'm very fond of the theater. And I believe we ought to build our new hotel somewhere near Times Square."

He made a half smile, then lit a fresh Kool and turned slightly away, probably so I wouldn't see his delight at the prospect of an easy sale.

"The very best locations are already spoken for," I went on. "The Astor, after all, is right *on* Times Square. A few blocks to

the east you have the Grand Central Terminal, with several hotels adjacent to it. To the north...well, I don't know. I've never been past the nightclubs on Fifty-second Street. Now, south of Times Square—that's rather intriguing. I believe it's called the 'Garment District,' which sounds divine! I *like* clothes."

"Miss Thornden, forgive me, but you don't want to locate there. Too many of the people in the rag trade are...different from you and me."

"In what way?"

"They're...well...they're of the 'Hebrew' persuasion."

"Oh, but I know some *very* nice—"

"Don't we *all*! Still, if I were you, I'd...pass on the Garment District."

"Of course, if you say so. That leaves the west—which I'd prefer, anyway. There's a quaint name for that district, too: 'Hell's Kitchen,' isn't it? Well, I'm not easily shocked, and certainly not by nasty words. It's a charming name, and the district is attractive. In places."

"You've been there?"

"Certainly. I find it somewhat bohemian, like Greenwich Village used to be."

"Oh, Miss Thornden! You are so right! I, myself, have made some small investments in properties there."

"It would be a perfect location for a hotel, don't you think? Being a short walk from the theaters, it should attract actors, dancers, musicians, all the people who bring an artistic sensibility with them."

"I don't think I follow you, Miss Thornden. Most hotels don't like to accommodate theatrical people."

"Oh, I know that. The people *I* want to attract are the ones who swirl around the theatrical *orbit*: the producers, the backers—they're called 'angels,' I believe. When *those* people take to a neighborhood, they encourage night life, good restaurants—" I leaned back in my chair "—all the things I love about New York."

He lit another Kool from the butt of the last one. I figured he was smoking, now, to dry up his mouth—to keep from drooling in anticipation. He pulled a handful of Manila folders from a credenza. "I can see you've done your homework. So, since you already know the area, I think we should focus on specific properties. And I happen to know a place that will suit your needs perfectly."

He opened a map covering about twenty square blocks, spread it over his desk, and pointed to the intersection of 48th Street and Ninth Avenue. "Do you know this corner? There is a very good parcel for sale there."

"Didn't I read something about that corner in the newspaper, yesterday? A robbery, wasn't it?"

"An aberration! Nobody will bother you there. Look how big the corner lot is. And there are *five* lots available, actually: The corner building and the one next to it, which front on Ninth Avenue; plus the three buildings adjacent to the corner, going west along Forty-eighth Street. If you were to combine them all, you'd have room for a fairly large hotel with its entrance right on the Avenue."

"What's there now?"

"On the corner? A dingy luncheonette. The building next door is vacant—it used to be a piano dealership. The three on Forty-eighth Street are owned by a Je—by *just* one man. He uses them for a music school. But they're in bad shape. Any contractor will say they ought to be demolished."

"Can I acquire all five lots, together?"

He leaned back and smiled. "Not today. And the piano shop is in probate. That means—"

"I know what it means."

"Excellent. But we think alike, you and I. I have been working to assemble these five parcels into one, for a single transaction."

"Why? Do you have another client who wants them all? Who is it?"

"I can't say. You understand, don't you? I wouldn't mention that *you* were interested, if someone *else* asked me. That's fair, isn't it?"

"Of course. But if this other party is also looking to put in a hotel—?"

"No. They have a different use in mind."

"Which is…?"

"I'm sorry. I'd be able to disclose that only if it came down to both of you offering competing bids. So far, there's been no offer accepted by any of the sellers."

"How much did they turn down?"

He hesitated, but, touching his finger to his lips, he took up the fountain pen from his desk set and wrote, "$28,000/corner, $25,000/probate, and $92,000/school" on a memo pad.

"That's still three separate lots. How soon could you assemble all of them into one?"

"If I knew that you had cash in hand…"

"I still have some reservations."

"Please tell me what they are. Perhaps this is *not* the right location for you."

"That's what I'm thinking. Being right there, on Ninth Avenue—" I ran my finger down the map "—there are elevated trains going by, day and night. That's why I asked about the other interested party. What kind of business would thrive under the El?"

"Oh! I thought you wanted to buy…in advance."

"In advance of what?"

"The new subway."

"What?"

"Excuse me. I forgot you're from out of town. There's a new subway line going in—" he touched it, on the map "—under Eighth Avenue."

"I've seen it. The street's all torn up. But it's a whole block away."

"Yes. But as soon as it's finished, next year, the city will abandon the Ninth Avenue El, and tear it down. And when *that* happens, property on Ninth will double, possibly even triple, in value."

<p style="text-align:center">⊟</p>

Riding the elevator down, I realized why that had never occurred to me.

Sure, the city was dismantling El lines all over town. Just yesterday, I'd seen them tearing down the El on Sixth Avenue, outside the Musicians' Union. And I knew that, in a year or two, the El in front of my apartment on Columbus Avenue would be coming down, too—and that's the same line that runs along Ninth Avenue through Hell's Kitchen. But I hadn't connected their demolition with a rise in property values, because I've never been able to *buy* property. I couldn't afford a bungalow upstate, much less five buildings in the middle of Manhattan!

I'd left the number of my answering service with Erik's receptionist, so as soon as I got to the lobby I found a phone booth, called the girl on duty, and told her I was using "Mary Thornden" as a stage name, so they should take messages for her. Then I rode a bus uptown, to my apartment.

The sun had warmed the day up enough, so, instead of changing back into my wardrobe-suit, I slipped into a maroon wool coatdress, with buttons down the front that I could close up at the throat, if it got cold again. Then I took the El—yes, *that* damned El—back down to Meyers.

What did I know, now? What Theo had said, about the anonymous offer on his property: that was basically true. And while Erik certainly didn't tell me—a stranger—that he was putting pressure on Theo or Joe, he acted as though they were merely holding out for more money. But for whom was he acting? For Ed and Susie Pierce? They were interested in the piano showroom for their recital hall; but they wouldn't need any bigger chunk of the block for that. Then

I thought: Erik might not have a client at all. Speculating in real estate is a natural sideline, if you buy and sell it for other people.

On the other hand, almost everyone I'd met since Wednesday had a need for money. With the tens of thousands that the manuscript would fetch, Joe could keep the school afloat. Susie could fix up the old piano showroom. Guy (*ooh*, when I thought about Guy, I couldn't help thinking about him *that* way—it was very distracting). Guy could live in comfort until he found a good job. Rebecca and her fiancé could take a place of their own, and not have to move in with her folks, or his. Theo could walk away from his restaurant, and become a patron of the San Francisco Opera....

But for all the people who had motives for stealing and selling it, none of them had a motive for forging it. That could have only two conceivable purposes: to embarrass Joe; or to get Amalia into trouble. And only some people might want *that*.

⊨

I expected Nina to give me one of her "go-away-kid, you-bother-me" looks, but she didn't. She glanced up from a magazine, and gave me a smile that reached all the way up to her eyes.

I let the chip slide off my shoulder, and said, "Hi!"

"It's nice to see you."

"It's nice to be back."

"The days are getting warmer, aren't they?"

"Spring's coming."

"Have you seen the new *Vogue*?" She handed the magazine to me. "With the World's Fair opening this month, they asked designers to dream up the fashions of the future, a hundred years from now."

Maybe she was starting to trust me. Or was it spring fever, librarian-style? I played along. We leaned over the magazine together, gushed over the designs that were clever, and hissed at the ones that looked like they'd been drawn not for *Vogue*, but for *Amazing Stories*.

"You could wear *that!*" I told her, pointing to an evening gown I thought would flatter her.

"No, I couldn't."

"Sure you could. Take off that tight old snood, the way you did the other day. A good-looking Spanish girl like you—"

"I'm from Argentina."

"Oh. Sorry. But you should let your hair down and perm it!" (Did I really say that? I sounded like a radio commercial.) "Could I look around the library?"

"Certainly. Is there something I can get for you?"

"I don't know. I just want to look."

She shut the *Vogue.* "Miss Green, I have a friend with a problem." (That's one of the oldest dodges in the world. Did Nina really think I wouldn't know whom she was talking about?) "It seemed to me that you might have the experience to help her." (Meaning: Neither of us is a virgin, but you, Miss Green, are a fast girl.) "May I ask your advice, on her behalf?"

I touched her hand gently and said, "I know a doctor in Jersey. Want his number?"

"No, no! That isn't it."

"It isn't?"

"Miss Green, when a woman grows tired of somebody...her boyfriend, I mean. What should she do?"

I relaxed, and kept to the light side. "Kiss him good-bye, and don't return his calls."

"And what if it were *he* who's kissing *her* good-bye? How should she respond?"

So that was it. I've been with some Latin guys: the tall ones with pencil mustaches and big Borsalino hats, who think it's *manly* to walk out on a girl and never look back. I didn't say that, though. I chuckled, and said, "I don't know. I always try to do unto others before they do unto me."

"Is there a way to...*make* him come back?"

"No. And if he tells you—if he tells your friend—that he wants
to come back, it'll be because he can still score a one-night stand off
her, before he catches a train."

She turned her head away. "That recording you asked about,
from the broadcast: it's here."

"Oh."

If I'd expected her to confide further in me, I'd pressed the
wrong button. Women can be very touchy, talking about men.
Either I shouldn't have been so flip, or I shouldn't have expected a
confidence in return. We were still practically strangers. So, Nina
was unhappy in love. So what! I'd come to get Amalia out of trou-
ble—not *her*. "Thanks," I said, after a pause I hoped wasn't too
long. "In a minute, okay? I still want to look around."

She said, "Be my guest," but frost was crystalizing around her
again.

"Do you have Miss Meyers's monograph about forgeries?"

"As a matter of fact we have five copies: four are circulating, and
the other is being repaired. But I can tell what you're thinking, from
your question, Miss Green. You think that, if you can find one per-
son here who's learned how to forge manuscripts, you'll immediate-
ly exonerate Miss Chen. I'm sorry to puncture your balloon, but
Miss Meyers put the subject into the curriculum. *Every* student is
required to read her monograph. One never knows, after all, when
one might have to distinguish a genuine manuscript from a fake."

I sang, "One never knows, do one?" with a smile, but from the
look on her face she didn't recognize the song. "Fats Waller," I ex-
plained. Then I turned to wander around the stacks and shelves.

Through the south-facing bay window, sunlight splashed over
the polished rosewood and leaded glass of the manuscript cabinet. I
hadn't noticed, until now, how very quiet the library was. Surpris-
ingly little noise came up through the bay window from 48th
Street. And the library's carpet had a thick, muffling nap.

At the opposite end of the library, at the back of the house, there

was a door. It wasn't a "secret" door, by any means, but there was no frame—just an outline in the oak wainscot paneling—and it had only a small brass knob and latch. It opened without a sound, too, revealing a narrow flight of stairs. When the house was new, these would have been the servants' stairs, leading to the parlor floor immediately below; from there, down to a kitchen on the ground floor; and to a root-cellar or a coal bin underneath, in the basement. They also led *up*stairs, to what were now offices on the third floor; and to the fourth floor, where the servants would have lived, but where the dean's apartment and office were now. Iris and Joe, growing up in this house, had probably trotted these back stairs all their lives.

A fumed-oak desk, a matching armchair on casters, and a tall floor-lamp with a green slag-glass shade stood in front of the paneled door. "That was Dean Meyers's desk," said Nina, surprising me by how close she'd approached without my noticing. "She could see the whole library from here."

I chuckled and said, "She still can!" pointing to an almost photographic portrait of her that hung on the wall, behind the desk. It had been painted more recently than the one outside her brother's office upstairs. "She was a handsome woman," I said. "I wish I could have made her acquaintance. Is this where she, I mean: was she working here, the night she died?"

"Yes. But why do you—? Oh. Excuse me." A student had come in through the French doors, and she walked over to help him.

In this later painting, Iris was mature: there were a few lines in her face, and she wore *pince-nez* spectacles. Yet it was not the conventional portrait of a middle-aged woman. Her expression was youthful, and full of…well, of pleasure—as though she were closer to the painter, emotionally, than a mere sitting subject. It was signed simply *RW*, in one corner; so I lifted the right edge of the frame and looked at the backing-paper. There was an inscription: *To Iris, as you will always be to me. Love, Roger.*

Remembering the portraits in Roger Winkler's office, I guessed that *he* was *RW*. And from the *Love*, that he was more than just a colleague of hers. I had to set the portrait back against the wall: a corner of the backing-paper was detached, and I didn't want to make the tear any worse.

I sat down in Iris's chair, and immediately, I had a better sense of her as she was when she was alive. I could imagine her, on a typical evening after work, slipping into a dowdy but comfortable old housedress, coming downstairs—the back stairs—from her apartment, and sitting right here at this desk. She'd look up citations, review her reference materials, write out a chapter in her next book…maybe dream of Roger Winkler, too! She'd spread her books across the desk and…had she left anything in the drawers?

The one in the center held a couple of pencils; pens and nibs; a stiff, inky rag; a small, screw-top bottle of Ritepoint black ink; and a matching bottle of red ink. In the right-hand pedestal's drawer I found a file-folder containing a packet of blank stationery, with envelopes that didn't match; and an ashtray. In the left pedestal drawer I found a brown half-pint bottle with no label, tightly stoppered with a cork; a mechanical Burroughs adding-machine; and a ledger, dated "1932–33," that was filled with both black and red entries. I'm no accountant, but there were enough red entries in the end-of-the-year pages to confirm what Joe told me: that the school had been short of money for years. And the bottle suggested that Iris liked to forget about her money troubles by taking a little nip, now and then. I smiled. It made her seem a lot more "human" than the witch Amalia had described, who cursed subordinates with silence.

I pushed the chair back on its casters, stood up, and walked to the nearest pair of tall bookcases, where a card that said RARE BOOKS was thumb-tacked to the top shelf.

There were some old leather-bound volumes, and titles about collecting and preserving books, too. I thumbed through one that

had a short chapter on historically famous forgeries, and I checked the card tucked in the flap inside its cover; but no one had taken it out recently.

"Do you still want to hear that recording?" Nina had stepped up silently beside me, again!

"Right now?"

"Come with me."

On the long interior wall, a glass door opened into what had once been a closet, fitted out like a listening booth in a music shop, with cardboard egg cartons nailed to the walls—the cheapest kind of soundproofing. There was a wide shelf with a phonograph on it, and a narrow shelf above that, holding a few records.

She handed me three acetate master discs in paper sleeves. The labels were hand-written: *Quarter Hour 4–16–39*, with *#1, #2,* and *#3* appended to signify playing order. From a box under the shelves in the booth, Nina extracted a set of black Bakelite earphones, and said, "When you're through, bring the records back to my desk. There's something else the radio crew brought in, that I'd like you to see. I think it will change your opinion of Miss Chen."

I said, "Okay," though I didn't mean it, and she walked away.

It was too bad Nina was so self-righteous. When she was pleasant, she was almost likable. And when she asked for help, I thought it might be a hint of something warm in her. But she was as tough as a man when it came to standing up for herself. Mind you, I do admire that in any woman. Those of us who can earn our own living get a feeling of self-reliance from it, a confident attitude, knowing we can walk away from any guy who's no good for us. Nina was only a little older than I, and certainly pretty enough to attract men—the right kind, as well as the wrong ones. Now that I knew she'd been hurt by a man who'd left her, we had that in common, too.

There was that sour edge to her personality, though: something I hoped *I* would never develop. But if I had stayed strictly on the

longhair side of the music business, all these years, and had taken a cushy job in a minor-league music school, then that librarian hiding her good looks under a snood—that desperate spinster who hoped every slicker with a smile under his mustache would be her One Great Love—that woman might have been me!

I wasn't giving the Paganini my full attention, so I restarted it from disc number one, and opened the tight top button of my coat-dress, at my neck. The interaction between the violin and guitar was even more powerful on the record than it had been in person. Guy had terrific tone. To be truthful, it was better than mine. Rebecca's playing was as strong as Guy's, and she made a clear, crisp attack on every note where that dynamic was called for. She was a virtuoso in her own way, and I hoped she wouldn't let herself fall into a marriage where she'd be nothing but her husband's wife. I smiled, remembering a conservatory classmate who'd dropped her career to pursue a famous musician, and become "Mrs. Him." That wasn't what *I* wanted. But then I thought: Who was I to tell somebody else that one choice in life was better than another?

I tried to focus on Susie's playing. It was flawless, like her penmanship, but it struck no sparks, and never caught fire. She was playing each note, I assumed, exactly as written, adding nothing of herself. Where was the gimmick? The hook? The…the "Susie-ness" that would make her memorable as a soloist? But maybe she wasn't motivated to play any better.

When the records ended, I bundled them back up. None of the players had revealed anything—in person or on the record—to make me think they'd stolen the manuscript and put the blame on Amalia. None of them had a reason to get her fired, or deported.

As I opened the door, I heard Nina talking, and realized how nearly soundproof the booth was. I kept the door ajar.

She was saying, "How dare you!" to somebody I couldn't see.

But I recognized the other voice. "'Tain't nothin' to get excited about!"

"You'll have to eradicate it, Miss Tharp, won't you? Or make restitution."

"But it's only one little book! And in Ecclesiastes, it says: 'Of makin' many books there is no end.'"

"I can quote scripture, too: 'The way of a fool is right, in his own eyes'—*Proverbs!* You'll make arrangements for reimbursement right now, or I'll go upstairs and tell the dean that you've defaced—" Nina stopped. (Had I made a noise? No. Someone had come in.) "Hello, Mr. Carson. May I help you?" she asked him.

"I'm bringing this book back."

"And I'm leavin'!" Rebecca banged the French door shut.

"I wanted to know," Guy went right on, "if there are any other books or monographs as extensive as this one."

"Not really." Nina's throat was tight. "That's still the definitive text."

"Okay. I want to get something else while I'm here." He walked toward where my booth was, and I decided to meet him halfway instead of letting him discover me.

"Hi," I said casually. "I was just listening to the radio transcription. I think you played the quartet better Wednesday, on the air, than you did yesterday in person."

"Oh, yes. I agree." He didn't look at me. He was scanning the shelves under the subject heading of INSTRUMENT REPAIR; he selected one about the scrollwork of violin peg-heads, and tucked it under his arm.

I walked with him to Nina's desk, where I said, "Thank you for letting me listen," and set the records down alongside Iris Meyers's monograph. It was the well-worn copy that I'd seen in Guy's room, but which he had apparently just returned.

She stamped the card from the book Guy was checking out. He

waved good-bye to me—nothing more—as he opened the French doors, and closed them behind him.

"I'm sorry about Miss Chen," Nina said to me. "I wish you'd been right. I wanted to believe her."

(I didn't think that was true, but I wasn't about to say so.) I said, "I still believe her."

"Then you had better see what *else* the radio crew brought."

She beckoned to me, and I followed her partway into the stacks. A movie projector had been set up on a small table, between two of the tall bookcases; and she'd taken a painting off the wall, four or five feet away, to create a makeshift theater.

"There's no sound." She flipped on the projector, and film began to chatter down into the gate. Even without turning off the library lights, the bookcases shadowed a cavern dark enough to make the pale plaster a screen.

"Where'd this come from?"

"From the sponsor, Mr. Quartermain. He brought a cine-camera with him, Wednesday—one of those little things for making home movies—and shot two four-minute reels."

It was no Hollywood epic, but I could see how the parlor downstairs had looked on Wednesday morning. A wide banner hung across the back wall, reading: A QUARTER HOUR IN QUARTER-MAIN SHOES WILL CONVINCE YOU. A couple of dozen chairs had been set up for the students and teachers, and their guests.

"There—" she pointed. "You can see Miss Chen with the announcer. He's going over the questions he'll be asking her on the air. He's written them out. See him show her the paper?"

"Yes."

There were some scenes of the radio crew adjusting the microphones, working the dials, and making hand-signals at each other. Then came a brief close-up of the Paganini manuscript on a music stand. Unfortunately, it had been shot from *too* close up, so it was badly out-of-focus. A sharper picture might've enabled Roger

Winkler to tell whether it was the original or the forgery they were playing from.

The quartet players were in formal recital clothes. Joe stood with them; he probably wore that tail-coat so he wouldn't have to button a tuxedo jacket across his stout figure. Everybody took seats. The Chens were in the front row. So was Ed Pierce, and a middle-aged Negro couple—his parents, no doubt. Hermione Wellfleet sat upright in her second-row chair, just the way ladies in her day were taught to do, talking with the man beside her, whom I didn't recognize. He was young but heavy-set, with horn-rimmed eyeglasses. Roger Winkler was in the row behind them, talking with Nina.

In the next shot, Joe had gained the attention of the audience, and gestured toward the Chens, who stood, turned, and accepted applause with polite smiles. Joe twisted the music stand around, so everyone could see the manuscript; and beckoned to Amalia to come up alongside him, which she did. Then the last feet of film chattered through the projector's gate and flapped out.

Nina rewound it, and threaded the second reel. "This one was shot *after* the broadcast."

The camera had been moved back to the pocket doors at the entrance to the parlor, to take a wide-angle shot of the entire room. Students were walking around, smiling and talking.

In the next shot, the heavy young man who'd sat beside Hermione was shaking hands, theatrically, with Rebecca and with Ed, and grinning toward the camera.

"Is that Mr. Quartermain?" I asked.

"No, that's Michael Cornelius, the bookseller. He and Mr. Winkler, from Beechum's, are the school's chief patrons; and we're very grateful for their contributions. *That's* Mr. Quartermain." She pointed to a mustachio'd gentleman, an *Esquire* magazine "Esky" type, who, in the next shot, was presenting each of the four performers with a Quartermain shoe box and shaking their hands, as if he were conferring a prize.

I saw Susie introduce her parents to Joe; while Ed, off to one side, chatted with Rebecca. Michael Cornelius came over and clapped Joe on the back, then waved grandly for the camera with his other hand. Nina stood beside them, smiling at the bookseller, but with the attitude of a teacher who's waiting for the class clown to settle down after a boisterous recess.

Guy spoke with Howard and Sue Chen, while Amalia thumbed through the manuscript pages. She pointed to a place in the score, and Guy—apparently playing that passage—took up his bow and fiddled one of Paganini's devilish *arpeggios.*

A couple of students—the ones I'd seen in the town lounge the other night, chewing on their reeds—mugged for the camera. Then they pulled Joe and Hermione into the frame with them. She tried to stay at the edge, stoically clutching a copy of *The Etude,* and smiling without showing her teeth.

I glanced at Nina, but she was looking away. Could *The Etude* that Hermione was holding that day be the same one in which she supposedly found the manuscript? If it was, why would Nina have hinted that the film would convince me of *Amalia's* guilt?

Each of the performers got a few seconds to themselves, in short scenes. Amalia held a pose, stiffly, with her cello. Guy showed off a trick-bowing technique—another Paganini invention, I guessed. Susie smiled and talked at the camera. And Rebecca tried to hide her face, but—apparently in response to something someone said off-screen—she looked up and stared right into the lens.

Then Joe was shaking hands with the announcer. Hermione was saying something to Nina; Ed was shaking hands with Michael Cornelius. Another scene followed, of the crew disassembling their equipment, and of two guys up on chairs, taking down the Quartermain Shoes banner.

"Look there, on the right," said Nina. Amalia was packing her cello into its case. "Keep watching." The camera panned across the room. "Now! See?"

Amalia plucked the manuscript off the music stand, and straightened the pages with both hands. Just as the camera panned beyond her, she opened the flap of the outer pocket on her canvas case-cover, and slid the manuscript into it. Then she was out of the frame, and a few seconds later the film ran out.

"Did you see? I told you," Nina exclaimed, triumphantly. "She had it all along!"

I shrugged my shoulders and said, "I believe it was taken later."

"I think you ought to consider the matter closed, Miss Green. The school has enough problems already. The last thing we need is to see our reputation for excellence, which Miss Meyers worked so long and so hard to establish, ruined in the pages of *The Etude*. It would be the end of everything her brother has tried to preserve, too. So, perhaps you'd better leave, now. And don't come back."

I left the library, without another word. But I couldn't *leave*.

I walked upstairs to Joe's apartment. He was there, I knew, because a phonograph was playing the finale of *The Flying Dutchman*. (Wagner again—twice in one day!) I knocked and he called, "Come in."

Joe was sitting in one of a pair of old wing chairs, his feet up on an ottoman in front of a gas log that had been lit in the marble fireplace. The sun had gone down, and he was reading the *World–Telegram* by the light of a floor-lamp, the top of which was reflected in the night-darkened skylight overhead. Beside his chair, a decanter and a wine glass stood on a fumed-oak cellarette.

I dropped into the chair opposite—perhaps it had been his sister's. We had a silent exchange in which he offered me a glass, I accepted, he poured, and we clinked our glasses together in a wordless toast. I took a sip. It was sweet Tokay, and it took the bitter edge off what I had been thinking about Nina.

With his round head and bald pate, Joe could have been cast to play Paul Whiteman in a bio-pic, though he had thicker eyebrows than the band leader's, and no mustache. If you like your men on

the heavy side (which I don't), Joe wasn't bad-looking. But he was on his way to becoming a truly fat man: his stomach rose up as high as the arms in his chair. There are girdles men can wear to flatten their tummies—you see them advertised in *Esquire*—but Joe didn't wear one, even when he was dressed up. If he needed to impress anybody, he didn't show it.

The room was cozy, and Joe looked comfortable, but I could tell he was exhausted, from the way he stared at the tiny blue flames in the fireplace. "Now that you've seen the film," he said, after the phonograph had played the last of the *Dutchman*, "are you convinced?"

"I'll grant you that Miss Chen put the manuscript into the pocket of her case-cover. But she *said* she'd done that, all along, and that she'd taken it up to her desk. And with the crowd, and all the commotion, it would have been easy for someone to slip upstairs and steal it. I saw Mrs. Wellfleet with a copy of *The Etude*, there, too."

"You're not suggesting—"

"*You* could have done it."

"Come on!"

"Look: isn't it possible that it was the *forgery* all along, that they'd copied their parts from?"

"No!"

"Why not? Since your sister...I'm sorry. But could anybody else in the school have told the difference? You didn't notice it was a fake when Miss Chen first brought it back to you."

"I wasn't paying attention, that's all. I was overwhelmed with relief that it was safe. But as soon as I saw that Miss Chen was filmed in the act of swiping the manuscript—"

"—or putting it safely away, as she said."

He gave a sigh, polished off the rest of the Tokay in his glass, and looked up at the ormolu clock on the mantel. "It's getting late, in more ways than one. If Miss Chen didn't steal the manuscript, then I don't know how we'll ever recover it."

I checked my watch, too: it was after eight. "I want her to have a

place to work when she beats this bum rap. Do you want to keep the school open, or don't you?"

"If it's at all possible, I'd like to keep it open."

"And if you get the Paganini back, you'll sell it and use the money to fix up the buildings, right?"

"Yes. Ed Pierce has already taken out the construction permits. But if work doesn't start soon, he'll have to take on another project instead. And the city building inspectors may not extend the permits for *this* job beyond the next few months. There's no chance of doing any construction during the winter, so this is it: work has to begin right now—this month. If we don't make the repairs, the city could declare the buildings unsafe, and condemn them."

"Then would you *have* to sell, and take practically any offer, no matter how low?"

His eyelids were heavy. He nodded slowly.

I got up, set my glass on the cellarette, said, "Believe it or not, we're on the same side," and left.

I walked downstairs, and took the inside passage through the classroom building to the dormitory. I was feeling tired, too, as I slowly climbed up to Guy's room.

He let me in, and gave me a nice—but brief—peck on the lips when he closed the door. We sat down on his cot and held hands, but he didn't try anything bolder. I must have looked as though I was wondering why not, because he said, "I have an audition tomorrow morning."

"Your first audition in New York? That's exciting. I saw you in the movies tonight, by the way." I told him how.

"I'd like to see that film. Is it still over in the library?"

"Should be. Tell me again: Where were you when Miss Chen was packing up?"

"We went through this, last night. I was shaking hands with the patrons, and the sponsor, and the crew."

"Yes. And I remember what happened next, last night!" I let a

big grin develop across my face, and waited for him to acknowledge
it with one of his own. He did, after a moment, but it didn't last. So
I said, "I wasn't angling to get you between the sheets. I really do
want to know what happened. You were shaking hands with the
audience, and the patrons, and then what?"

"I'm trying to tell you. But—" he lowered his voice "—I *would*
like you to stay here, with me, tonight." He'd draped his arm
around my shoulder and began stroking the back of my neck. "The
whole night, I mean." Now he was running his fingers through my
hair, unwinding my curls, teasing them straight. The top button of
my coat-dress having been open, all along, it was easy for him to
move his hand around my neck, and trace the line of my chin
down my throat.

"That would be nice," I admitted, "but I'll have to stop you,
soon, and run back to my apartment to get…something."

He took the hint, and went back to fingering my hair. "I have
something here that would make that trip unnecessary."

"Is it what you have to ask the druggist for, because he keeps
them behind the counter?"

"I wouldn't want to get you in trouble." He wriggled his fingers
a little, right on the tip of my earlobe.

"I like a man with foresight."

"I do have to go to bed early, for my audition." We both chuck-
led. Guy drew me close and licked around the edge of my ear.

I smiled and whispered, "Then let's wait, and get together on
Sunday. You could come uptown, to my place."

"I'd like that."

"I'd prefer that. Meantime, get all the sleep you can, for your
audition. Be completely rested. Where is it?"

He looked me right in the face and grinned. "The Metropolitan
Opera."

I stiffened up. I'd expected a chamber music group in the sub-
urbs, or a small theater orchestra. "The *Met* is *hiring*?"

"Shh!" He took my hands between his, and whispered, "It's not exactly an audition. I have a friend in the oboes there, who says the concertmaster went into the hospital last week. He's an old man and they don't think he's going to make it."

(A concertmaster is the *first* of the first-violinists in an orchestra, usually the most experienced, and a kind of assistant conductor besides.) "You could never fill that chair!"

"Of course not. But everybody else will be moving up, and that'll leave a vacancy down in the third-desk violin section. My friend's going to introduce me to the boys in the pit, and I'll be expected to show what I can do. If they like me, they'll put in a good word. I should hear 'yea' or 'nay' by next week."

The boys! That really hurt. I'm good enough to play third-desk fiddle at the Met, and there are plenty of women who are even better than I, who ought to be in that pit right now, working their way up, maybe even all the way up to concertmaster. But it's like there's a NO GIRLS ALLOWED sign on the stage entrance. And the Met is a union shop! I was over at Local 802 yesterday. Why wasn't there a notice of a possible opening posted on the bulletin board?

I got up off the bed, straightened my dress, and paced the room. I was mad. But what I finally said was, "What about Meyers?"

"I can take the course work on my own time. This could be my *entrée* to the major leagues." He got up, too, and smoothed out the blanket. "I wouldn't mind, some day, becoming concertmaster at the Met. But even a third-desk slot there is sure to pay off, in some way. I could get a second- or maybe even a first-desk slot at one of the other big-city orchestras, like Chicago or St. Louis."

"All that, before you go off to war? 'Bullets to the east of you, bullets to the west of you—'?"

"Oh. Yeah. Well—"

"You'll let me know how it turns out, won't you?" I was right beside the door. It was time for me to go. Not forever. Just long enough to cool down.

"Of course. And remember: we've got a date on Sunday. At *your* place."

I smiled. Though I kept my lips closed, he gave me a good-night kiss. I backed off; and before I'd reached the top of the stairs he'd closed his door.

I took a couple of deep breaths, then went down one flight to room 3B. The door inched open when I knocked; it wasn't latched.

"Rebecca?"

No answer. Maybe she'd gone to the bathroom. I'd gotten her out of a jam the other night; she oughtn't to mind if I waited inside.

Her guitar case was leaning up behind the door. A hymnal lay open on a flimsy folding music stand; the names of chords were penciled in above the staves. She hadn't bought any cosmetics since I was there last, but a new dress lay out on the bed. It was pale green rayon, and modestly styled, with a high collar and a low hem; the Gimbel's department store price tag was still attached. I glanced at the photos on her mirror again. The face of her sailor-beau was wedged more prominently into the top of the frame—maybe he was taking her out to some church social. He'd probably want to see more of her than the dress showed, but he'd also be grateful that nobody else could.

Three Bibles still lay on the night stand. One was leather-bound and new, and had Rebecca's full name embossed in gold on the spine and the cover. There was a handwritten inscription on the flyleaf, the souvenir of a funeral, most likely, because it said: *Remember James—Mother, Father, William, Van. September, 1938.* It could also have been a going-away present from her worried family, as their precious girl headed up to sinful old New York. If they only knew she was in the arms of a sailor! But with no makeup, a sober, unrevealing frock, a book of hymns…and he being a churchgoer… I figured the Tharps didn't have to worry.

The second bible, also new, was a small, cheap edition, with pebbly brown pasteboard covers. ASSEMBLY OF GOD was rubber-

stamped on the flyleaf, along with an uptown address—most likely that of her congregation.

The third Bible was old. A pale silk ribbon bookmark dangled out of the bottom. The binding was frayed, but repaired with strips of cellophane tape. It was so well used, yet obviously, also long cared-for, that I guessed it was the one Rebecca had been given as a child, and had carried to church with her ever since. I picked it up. Where the silk ribbon divided it, the Bible fell open to the First Book of Peter. Underscored in red ink was: *"Be sober, be vigilant, because—"*

Footsteps. Hinges creaked.

I looked around and closed the book, as Rebecca stepped through the door.

"Sorry!" I said right away. "I knocked, but it was open. I just came in to—"

"They always told me reporters are real nosy, but Miss Green, you take the cake!"

"I apologize."

"Will you get out!"

"I need to ask you a question first."

"For your darned ol' magazine?"

"Sort of. I have to help Miss Chen."

"Takes one to know one, I guess."

"What does that mean?"

"Go on down to the jailhouse where the rest of your friends are!" She was looking around the room, probably to see if I'd stolen anything.

"After you played the quartet, Wednesday, did you happen to see what Miss Chen did with the manuscript?"

"Nope."

"The movie shows her putting it in her cello case."

"What movie?"

"The one Mr. Quartermain, the sponsor, shot."

"Oh, that. I don' like nobody to make pictures of me, 'less I ask 'em to."

I pointed to the band photo on her mirror and tried to be friendly again. "You look good in pictures."

"I do not!"

"Got a date tonight?"

"None o' your bee's-wax. You leavin'?"

"Sure. But I was just—"

"Get out. Right now!"

I turned and left. She slammed the door behind me.

I sat for a whole five minutes on a sofa in the town lounge, but couldn't decide what to do next. I checked my watch: it was almost nine o'clock. I walked out into the hall, opened the door under the stairs, dropped a nickel in the pay-phone, and called my service.

"There are four messages for you, Miss Green. And I have a note here that we're also taking calls on your behalf for a Miss Mary Thornden. Did they explain to you that there's an extra charge for us doing that?"

"Does Miss Thornden have any messages?"

"Yes. There's one."

"Let me have it."

"But—"

"Put it on my bill."

"Okay. It came in at six thirty-two P.M. from a Mr. Erik—"

"Hold on a second." I got a pen out of my bag, but…oh, why do I never have any paper to write on? I dipped into the wastebasket and fished out a half-crumpled music composition page. "Yes. Go ahead."

"Mr. Erik DeReuter at Melrose five, five-three-oh-oh. It reads: 'I can show you the property at Seven-oh-two Ninth Avenue tomorrow. Can you meet me there at ten A.M.?'"

"Thanks. What about my regular messages?"

"The first one came at nine-oh-five this morning from a Mr.

Joshua Forman, of the *Daily Mirror*. Oh, my! A reporter at the newspaper. Imagine that!"

"What'd he say?"

"The message is: 'It wasn't my fault that she looked like a thief.' A *thief*? What kind of work do you do, Miss Green?"

"Just read it!"

"Yes, ma'am. He goes on to say: 'Will you let me buy you supper?' That's all."

"What's next?"

"This one came at twelve forty-one this afternoon, and says: 'Call Mother.'"

"Okay."

"At three thirty-seven, a Miss Madeline Roark called. The message reads: 'Saw your little girl in the paper. What's happening?' She didn't leave a phone number."

"That's all right."

"It's none of my business, I'm sure, but you being a *Miss* Green and all, don't you think your daughter ought to—"

"What daughter?"

"Your little girl. Like Miss Roark said."

"Is this an answering service or a settlement house? Read me my messages!"

"Yes, Miss Thornden. I mean, Miss Green. The last one just came in a few minutes ago, at eight forty-two. It's from a Mrs. Wellfleet, at Murray Hill four, four-one-one-two. It says: 'Poor Am-a-lye-uh—'"

"Am-a-*lee*-uh."

"Thank you. 'Poor Amalia. I can help. Come to my home before ten this evening, or after twelve noon tomorrow.' Her address is: Three fifty-one East Thirty-fifth Street, top floor front. That's all your messages, Miss Green."

"Thank you." I finished the "top-front" with a scratchy pencil, after my fountain pen ran out of ink. I glanced through the window

in the door; no one was waiting to use the phone, so I put in a collect call, station-to-station, upstate.

My brother, Tim, accepted the charges, but said "Mother's out playing Mah-Jongg," as soon as the operator put me through. Tim was home for spring break: he teaches physical education and coaches men's sports at Hamilton College, near Syracuse. He's also an amateur wrestler who was on the U.S. Olympic team in 1936, though he didn't win any medals over there in Berlin. Which, he likes to say, is just as well—he didn't relish the idea of shaking Hitler's hand.

"I found a terrific *ju-jitsu* teacher here in Syracuse," he said. "You ought to take some lessons from him, Katy. He says *ju-jitsu* is about more than just self-defense and protection: it's a whole philosophy."

I hadn't digested Amalia's Indian (or was it Armenian?) meditation lessons yet, so I didn't care to know about some other mystic Oriental teaching. "What did Mother want?"

"Three-A."

I laughed. That was our code, Tim's and mine, for Mother's repertoire of questions. Number One was "When are you coming home?" Two was "Are you sure you're all right?" And Three was "Have you found a nice young man?" Three-A was what she'd ask after I'd say "No" to Number Three: "Would you like to meet So-and-so?"

"Who's the lucky bachelor this time?"

"Mrs. West's son Harris. He's back from engineering school, and working at the Solvay Process, making sulphuric acid."

"Maybe he'll melt my heart! Tell Mother I'll call her tomorrow. No. Wait. I have a gig tomorrow at the Copacabana, and a date Sunday night. I'll call her Sunday afternoon."

"A date, huh?"

"He's a violinist, and I just met him this week, so don't tell Mother, okay?"

"Sure. 'Bye, Katy."

I got more nickels out of my pocketbook. Erik DeReuter had an answering service, too; so I left a message that Miss Thornden would meet him at ten in the morning. I wanted to call Josh, but I called Hermione first.

"Oh, hello dear," she said. "I only got around to reading the morning papers this evening—isn't that terribly slow of me? But imagine my surprise! There was poor Miss Chen staring out from the page, looking like Myrna Loy in that dreadful movie where she played Fu Manchu's daughter. Do you remember? Karloff was Fu Manchu."

"You said you could help."

"I certainly can. I gave her that copy of *The Etude* that had the Paganini manuscript inside. Well, it wasn't *her* copy, after all. Another copy came in the mail today, and *that* one had her name on the label."

"Whose copy was the first one?"

She let a beat go by. "Have you asked Miss Rovere for the library's copy? I think she'll tell you it's 'circulating.'...Are you still there, dear?"

"Yes."

"I have to hang up now. It's after nine o'clock."

"Oh, I'm sorry to call so late. Forgive me. You must be ready for bed."

"Goodness no! There's a 'jump' band at Small's Paradise that I'm very keen on. I want to catch a couple of their sets tonight. Perhaps you'd care to join me?"

I needed time to think, and a quiet place to do it, not a noisy Harlem jive joint. "Another time."

"All right. Why don't you come around to my apartment tomorrow? It's a Saturday, so I don't get up before noon."

"How's one or two?"

"The later the better. They don't water the drinks at Small's. Good night, dear."

By now, the two reed-chewing students were standing near the door, leaning close enough to imply that they wanted to use the phone. I'd have to call Josh later.

Susie popped into the hall, carrying her viola, and waved. "Hi, Miss Green! Any news about Miss Chen? Is she out of jail?"

"I don't think so. Not yet, anyway." I followed her into the town lounge.

"That's too bad." She hung up her coat and hat, went over to a cubbyhole, gathered up an armful of composition paper and notebooks, and called over, "Maybe I'll see you back here later. Ed's not picking me up till around midnight." She held up her instrument case, added, "If you want to chat, I'll be in practice room five," and trotted out the door and up the stairs.

One of the boys was still on the phone. I waited for a few minutes but he handed it over to his friend, and they didn't seem ready to relinquish it. I walked to the back of the building, and leaned against the wall to think. Could Nina have done it? I mean—of course, she *could* have. But *did* she? And even if she did, why did she set up Amalia as the thief? Why not just quietly switch the copy for the original? Why make a fuss? Or, if it had to be considered as stolen, why not make the theft look like a burglary by an outsider? But the only thing that suggested Nina might have turned the manuscript into money was that she'd bought a copy of *Vogue*, and was imagining herself wearing a modiste's original gown.

At the opposite end of the hall, Rebecca skipped down the front stairs in her new dress, darted through the vestibule, and out the building. I walked to the door, to see where she was going, but by the time I reached the stoop I didn't see her, and a coupé was pulling away from the curb.

The door swung closed and latched itself behind me, which was all right since I had Amalia's keys. There was a chilly breeze, though. As I buttoned my coat-dress up to the top, I let my eyes wander across the street. Three Dusters, lounging on a stoop, mis-

took my stare for interest, and tossed me a few suggestive catcalls. I started to walk toward Ninth, but one of them strode over, got in step with me, and said, "Hi ya!"

He was taller than I, with uncombed black curls. And this close, I could see he was only about seventeen. It was his plaid shirt, however, that I recognized; and by the aroma, it hadn't been washed since he'd worn it on Wednesday.

"I've seen you around, doll. Feelin' lonely, tonight?"

I gave him the air.

"Don't be a cold fish! How about a drink? It'll warm you up." He thrust a pint bottle in my direction.

"Get lost."

"Frigid, huh?" He looked down my buttons. "I got a little happy-dust, make you hot all over. Loosen you up. C'mere!"

I'd expected him to lunge at my chest, so when he did, up went my arm, knocking his away. He tried for my hair with his other hand; but by then, my arm had made a full-circle, turning the up-stroke into a roundhouse punch. My fist connected with his chin. It knocked him away, backwards and off-balance, against a fire hydrant. He tumbled over it, landing in the gutter on his behind.

His pals across the street laughed out loud. One of them yelled—like a fight announcer—"In dis caw-ner, we got duh *faw-mer* middleweight champeyun o' duh woyld."

I trotted to the corner and rounded it. Just up Ninth Avenue, a cop passed by me, walking his beat and twirling his nightstick. The Duster must have turned back when he saw the cop, because I checked behind me every couple of seconds and nobody was after me; so I slowed down to a brisk walk. It seemed like a good time to go home, but I still hadn't phoned Josh.

None of the bars I passed on the way to the El station was crowded, though most of them had radios tuned in to the Dodgers game, in Brooklyn. The El didn't run as often as it did in the daytime, so, except for the hoots and hollers of drunken baseball fans,

the whines of babies from the rooms above the stores, and the occa-
sional scream of a woman to a man, or vice versa, Hell's Kitchen
wasn't very hellish that night.

Opposite Madison Square Garden, there was a saloon with a
phone near the front door, so I wouldn't have to stroll all the way
down the length of the bar. Only one old duck whistled at me as I
walked in. The phone was almost as old as I—the kind with a sepa-
rate earpiece that looks like a black ice cream cone.

"Forman," was Josh's salutation.

"It's Katy Green."

"Oh, jeez, Miss Green, I'm sorry about that story. Old man
Dingall's got a complex or something about the 'yellow peril.' But
your friend's out on bail now. I checked."

"Really? That's great. Thank you." The Chens had no phone on
Pell Street, so I'd have to go visit Amalia there, in the morning.

"If you forgive me, I'll buy you dinner."

I needed him to do me a favor, so I sweetened the pot. "How
about a drink, right now?"

"Where are you?"

"In a bar called, uhh…" It was painted on the window, so I had
to read it backwards. "Sully's, on Ninth Avenue, across from the
Garden."

"I'm on the East Side. Give me twenty minutes."

It was closer to thirty when he finally came in, blaming the
cross-town bus; but I'd drunk only half of my Rheingold beer. He
took off his hat, called for a Rheingold, too, and pulled the stool
beside me up a little closer than I would have liked. But he left ex-
tra dimes from his change, to cover *my* beer and tip, too, which was
gentlemanly.

"So, like I said, I'm sorry about the way the *Mirror* played your
friend's picture, and about Dingall's rewrite of what you phoned in:
how she could be deported. Believe me, I didn't think she was—"

"Did you cover what happened to Iris Meyers last January?"

"Iris...Meyers... Oh! The dean of the school. Yeah. I wrote about that. Good local angle, too: she died in the house she was born in. Did you see my story?"

"No, I was out of town."

"Did you know her?"

"What happened, exactly?"

"Nobody's saying your friend murdered her, if that's what you're thinking."

"*Was* it murder?"

"There was no evidence of murder. She was working at her desk, and her heart stopped."

"Could somebody have stolen her pocketbook? Maybe she had it with her, with something valuable in it." I didn't tell him what I thought that *something* might be.

"The cops found her handbag, with her wallet and keys and compact, and stuff; but it was up in her bedroom, on her dresser. And she was wearing jewelry: a class ring from...uh, Barnard College, I think it was. And a small diamond."

"Like an engagement ring?"

"Only about one carat's worth, but expensive 'cause it's old. There's an appraiser from Beechum's, named, uh..."

"Roger Winkler?"

"Yeah. How'd you know?"

"I met him. Did he appraise the ring?"

"This is ironic—and kind of touching. He *gave* it to her! They were engaged."

"He didn't tell *me* that."

"Why are you—?"

"So, she definitely wasn't robbed, is that what you're saying? A thief would have taken the rings."

"Yeah. How come you're interested in this?"

"I just *am*, that's all. Could the Dusters have...done something to her? Or just one kid, maybe, on his own? He breaks in to

steal something, she puts up a fight, and he kills her—maybe accidentally."

"That's the only angle the cops could find to work on. They pulled in the guys who hang out on Forty-eighth Street, but they all said: 'I don't know nothin'.' And, uh…nothing will come of nothing." He flashed a smile. "Shakespeare."

That was unexpected. And welcome. But I needed to know more. "So, the cops don't think the Dusters had anything to do with it."

"Tilda Kowalczyk—the lady-cop—she thinks they do. The trouble is, one of the other cops—Frank Bond is his name; you saw him at the station house—he doesn't lean on the gang for petty crimes. His excuse is: he's 'waiting,' so he can catch them doing something big that'll put 'em away for good. But Tilda and a couple of the other cops in the Sixteenth don't think so. They told me Frank's not going after the boys *at all*—and maybe he's even taking money under the table, to see that they don't get busted, ever. You were there when I asked him if the guys who held up Theo were Dusters. He didn't say yes or no: he asked me if I heard the ball game!"

"So, he's crooked?"

"Oh, yeah. Tilda says she's trying to find a witness that'll link him to the Dusters, and she'll tell me as soon as she can make a charge against him that'll stick. So I don't cross her, even when I think she's wrong, like she was yesterday, about your friend."

"Ever think there might still be a story in what happened to Iris Meyers?"

"Not really. The Dusters don't steal stuff out of libraries. When they commit a crime, it's something that pays off in dough."

"But holding up Theo's place—there wasn't much money in *that*."

"Yeah. And I still can't explain it."

"Will you do me a favor, Josh?"

"I owe you one. I was thinking of dinner."

"I was thinking of research."

"You're not a normal girl, are you, Miss Green?"

"The *Mirror* has a room full of old news stories in filing cabinets, right?"

"Eet ees called," he said, with an accent somewhere between Bela Lugosi and Charles Boyer, "ze *morgue.*"

"Can you look something up for me?"

"Later tonight, after the paper goes to bed. What do you need?"

I took a swallow of beer. "I want to know about back-date bookstores: do any of them sell old music manuscripts and antique writing paper?"

"New York's a big place; there's lots of—"

"Try Fourth Avenue, south of Fourteenth Street."

"What are you, an undercover policewoman? Is that why you were so cagey with me yesterday?"

"I'm not a cop."

"Please don't be a reporter for another paper! If I was to help you get you a scoop, they'd fire me so fast—"

"I'm not a reporter either. I'm just trying to help my friend. I told you that, at the police station."

"Okay. If I get some store names, can I give them to you at lunch tomorrow?"

(What could I do?) "Yes. Where should I meet you?"

"There's an Automat on Seventy-second, near Broadway. D'you know it?"

It was in my neighborhood, but I just said, "Yes."

"See you there about noon, okay?"

"Okay."

"And Katy…"

"Yes?"

"Go out with me sometime, will you?"

"Maybe."

"I know all the jazz joints on Fifty-second Street. Ever been to Eddie Condon's?"

"I'm sorry. I can't go to—"

"Look. I'm no prize catch, but I'm a regular guy. I haven't got a wife, and you said you don't have a husband. Is there somebody who'd be jealous, if you went out with me?"

For some reason, I thought of Nina. She had nothing to do with what he'd asked me, but she'd popped into my head. I got distracted and had to say, "What?"

"Please don't give me the run-around. If you've got a boyfriend, tell me."

"There's nobody."

"Okay. I only asked because you seem like a real nice girl—*strange*, but nice. And I could—"

"I said there's nobody." (Why was I thinking about Nina?)

"What about Eddie Condon's tomorrow? It's Saturday night."

"Not tomorrow." I wouldn't enjoy myself until I'd gotten Amalia's mess straightened out. Besides, I had to play in Panchito's rhumba band, tomorrow, at the Copacabana. "How about next week some time?"

"Okay. I'm just trying to get to know you."

"I understand."

"You ever been in the *Mirror*'s building on East Forty-fifth? I can introduce you to Winchell."

Madeline would kill me if she knew I'd talked to Walter Winchell. Besides, I didn't want *him* to know *me*. The last thing I needed was to see my name in his gossip column. So I said what I knew Josh wanted to hear: "We can have a *real* date next week. All right?"

"But we're still having lunch tomorrow, aren't we?"

"Strictly business. You're going to find out—"

"I've got it."

"I'll see you tomorrow." I got up and headed for the door. "Good night."

I think he said, "Good night," too, but I'd already reached the sidewalk.

It was only a little after eleven o'clock, but definitely colder than before. I'd keep warm, if I walked home fast enough. I checked to see if the Dusters were around, and they weren't.

Walking gave me time to think, to go over everything again. But just as I was crossing the parking lot in the middle of Columbus Circle, a car raced its engine. I was distracted—but I *needed* to be! I realized, suddenly, why Nina had popped into my head before.

She'd been the cello teacher at Meyers, until money got tight and she'd had to take over the library. Maybe Iris promised Nina she could have her old job back, once the school's books were in the black again. But she hired Amalia, instead. And now, with Iris gone, Amalia wasn't merely another teacher, but a veritable celebrity—a "radio star," no less!

Frozen in her role as librarian, Nina could be discrediting Amalia in order to get her teaching job back. In the catalog of jealousies, it seemed awfully petty; but it made sense. Could I prove it, though? I had Amalia's keys. Maybe I could find something in the library, after hours.

I turned around and headed south, down Ninth Avenue again.

♯

I used Amalia's key for the front door at the Meyers brownstone; but in case anybody saw me let myself in, I went up and checked her mailbox—it was empty—before going back down to the library.

Her ring had a key for the French doors, too, but not for the manuscript cabinet, though it wouldn't be hard to force it with a hairpin, or simply pry it open with a penknife or a screwdriver. The manuscript bundles and leather folders were right there, behind the stained-glass rosettes. Why hadn't Nina or Joe made the place more secure after Iris died?

I heard a noise in the hall, tip-toed back over to the French

doors, listened, and then opened one and looked out. The hall was
empty; the stairwell was quiet. But something was different. The
framed photograph of the old neighborhood, of the corner at 48th
Street, under the Ninth Avenue El, wasn't hanging on the wall. I
squinted. The nail had been pulled out of the plaster, and there was
white plaster dust on the floor. I looked around, and saw the pic-
ture leaning against the oak wainscot in the hall, a few yards away.
Had it been there when I went up to the mailbox, or when I'd come
down to the library? I wished I'd paid attention.

Stepping back inside, and closing the French door behind me, I
saw Iris's monograph about forgeries on the shelf beside Nina's
desk. I picked it up and took it to the back of the library, and—
appropriately—I sat down to read it at Iris's old desk. It ran over
two hundred pages, so I skimmed and flipped more than I actually
read.

But I noticed right away that several paragraphs had been un-
derscored in red ink. The highlighted passages had words in them
like "folio" and "vellum," that I should have known—or looked up,
a long time ago. I decided to copy out some information, but (of
course) I hadn't brought any paper with me.

I remembered seeing stationery in one of the pedestal drawers. I
tugged it open, but someone had neatened it up: the ledger was
gone, and so was the brown bottle. But the stationery was still
there—heavy, stiff paper, probably expensive, from back when
Miss Meyers could afford it. I pulled two blank sheets out of the
Manila folder, stuffed one into my pocketbook, and started writing
on the other.

One passage I copied was about handwriting: specifically, the
fact that people write differently in different countries—in Europe,
1's look like 7's, while 7's have little dashes through them. So, Amer-
ican forgers might give the game away if they made American-style
numbers. I was sure that wasn't the case with the Paganini: the forg-
er had been careful, at least in that way. I also paid attention to the

chapter about aging inks with volatile solvents; and to another that listed famous manuscripts known to have been lost, stolen, or forged.

I felt a cool puff of wind, and for a moment I had the impression that Iris herself had stepped out of the portrait that hung behind me, and was standing just to one side. I smiled at the thought. But I also realized—again—how foolish Iris had been, to keep her collection in so public a place as a hospital.

Huh? I meant a *library*! I was in the hospital, once, when I was four years old. They were taking out my appendix. They gave me gas. It tickled my nose. It still tickled. I tried to wipe it, but something like a bird's wings, only cold, and wet, flew up, pinched my nostrils tight, and covered my mouth. I gulped for air through the chilly damp and cloying sweet taste of—*what*? There was a ringing in my ears.

I wriggled and groped with both hands behind my head. Hair got tangled in my fingers—hair that wasn't mine!

I had no breath anymore. I couldn't taste anything but the hospital. *Taste the hospital?* The book, the desk, the room...everything went white all over. Then black.

They're gonna cut my tummy open, Daddy. You told me not to cry, but it's so dark....

Sometimes, one voice appears on the scene with a scrap of melody before the previous voice has finished with it. The overlapping that then occurs is called stretto, *an Italian word meaning "squeezed together."*

—*The Oxford Companion to Music*

7. Squeezed

Push me, push me—my heart was pumping blood up my neck, so hard my ears rang, and my head hurt.

The air was stale, and smelled of old, burnt tobacco. I opened my eyes, but everything was dark. I couldn't see, but I could feel. I was lying on my side, curled up like a baby; my legs felt all prickly, asleep. I rubbed them together, and they woke up, but continued to tingle. I pulled my left wrist close to my face, and peered at the radium dial of my watch. Twenty to ten. What time did I get back to the library? After midnight, surely. I put the watch to my ear and heard it ticking. It was twenty to ten in the *morning.* Saturday morning.

My head throbbed. I made myself breathe slower until it didn't hurt so bad. My mouth felt like I'd dried it with a rug. I worked up as much spit as I could, and swallowed hard, until my ears popped open. I heard cars, somewhere.

I was lying on something cold and hard, like stone. (Oh,

please—don't let this be the morgue!) I straightened my legs, and my spine crickled; but when I tried to stand, I bumped my head.

Crouching, I looked up. My eyes had been open long enough now to notice a crack of daylight. I turned my back to it. A few feet away, I could see rough slats of wooden crates, with small cardboard boxes, bottles, and tin cans nested inside.

After another minute of stretching, my arms and legs felt normal, and my eyes were getting used to the feeble light. A metal chute slanted up from the stone floor to a double door in the ceiling, from where—I now realized—the crack of light was coming. The chute was narrow; I had to shinny up on my side. I felt all around the top for a latch, but it must have been locked from the outside.

I slid down again, worried that I'd gotten my dress dirty—and then I laughed: that should be the *worst* of my problems! I felt my way around, along the walls, for some way out. And I found a metal door, but—damn!—it didn't have a latch, either.

I bumped into the wooden crate again, and squinted, trying to read the labels on the boxes inside. Suddenly, a bright, square hole appeared in the wall—the door had opened—and somebody's head poked through.

"Hey! Is somebody in there?"

It was a man's voice. I held my breath and reared back, to give myself enough room to deliver a kick to his head. Then I could, maybe, dive through the hole, and get past him before he—

"Are you hurt?"

That didn't sound like a threat. "I'm…all right. Who's there?"

"Bill Wilson."

"Who?"

"Who are *you*?"

"Let me out!"

"Sure." He thrust his hand toward me. I took hold of it, letting him pull me gently, and crawled through the little door. I found

myself on a ledge, partway up the wall of a basement room. A small, bare lightbulb, glowing from a simple fixture, didn't make where I was much brighter than where I'd been. But I could see now that my rescuer was a tall man in a long overcoat.

I said, "Thank you. Thank you very much."

He helped me jump down from the ledge to the floor. "How long have you been in there?"

"I don't know. All night, I think. Where am I?"

"In the coal-cellar of the Meyers dormitory. What'd you do? Drink too much? Boyfriend leave you to sleep it off?"

"Somebody *threw* me in there!" I snapped back. Which wasn't nice, so I said, "I'm sorry," and brushed myself off. "Thank you, again."

"Excuse me a second. I need to get something." He hoisted himself onto the ledge and through the little door.

"Mr. Wilson, I think my pocketbook's in there, too. Would you bring it out, please?"

I heard him strike a match. "Got it! Here—" He tossed it to me; then rummaged through the cardboard boxes inside, setting a can of stewed tomatoes out on the ledge, followed by a package of dry spaghetti, and a glass Mason jar with greenish-yellow oil in it. Hopping down, he slid his groceries into the pockets of his overcoat, picked up his cap from the floor, and put it on his head. He was standing between me and the lightbulb, so I couldn't see his face until I walked around him.

"Saturday mornings," he said, "I and another fellow can use a friend's cook-stove, a couple of blocks away, to make ourselves a meal. It'll do till Theo's hands get well, and he can open the restaurant again."

"Oh my God! You're the busboy!"

"I thought you recognized me, before."

"I'm sorry. I'm Katy Green." I shook his hand.

"We met on the street once, too."

I felt ashamed at having to be reminded. He was the "forgotten man" who washed windshields for coins—and who had panhandled me on the corner. I'd gotten back my nickel's worth of charity, all right!

"Thank you, Mr. Wilson. I really appreciate your helping me. Um, have I got any coal dust on me?"

"They haven't kept coal in there for years, since they got fuel oil. You've got some smudges, but you're more wrinkled than dirty. Your buttons are all on, and—" he looked me up and down "—nothing's torn, that I can see. How did you get into th—"

"Do a lot of people know about this place?"

"Students, you mean? Yeah. They use it as a hideout, to drink and smoke."

"It smells like an ashtray!"

"They sneak in there to neck, too. That's why I thought…you know."

My nose itched, but when I reached up to scratch it, I remembered being unable to do that last night. I remembered the wet cloth. A hospital. It smelled like a hospital! I looked at my watch deliberately, and took advantage of the moment to slow down my breathing. A black hair had snagged in my watchband. I pinched it taut. Not mine… It had to be Nina's. (I'll throttle her!)

"Did you say something, Miss Green?"

"No. Just…would you tell me how to get out, please?"

"Sure. Those stairs, back there, lead up to the kitchen. You can go through, to the front of the building, and out the street door onto Forty-eighth."

I hesitated. It was almost ten o'clock in the morning. Nina'd be in the library, and there'd be students all around. Erik DeReuter would be on Theo's corner, too, waiting to show it to "Mary Thornden." I couldn't let him see me like this. And the Dusters— especially the kid in the plaid shirt—might be back on their stoop.

"Is there a…a way out, so nobody can see me leave?"

"Not from this building. But I do know a way to get into the middle of the block from here, and come out on Forty-*ninth* Street."

"Really? That'd be great!"

"A lot of these houses in Hell's Kitchen have connections to the space between them, in back. When the Dusters get chased by the cops, they can run into one house and come out of another, on the opposite side of the block. They can jump some of the roof-tops, too."

"Tell me how to get there on land."

"I'd better go with you. Some of them might be hiding out between the buildings."

"You're a good man, Mr. Wilson. Thank you."

He made a half smile, and closed the little door to the coal bin.

"Do you…live in there?" I asked.

"I sleep there sometimes, when it's not too cold. I used to have a tar-paper shack in the Hooverville in Riverside Park, but last winter I traded it to a guy for this suit, the hat, and the overcoat, too." He did a little strut, like a mannequin. "I got the better end of the deal, don't you think?"

I said, "I'm sure you did." But what I was really thinking was: What kind of a life is it for somebody whose clothes are worth more than his home? Here was a guy, like thousands of other guys in this town, with no steady job and no place to live, but he knows where there's a coal-chute he can bed down in, if it's not too cold. My eyes got wet, and I wiped them with my sleeve.

"Let's go," he said, and strode off.

Past the boiler, there was a flight of narrow stairs; but Bill circled around them and put his shoulder against a wooden door. It creaked open, and we stepped into someplace that was in the open air, although it wasn't exactly "open." Brick walls with small windows ran up on either side, far above my head. And there was a big pile of junk on the ground: mostly old newspapers and tin cans.

"Do you know where you are?" he asked.

"You said we were in the dormitory building, so this must be the airshaft for the students' rooms. Only, it looks like they use it for a garbage can!" I walked toward a doorway opposite the one we'd come through.

"Hold on a second." Reaching his arm into one edge of the pile, he plucked out a brown Bakelite radio and immediately turned it over, checking the inside for broken tubes. (He does this all the time, I thought. How far am I—how far are *any* of us, really—from having to live like that?)

I stepped on something that crunched: a piece of shattered saucer with burn marks on it. Maybe that was the ashtray Rebecca had thrown out her window? And if it was, her cigarettes would be down here, too—cigarettes that Bill might want to smoke, or trade for food. I didn't feel like rummaging through the heap with my fingers, so I picked up a broken mop-handle and poked with it, dislodging a shoe with no heel, an empty sardine can, and a celluloid collar, but nothing of value. Somebody else must have picked up her Luckies.

Bill concluded that the radio was beyond help, and dropped it. He came over to where I'd been poking, gave the heap a look-see, then shrugged and motioned me away. I tossed the stick on top of the pile.

He opened the doorway at the far side of the airshaft. It led to a tiny urban valley—a strip of rough, stony ground that divided the backs of the buildings that faced 48th Street from the backs of those facing 49th.

The wind funneled through the hollow, blowing cold air right through my coat-dress. The sky—what little you could glimpse— was bright blue. Yet that brief snippet of daylight, trickling down between the drainpipes and fire escapes, was enough to grow a tree, waist-high, in Hell's Kitchen.

Bill pointed, and whispered, *"Ailanthus.* 'Tree of Heaven.'"

"Huh?"

He made a small "shh" with his finger to his lips, and inclined his head toward a door in the back of a building.

I nodded. Also, I was shivering. I clutched my arms.

He twisted the knob gently. The door swung open, with hardly any sound, and we stepped through into a chilly storage room that reeked of motor oil. There were cans of the stuff all around, and dozens of grimy things, like tires and brake drums and old engine parts. The door across from us had a glass pane in the center.

Bill gestured to stop. We ducked and came up on either side of the glass. He inched one eye over, cocked his head to check the opposite direction, then motioned for me to do the same. Cars in the garage were parked in regular rows, though a few, near the street entry, stood at odd angles. I couldn't hear any engines running.

"I think it's okay," he whispered.

I was ready to walk right out, when I recognized a car parked near the front. My red lipstick was still smeared on the white side-wall of the right front tire, where I'd rolled up against it on Wednesday.

I grabbed Bill's sleeve, pulled him away from the door, pointed through the glass pane, and whispered, "That green Buick sedan— that's the one the Dusters got away in, after the shooting and the stickup at Theo's."

"I'm not surprised," he whispered back. "I've seen them hang out in the office, on the far side of the garage. When we go through this door, duck down, and crawl along the floor on this side. We should be able to reach the entry, and get out onto the street, before they see us."

"Okay."

Bill turned the doorknob and opened it just enough to let me out. I crouched and crab-scuttled, on fingers and toes, between the wall and the nearest row of cars.

There were voices—young men's voices—maybe three or four

of them. Somebody in the office was thanking somebody else for a job well done. I couldn't catch it all, but I heard "kike," followed by a big laugh. The words "frighten him" came through, and then a couple of shouts, the loudest of which was "a thousand dollars!" followed by a quieter voice saying, "When the deal's all done."

There was a scuffle of shoes. A man came out of the office. I froze behind a Plymouth sedan, so he wouldn't see me. But I couldn't see *him*, either. Not his face, anyway, just his feet—brown wing-tip shoes and green socks, and the cuffs of tan houndstooth slacks—as he left the office. He climbed into a blue car and started the engine, though he must have still been talking to someone, because another man stood alongside the car for a moment, with one foot on the running board. He wore scuffed black shoes and greasy dungaree overalls. Finally, the car went into gear and headed out into the street, while the other man stood by the big garage door whistling "Puttin' on the Ritz"—badly.

I half rose, looking behind me for Bill, to tell him we might make a better escape if we ran out in different directions. But I couldn't see him; maybe he hadn't come through the door yet.

I turned, but my sleeve caught the door handle of the Plymouth and yanked it open. It clunked against the wall.

"Hey!" The overalls started toward me.

Someone else yelled, "What's up?" Then he saw me, and I saw him. "*Whoa!* Miss Frigidaire of 1939." It was the Duster with curly hair, in the plaid shirt.

"No foolin'!" the one in overalls called to his buddy.

Somebody in a gray jacket yelled out from the office door, "Watch the street! Don' let nobody see you!"

"C'mon, sweetheart, we're goin' on a date," said the one in plaid shirt. He took a step closer, grinning, slipped a switchblade knife from his trouser pocket, and flicked out the blade. "I got a blanket, back in the store room. Let's you an' me get *comfortable.*"

The one in gray was moving closer, too. "Seconds—I called it!"

"Me after you!" the boy in overalls bellowed, as he strode up.

I was already tense; now I heard my heart pound. If two of them could grab both my arms, and hang on, I'd be sunk. But unless they all closed in together, the one with the knife was the biggest threat—and yet, maybe my best chance, too. So I stood still, facing him, waiting—hoping, really, that he'd show off by lunging at me with it, expecting me to leap away, backwards, toward one of the other boys.

And that's just what he did!

But *ju-jitsu* teaches you to anticipate your opponent's moves, and turn them against him. So, as the knife came at me, I already knew what I'd do. I stepped to one side and seized his wrist, raised my right knee, and flung his arm down hard on it. That knocked his elbow right on the funnybone, and sent enough of a shiver through his arm to make him drop the knife. He grunted, clutched his elbow, and spun away.

The two other boys swapped nods, and stepped in.

Suddenly a big engine started up, and sooty exhaust blasted out of a tailpipe. Tires screeching, clutch whirring, thunking into gear, a yellow Packard convertible leaped out from the back of the garage, with Bill at the wheel. As soon as it was in front of me, I jumped onto the running board, swinging my outside arm and foot wide, to knock the boys away.

Bill gunned the engine and spun the tires into the driveway. I ducked down and clutched the spare tire on the fender. Bumping over the sidewalk to the street, we swung hard into a right turn and headed east on 49th—the wrong way against the one-way street. I couldn't worry about oncoming traffic. I had to squeeze my pocketbook against my side, and clutch the tire with both hands.

When I felt I was holding on tight enough to risk looking back, the Dusters' green Buick was roaring out of the driveway, all cylinders firing. It almost caught up to us, but—first its windshield

wipers, and then the sedan itself—began swinging back and forth. It veered from side to side in the narrow street, then jerked to a stop.

We were far enough ahead for Bill to slow down at the corner; I pulled the door open and flung myself safely inside. Then we jumped the red light, turned downtown on Ninth Avenue, took a left under the El, and headed east on 48th.

I craned my head around. "We lost them!"

"D'you know anyplace we can leave the car? We just broke a few laws, including 'Thou shalt not steal.'"

"There's a parking lot in Columbus Circle."

"That'll do." He turned north onto Eighth Avenue. "Look in the glove-box for registration papers. Get in touch with the owner. Tell him, uh…I don't know."

"How about: 'I work for the garage. The building's condemned, and we had to move everybody's car.'" I checked the papers while Bill steered through the Circle and into the parking lot.

The boy at the gate wrote the time on a red claim ticket, tore off half, stuck one piece under the windshield wiper, and gave Bill the stub. We got out and the boy hopped in, crunching the shift-lever hard into reverse and backing the Packard into a tight space under Columbus's statue.

Bill handed me the stub. "Will you be okay?" he asked.

"Yes. Thank you. I'm supposed to meet somebody in the Automat on Seventy-second Street. Come with me—I'll buy you a meal."

"Another time. I'm gonna walk back downtown, and cook my spaghetti."

I tugged my pocketbook open, and gave him a dollar.

"I'll take it. But right now I only need a dime's worth of olive oil."

"Didn't you take some with you? Wasn't that olive oil in the jar?"

"I poured it on the windshield of the Buick, back in the garage.

On a cold day like this, it gets gooey. You can't see through it, and it smears worse if you try your wipers." He grinned. "It's a little trick I pull on street corners sometimes, to get the snobs to let me clean their windshields."

<div align="center">⊟</div>

Did you ever see the cartoon in the movies where Popeye runs off a cliff, keeps on running straight out into thin air, and falls down only when he *looks* down?

I strolled all the way up Columbus Avenue, lazily window-shopping at the milliner's and the florist's, oblivious to the chill in the air. I waved to the old man in the candy store in my building. I climbed the stairs, slid my key into the lock, set my pocketbook down on the little shelf beside the door, and came face to face with my own eyes in the mirror, before everything came to a stop.

I woke up on the floor, pulled myself up by the doorknob, and leaned against the wall. I couldn't keep my teeth from chattering or my skin from sweating. I barely made it to the toilet in time.

I shuffled over to my bed, flopped down flat on my stomach, and fell asleep.

I was on my side, curled up tight, when my eyes opened again. I couldn't even get off the bed right away. I had to take it slow, breathing deliberately, wondering if there was some sound like Amalia's minor third that would keep me calm.

Last night, Nina must have come up behind me from the back stairway, through the paneled door. What had gagged me, cold and wet—and reprised the memory of my appendectomy—was a rag soaked in ether. She'd have *had* ether, of course, to make ink for the forgery. After she'd knocked me out, she carried me downstairs, and locked me in the coal-cellar. But I wondered why—and I almost laughed—why hadn't she killed me?

I still had my wrist watch on: it was almost noon. I didn't care if Erik thought "Mary" had stood him up, but I had to meet Josh at the Automat. My stockings were full of ladders: a total loss. But my

coat-dress had only a small tear in one seam, down the side. The left strap of my brassiere had pulled loose, too, but since I'm not very big on top, I hadn't noticed. I tossed the stockings under the sink, for a scrubbing-pad, and put everything else into my sewing box.

With no time to draw a bath, I wiped myself all over with a wet towel, and rubbed Odorono cream under my arms, before getting into a fresh slip and stockings. The day hadn't warmed up too much, despite the sun, so I dressed in wool, top and bottom: a navy blue sweater-jacket over a cream pleated skirt. Stuffing my hair into a snood—just the kind of net I'd thought was so unflattering on Nina!—I topped it with the black beret I'd brought back from my one and only trip to Paris, almost three years before. People might see it was slightly crushed, but nobody would know I hadn't shampooed.

I was only a little late in getting to the Automat. Josh rose from his chair and took off his hat. He'd brushed his hair, and dressed up for me, in a single-breasted camel-hair jacket over blue slacks, a white shirt, and a red bow tie with white polka-dots. I was impressed. I don't know what I expected him to say, but "I got nickels already" was his big greeting.

On the way over, I'd decided not to tell him, or anybody, what had happened to me. I'd look like a weakling; Josh would pump me for everything I knew, and I had nothing *else* to tell him. I smiled, in lieu of "Hello."

We went over to the service wall. He headed for the casseroles of franks and beans that were steaming behind their little windows, dropped two nickels into the slot alongside one of them, twisted the knob, and pulled the window open. He set the casserole on the shelf below the windows, and edged the hot dish on, gingerly, as he moved down the row toward the coffee spout.

I took advantage of his picking up the tab and went for my favorite meal in the place: a three-nickel casserole of macaroni and

cheese and a two-nickel slice of lemon meringue pie. We each pumped a nickel's worth of coffee into the Automat's heavy white cups, and smiled, discovering that we both drink it black with one sugar.

Another couple of quiet seconds went by, while we sipped our coffees. Then I asked, "Did you find me any booksellers that—"

"Yeah. Two. And I phoned them to check that they still carry the stuff you wanted. I told them the *Mirror*'s starting to run book-reviews—" he chuckled "—as if our readers bought serious books!" He pulled out his note pad and thumbed it open. "Fogarty and Cornelius is one; Slomer's is the other. Here are the addresses." He tore out the page for me. "They're about a block apart."

"I appreciate it, Josh. Thank you."

"Can I ask you something now?"

I nodded, but I tensed up, too, hoping he wasn't going to ask me out again.

"Do you know any of the other teachers and staff over at Meyers?"

I exhaled. "A few."

"Another one's dead."

"No!" Tightening up inside again, I set my cup down.

"A woman fell down the stairs and broke her neck."

"On the stoop?"

"Inside."

I rubbed a finger around the rim of my cup. "What was her name?"

"Stand by." He flipped the pages over. "Nina Marie Rovere. Age forty-one. She was the librarian. Did you know her?"

With the stretto *begins the finale of the fugue. Here is a return to the original key; the subject is worked up to a climax, and the conclusion follows.*

—Parkhurst & DeBekker,
The Encyclopedia of Music and Musicians

8. Original Keys

"Hey! Watch it!"

That was the man who'd been walking behind me when I jerked back in my chair, knocking the pie out of his hand. I gave him two nickels to buy another slice.

Josh smiled sympathetically. "I'm sorry. I didn't know she was a friend."

I laughed. "Some friend!"

"You didn't like her?"

"I don't...I mean, I didn't know her, really."

"What was she like?"

"I only met her this week. She—oh, excuse me." One of the Automat's crew had arrived with a mop and a dustpan; I stood up, so he could scoop away the splattered pie and broken china. "She was very efficient," I hedged.

"Did she have any close friends?"

"She was kind of cool—chilly, almost. But I'm sure there were

people on the faculty who admired her. You should ask Dean Meyers. What happened to her? Do you know?"

"A couple of students found her this morning at—" he checked his notes "—eight forty-five, on a landing, just down the stairs from the library. There was a picture in a frame underneath her: an old photograph of the street corner near the school. It must've hung over the landing, because there was a hole where the nail was pulled out."

"I know the picture."

"The cops figure she missed the first step and grabbed at it— knocked it off the wall, on her way down."

"Was there a ladder, or a hammer? Could she have been hanging it back up?"

"What do you mean *back* up?"

"It wasn't hanging there last night."

"You were there last night?"

"After I left you in Sully's bar." I waited for him to say something sarcastic, but he must have realized I wouldn't appreciate it, and kept his mouth shut. "The picture was standing up against a wall, maybe eight or ten feet away. The nail was already pulled out, but I don't know when."

"Okay." He sipped his coffee. "She went to *re*-hang it. She was carrying it down the stairs and missed her step."

"I don't think so. She'd been working there for years. A person who's been in the same place for a long time doesn't just forget, one day, where the top step is."

He nodded and leaned back, lifting the front legs of the Automat's chair off the floor. Finally he said, "Was she...? You know—" He twirled a finger around beside his temple.

"If you'd asked me yesterday, I'd have said, 'Definitely not.' She was efficient and intelligent. She was also the suspicious type. And she had what you might call an 'angry streak,' though where it came from, I don't know. She took out her anger on m—on Miss

Chen—and on anybody who stood up for her. At work, though, she was all business, and kind of a stuffed-shirt."

"Can I use that, in my story?"

I grinned. "Don't let Dingall say the shirt came from a Chinese laundry!"

He rocked forward. The chair's legs hit the floor, but he continued on until his face was right up in front of mine. "You want to make a federal case out of it? I said I was sorry. It's just the way Dingall is, and the brass at the paper *like* stuff like that. *I* don't like it, but I can't complain. There's a hundred guys waitin' on the street to grab my job, if they fire me."

It was my turn to apologize, and I did.

"When did you leave the school last night?"

"Between midnight and one." (Which was true, in a way.) "What time did this happen?"

"This morning, apparently only a little before she was found—seven o'clock, eight o'clock, maybe. I tagged along with the cops from the Sixteenth. We got there just after nine."

"There are Saturday classes, so Nina may have just opened the library. Seven-thirty's when she usually comes to work."

"Maybe the stairwell was dark. Is there a skylight?"

I thought for a moment. "In the dean's office. But not over the stairs."

"Any of the bulbs burned out?"

"I don't remember."

"Could she see all right? Did she wear glasses?"

I pictured her, sitting at her desk. "Not for reading. I don't know if she needed them for distance. Who was it that found her?"

"Stand by." He thumbed back to that page. "Phillip Guyander Carson, Junior, from Boston: third-year violin student. He phoned the cops. Also Susanah Bethany Pierce, second-year viola student. He lives there; she doesn't." Josh leaned in close; his blue eyes were bright. "D'you think one of *them* pushed her? Junior, maybe?"

I clutched my pocketbook to my chest. Suppose it *wasn't* Nina who'd knocked me out? Maybe that black hair was snagged in my watch some time before. I'd left Guy in his room, but he might not have stayed there. Joe lived right upstairs. Susie was studying in the next building. Rebecca had ridden away, but by the time I'd had my beer with Josh and gone back to the library, she could have returned. Maybe Hermione didn't go up to Small's, in Harlem, either. Any one of them could have forged the manuscript, and knocked me out with the ether that was used to make the ink. And it didn't have to be *any* of them! If Bill and I could get out through that garage, then one of the Dusters could have come *in*, from the opposite direction, and—

"Miss Green!" Josh was tapping me on the shoulder. "You're lost in your thoughts."

"Could one of the Dusters have pushed her?"

"It's possible, I guess. Look, Katy: I hope you don't mind my saying this, but you look like you didn't get any sleep last night. It's Saturday. Why don't you go home and rest?"

"I can't. Not yet."

He shrugged, and stood up. "My deadline for the Sunday edition's later tonight than it is on weekdays. If there's anything more you can tell me about Miss Rovere, call me before ten-thirty."

"If I do, you can't use my name."

"What, again? Come on, Katy."

"Don't use my name, or I won't call you."

He gave it a whole-note rest. "All right."

<div align="center">〓</div>

They sell everything on Canal Street, from East and West—and I don't mean only the two sides of Manhattan: I mean the whole world. Saturday afternoons, everybody in Chinatown is out there buying clothes, fish, vegetables, sponges, brooms, teacups....

"Firecracker, Missy?" A small boy had stepped up beside me. "Firecracker, ten cent."

When I didn't respond, another boy pushed the first one away and said, "Firecracker, *two* fo' dime!" and opened his palm to show me two red-paper packets. Maybe I'm a sucker for a bargain; maybe he looked like he needed the money more than his competitor did; maybe I thought firecrackers would come in handy if I had to distract any Dusters again.… I was hesitating, so he said "Real loud!"

I fished a dime out of my pocketbook and made the trade. Turning down Mott Street and crossing over to Pell, I saw—as I expected—a young man in a dark suit, lounging against the tenement door. He stepped aside to let me in.

Amalia didn't throw her arms around me when I showed up at her room, but she didn't dangle a timid hand either. She clasped my hand firmly between both of hers, and said, "My parents will want to thank you, too. We're going out for lunch when they come back from Beechum's. Please join us."

"Were they up at the auction, selling…?" I pointed at the wrapped-up paintings.

"Yes. If we have to go before the immigration authority, they'll have to sell another, because we'll need a lawyer who's a specialist. We wouldn't have to, though, if the manuscript turned up. Has it?"

I shook my head. "There weren't any letters in your mailbox, either. Here are your keys."

"Hold on to them, would you? I don't feel like going back there until everything is straightened out. Would you like tea?"

"And Nina Rovere's dead."

"What?" She spun around so quickly that she had to take a step to catch her balance, and grab the table for support.

"She fell down the stairs this morning. Broke her neck."

Amalia stiffened. "When?" Her tiny, helpless voice was back.

"Before eight."

"You better go."

"Why?"

"I'm in trouble again."

"How could you be?"

"I was *there* today! I went straight to the school, first thing this morning, as soon as they let me out."

"When was that?"

"Six-thirty, I think. I took a taxi, and rang the bell. A student let me in. I wanted Dean Meyers to tell me, himself, that he thought I was a thief. But he wouldn't even open his door to me. I went down and found Nina in the library. I yelled at *her*, instead. She yelled right back at me—said if I went back to China, it'd be good riddance—"

We heard heavy shoes outside the door, scraping their way up the steps. The knock was loud, but barely a second later the door banged open, and two uniformed cops—a man and a woman—stood there.

"We got a warrant," the man said gruffly.

I recognized his red face. It was Frank Bond—the one Josh didn't trust. And the policewoman with him was Tilda Kowalczyk, who didn't trust Frank, either. But they were teamed up, today, against Amalia. Tilda began poking through the paintings against the wall, and sticking her fingers into the boxes of tea and jars of cold food that were piled on the little table.

Frank glared at me. "What's your name?"

I told him.

"You live here?"

"No."

"What're you doin' here?"

"Visiting my friend. We play music together."

"I didn't *hear* any music, comin' up. Where're your instruments?"

"Got it!" cried Tilda, holding up a music folder. "Where'd you get this?" she asked Amalia.

"From school."

"Yep!" Tilda waved it toward Frank. "It says 'Meyers Conservatory' on the top."

"That's the music you stole from the school," Frank declared.

"No it isn't. It's a new edition of the Mozart F-Major sonata. I checked it out of the library two weeks ago." She actually made coy eyes at Frank and added, "I didn't think it was overdue."

"What's the name on the sheet music?" he called to Tilda.

She snapped it open. "Moze-art."

"That's not the one we're lookin' for." Frank took a penknife from his pocket, slit the top edge of the brown paper wraps, and peered in at the paintings.

Amalia declared, "It's not there!"

"Nothin' but pictures," he called up to Tilda, and looked around the room. "Got no place to hang 'em, though."

She continued to glower at Amalia. "You went over to school this morning, huh?"

"Yes."

"You said some nasty things to a Miss Nina Marie Rovere."

"She did the same."

"Did you hate her enough to break her neck?"

"Excuse me—that warrant," I called over. "Are you arresting Miss Chen for murder?"

Tilda was still looking at Amalia. "*Search* warrant. Seems you walked outa the liberry today with *more* sheet music, by some other wop. What's his name, Frank?"

He checked the warrant in his pocket. "Tar-teeny."

"The Tartini's in the school library!" Amalia said. "I saw it just the other day."

"Well, the dean an' that Winkle-heimer guy…they're swearin' it's gone."

"She didn't take anything," I said, louder than I'd expected to.

"Are you still here?" Frank yelled.

"I'm leaving."

But Tilda blocked my way and said, "Open your bag." I let her prowl through it. "Hey! These're illegal in the city. You know that?"

"It's only illegal to set them off." (Which was true.)

"Has she got firecrackers?" Frank called over. "Damn! My boy loves those things."

"It must be difficult for a policeman to buy them," I said, sympathetically. "Why don't you take them and give them to your son?"

"Hey, thanks, I will." He plucked the red packs out of Tilda's fingers, and looked back at her, saying, " 's a present! You heard her."

Tilda squinted, contemplating the...well, it *was* a shakedown, wasn't it? But very small potatoes. She looked around and said, "I don' see any more music in this junk."

"I told you it's not here," Amalia insisted. Her eyes were clear. She wasn't going to shrivel up, frightened, as she might have before she'd been jailed. Now she was keen, and taut.

Tilda and Frank kept probing, but there weren't many hiding places in the room to poke into. After another round of posturing and bluster, they left, clomping noisily down the stairs. I helped Amalia straighten out the mess they'd made.

"Thanks, Katy."

"Go back to school today and get your paycheck. Joe Meyers owes you *that*, anyway."

⊨

While I waited for an uptown train, I played a little game in my mind that was like the one I'd played years ago, when I was trying to figure out which boy in my high school was going to invite me to a big dance. I'd give each of them a score on a scale from 1 to 5, with 5 being the certainty that we'd be married on graduation day, and 1 being so remote a chance that the moon would have to crash into the earth and kill every other girl on the planet before he'd ask me out. It was a good exercise, except that none of the boys I

ranked actually invited me. I went to the dance alone, and sat in with the band. Now, though, I was ranking potential killers.

I would have given Nina a score of 5, but...

Joe? I started to give him a 1, because I'd ruled him out before. But the more I thought about it, he could have gotten close enough to Nina to push her. Maybe they'd had an argument about something. So he deserved a 3. But it could have been an accident. Back to 1. Suppose he killed his sister, too, and Nina found out? That bounced him up to 4. But why would he kill Iris, if he didn't want to be dean? Joe's score didn't add up to more than a 2.

Rebecca? She was too unworldly and slow-thinking to forge an antique manuscript and pull the switcheroo. From the way she'd reacted to my "goddamn," she was also too devout to commit *any* sins—well, maybe only some involving her fiancé. She got a 1— a solid 1. But then I thought: she's mapped out her future with a guy she can't bring home to her parents. A chunk of money from selling an old manuscript would definitely set them up. That was grounds for giving her a 3, though how she might actually find a buyer and make the sale, I couldn't imagine. I did hear her argue with Nina, but was that enough to provoke a killing? And Iris had encouraged her—*championed* her. I split the difference and gave Rebecca a 2. Still, if she really needed money badly, the 2 could edge up toward 3.

Guy? Another 3, but for the opposite reason. He was ambitious—that alone was worth a 3, maybe even 4. And clever enough to do it all: forgery, theft...maybe even murder. But he was pretty sure to get what he wanted out of life, anyway—at least, if war didn't break out soon. What motive could he have for risking it all? I had to bring him down to 2. Of course, he was *capable* of killing Nina—and Iris, too. So he got a 3, but a 3 that was leaning back toward 2.

Susie? A steady hand implied a cool head. She definitely had the brains, so she started at 3. On the other hand, she had a pleasant

disposition, and came from a rich family. What could she gain from killing *anybody*? It was a 2 for Susie.

But Susie had a big brother. What Ed had implied, the other day, was that he'd made a deal with the construction unions for labor peace on his job sites: that there'd be no white hotheads coming around, starting a race riot. So he might know people who could... well, who didn't *mind* doing dirty work. And an architect has to be a draughtsman, too—he could apply that skill to forgery. He was closing in on a rating of 4, until I realized he had no reason to kill Nina. And as for killing Iris—she'd hired him to fix the buildings: he needed her *alive*, especially if he expected to get paid! I had to give him a 2.

Hermione? Beneath that elderly breast beat the heart of a jitterbug—and maybe a hidden reserve of energy to match. She was intelligent enough, I supposed, to plan a forgery and a murder; but I couldn't imagine her carrying them out. I wanted to give her a 1, but she knew too much about what was going on inside the school for me to mark her automatically as innocent. And she had fingered Nina as the source of the magazine. Why? I played it safe and gave her a 2.

Theo? He didn't need money. Oh, sure, he could use it, but he wasn't in trouble without it. Joe wasn't likely to foreclose on the luncheonette's mortgage. And Theo had nothing to gain from forgery or muder. If anybody rated a 1 it was Theo.

Roger Winkler? He had artistic talent that he could have applied to forgery. And he didn't have to have a grudge against Amalia: he could let blame fall on anybody at the school who'd checked the manuscript out of the library. But would he—*could* he—have killed Iris Meyers? He loved her, or so it seemed, from his painting her portrait, and the engagement ring.... I'd have to re-jigger his ranking if I learned anything to the contrary, but for now, I couldn't give him any score higher than 3.

Erik? *There* was a likely killer! He practically admitted to pres-

suring Joe and Theo to sell. He was even going after the piano showroom that Ed and Susie wanted to buy. Erik had been in the restaurant Wednesday, so he could have given the Dusters a signal to start shooting. He could afford to pay them to rob the place the next day, and maybe to do other things, like push Nina down the stairs. But could he have come in, late one night, and killed Iris? He might just have a mean streak. After I didn't show up this morning, he could have walked around the corner to the Dusters' garage, and promised them a big payoff "after the deal is done." Erik rated a 4, all right. But what about the forgery? Did he have the know-how? And as for paying the Dusters to commit murder, the more I thought about it, the less sense it made. Gang killings make people uncomfortable about a neighborhood; and if *respectable* people get murdered there, it can drive the price of property down! No real-estate agent wants *that*. So, I had to drive Erik's score down, too, from 4 to 3.

And thinking about what happened this morning, I decided it wasn't Erik in the garage. He favored tweedy Brooks Brothers suits. The man in the garage wore houndstooth slacks, and brown shoes with green socks. It's only hicks or roughnecks who go around New York dressed like *that*.

Roughnecks...now, there was an intriguing thought. It might have been Frank the cop in the garage: off duty, and out of uniform. He was certainly a thief: he stole ten cents' worth of firecrackers, didn't he? Maybe he'd done worse. If I could link Frank to Iris, his score would reach 4, at least. But there wasn't any obvious connection there, and none to Nina either—unless Frank were the ex-boyfriend who'd left her! No—probably not. Between feeble-minded Frank and supercilious Nina, a love affair was ridiculous. Frank came out with a 2.

That left the Dusters. One of the boys might have been in the Meyers building this morning, to do some kind of mischief. If he'd run into Nina on the stairs, or if she'd caught him vandalizing

something, he might have killed her—although even that could
have been accident. Ditto for Iris, back in January. I wanted to give
the Dusters a 4. A 5 wasn't out of the question. But they were so
very unlikely to have stolen—much less forged—the manuscript
that, try as I might, I couldn't give the gang more than a 3.

But there could be another gang involved. Suppose that neigh-
borhood "Society" on Pell Street were a tong. Maybe those boys in
dark suits were doing more than just standing guard in front
of the building. Maybe the Chens were giving me a song-and-
dance about being in debt to their landlord for protection. Maybe
Howard Chen was a big wheel in a tong himself! He could have
blamed Nina for the theft, and sent one of his thugs to make trou-
ble for her—trouble that went too far. Maybe we were on the verge
of a gang war between Hell's Kitchen and Chinatown that
could...no! Gangs don't get into fights across town over stolen
manuscripts. The Chens—and by extension, the Society—got a 2.

So where had my scoring game led me? Nowhere. I had plenty
of 2's and 3's. But no 4's or 5's. Anybody could have committed one
crime, but nobody could have done them all. Or could they?

＝

I rode the train up to 135th Street, got out, and walked west. I
crossed The Stroll—that's what they call Seventh Avenue in Har-
lem, where Small's and the other hot jazz clubs are—over to Eighth
Avenue, and then up Eighth for a couple of blocks to 139th Street.

The townhouse was one of the widest on the block, and faced
with white limestone. Almost every window had a green awning on
top and a flower box underneath, full of lively pink geraniums that
would have just been planted after the winter. A bronze plaque be-
side the doorbell said R. E. PIERCE, M.D. I expected families on
Strivers' Row to have live-in help to cook and clean, gardeners for
their yards; maybe even chauffeurs. The Pierces had a maid in uni-
form who answered the bell. When I told her I'd come to see Miss
Pierce, she picked up a house-phone in the hall and announced me.

Susie bounded down the stairs wearing brown man-tailored pants and a yellow cashmere sweater, and calling, "Have you heard? Miss Rovere fell and broke her neck this morning."

I nodded.

"How about some coffee, Annie?" she said to the maid. Then she ushered me into the front parlor with her arm around my waist, motioned me toward a wing chair, and sprawled on a damask sofa, stretching one leg up and over the backrest. "It was I who found her—well, Mr. Carson and I."

"You got to school awfully early."

"I slept over, on the couch in the town lounge. I've done it before. I hate the subway, and Ed never picked me up last night, after all. He phoned me at school, to say he had a big date, but he won't tell me her name. I think it's somebody he met in church. Anyhow, he did pick me up this morning. But that was afterward, after the police had gone."

"What was it like, when you found Miss Rovere?"

"Guy saw her first. I was right behind him. We were on our way to the library. I, uh...I lost my stomach in the bathroom. I'm all right now, though. I took a pill."

I want to believe there are pills in this world that can make someone relax after finding a dead body, but I've never heard of any. Maybe they were pills Susie had taken before. Maybe she took dope, too—and if she did, she'd need money for it, that she couldn't get any other way except... Well, maybe she was just a cold fish, and nothing ever got under her skin. Whatever the reason, it helped to explain why there was no passion in her viola playing. (She was staring at me. I had to say something.) "You look okay, now."

"My folks are away, or I'd introduce you. They're at Beechum's, for an auction. Do you know the French Impressionists?"

"I don't know much about art." Before she could tell me about the pictures on the walls, I said, "I saw the plaque by your door—

my father was a doctor, too; what kind of medicine does yours practice?"

"Pop teaches history at City College. *Mama*'s the doctor. She was the first Negro woman in New York to be certified as a psychiatrist—d'you know what that is?"

"It's a doctor who's also a psycho-analyst."

"Her office is downstairs. That's where I got the pills for—oh, thank you, Annie."

The maid had brought coffee in one of those French urns, where you push the plunger and it squeezes the grounds down to the bottom. Susie swung her leg off the sofa back and sat up to pour, passing me a gold-rimmed cup and saucer, and silver tongs for the sugar cubes.

"This is strong java!"

"I buy the same Viennese coffee that Theo Levant serves."

"Oh."

"The beans are roasted really dark, so they're bitter from all that caffeine. But I sure like the extra kick. Don't you?"

"It comes in handy."

It still tasted like mud. I added a second cube. We bantered a while about coffee, then about food, until we segued into music.

"I just loved playing that quartet," she said. "Paganini always gave the viola good parts. Did you know he owned two Stradivarius violas? And—this is so typical of his swelled head—he commissioned a viola concerto from Hector Berlioz, but when it was delivered, Paganini said it didn't have enough solos, so he never performed it."

"He paid Berlioz for it, though."

"That's right. He's supposed to have tried writing his *own* viola concerto, too, but nobody's ever found it among his papers. I wonder if there's a manuscript around Meyers, somewhere."

(Thank you, that's just what I need!) "That quartet you played, in B major—*that's* a rarity!"

"One of a kind."

"Who do you think replaced it with the forgery?"

"Is that why you're here? Did you think it was me? Well, it wasn't. It was Mr. Carson."

"How do you know that?"

"On Thursday, after we'd reprised the quartet, he was the last to leave. He'd have been able to slip the manuscript into the magazine while we were packing up. Ask Miss Tharp—she might have seen him do it."

"Do you think it might have been *she*?"

"Stealing is a sin—or haven't you read the 'Good Book'? *Everything* is a sin. She'll tell you all about it, when you ask if she steals."

"I don't think I'd ask, point-blank."

"There is one sin she *does* commit."

"Really?"

"And it's one hell of a sin, if you ask me. Have you heard her sing? After she's had a couple of drinks, she squawks out those mountain hymns like—"

"She *drinks*? She told me she doesn't."

"Yeah, I forgot. Demon Rum. Well, I *wish* she were drunk. I'd hate to think that's really her, *sober*!"

"I'm impressed by her playing, though. Aren't you?"

"She's okay."

"Considering where she's from, I'm surprised at how liberal-minded she is. She had no qualms about playing with...you."

"Oh, she's no bigot! I give her a gold star for that. But I wouldn't call her 'liberal-minded.' *Dancing*, too, is a sin."

I took a sip. "Do you think it's possible that Miss Rovere could have taken the manuscript?"

"You know, I was wondering—when you asked if it was I: How is this going to fit into your profile of Miss Chen, for *The Etude*?"

I took a another sip, to think. "Her getting arrested makes the story more newsworthy. And now, with Miss Rovere—"

"Write anything you want to about *her*, Miss Green. I'm sorry to say this, now that she's dead, but I really didn't like her."

"When you found her, what did you see?"

"If I tell you, would you do something for me in return?"

"I guess so."

"I'm not angling for a glowing review, for playing in the quartet. But I would like it if you would work my recital hall project into your article. Just *mention* it, somewhere. I need some clippings—anything at all—to help get it off the ground. Would you do that?"

I shrugged. "Sure. Now tell me about Miss Rovere."

"She was on the landing, between the library and the parlor floor."

"Where was the photograph—the one of the old neighborhood corner. Was it hanging on the wall? Was it near her? Underneath her?"

"Underneath. We thought she'd been knocked out. Mr. Carson rolled her over. Her eyes were wide open." Susie swallowed, closed her eyes, waited for a few seconds, then she said, "That's when I ran to the bathroom."

"You said your brother came and got you at school. Where was he before that?"

"Huh? Are you trying to—"

"No."

"Yes, you are. Whenever something terrible happens, we're the first to catch blame—"

"I didn't say that, Susie."

She took a breath, and nodded. "I'm sorry. It's a touchy subject in this house."

"It is?"

"Oh, I might as well tell you. Ed used to be a real scrapper, and he got in trouble once, a few years ago. Got on probation for it. There was a fight at work, on a construction site, and…he hurt a man pretty badly."

"A white man?"

She nodded. "The guy had said something about not liking to work for a…well, you know what those people call us."

"Why did that set Ed off?"

"Wouldn't it set *you* off?"

"Not if I hung around with construction men all the time. They're tough characters."

"Well, Ed doesn't let it bother him *now*," she said. "He just quotes from the Scriptures, when he needs to remind himself to cool down. Oh, and is Mama in a snit! He's not coming with us to *our* church, anymore. We go to Reverend Powell's, but—"

"Where?"

"The Abyssinian Baptist, that's on a Hundred-and-thirty-eighth Street. But where Ed's been going, it's called the Assembly of God. They're all over the country, especially in small towns. But they *are* integrated—they say black and white should pray *together*, which I think has been good for Ed. Mama thinks so, too, but what she says out loud is—" she lowered her pitch, to mimic her mother's voice, I supposed "—'Better he's going to *some* church, than none.'"

"Where's Ed now?"

"Up in his room. Want me to call him?"

"Would you? Thanks."

She didn't yell up the stairs, like we used to do in my family. She went to the hall, picked up the house-phone, and pressed a button to buzz him.

When Ed came down the stairs, he was wearing a forest green gabardine suit, a pink shirt with a white collar, a red silk tie, and a matching pocket-square. It was a combination that would turn heads at the Astor Roof, but go unremarked at the Savoy Ballroom.

He saw me staring, and stared back for a moment. Then he grinned, and explained: "There's a club up on The Stroll, called Small's Paradise. They want me to expand their backstage. I'm

going over today, to start making estimates." He cleared his throat, made a mock-pirouette, and with a theatrically jazzy accent, he said: "How 'bout you, Miz Green? You figure dose cats gonna *dig* me up dere 'long de Stroll?"

I smiled and played along. "They're gonna dig you *solid*!"

Susie said, "Hang on a second," ducked into a coat-closet, and reappeared with a small Kodak camera, unfolding the bellows. "Stand still." When she'd snapped the picture, she said, "I'm sending this to the Cornell *Alumni News*."

I chuckled.

"Don't laugh!" Ed chided me. "They told us, in architecture school: 'Wear what your clients wear.' And 'Dress to impress the people you're doing business with.'"

I looked at my watch. "Ooh, I've got to go."

"Where to? Can I give you a lift?"

"I have to see Mrs. Wellfleet; she's downtown, in Murray Hill. It's in the other direction from Small's."

"I've got almost an hour. Let me drive you there."

"Are you sure you don't mind?"

He looked at Susie, then back at me. "Consider it a trade. You'll give my sister's project some ink in *The Etude*, won't you?"

"Sure. Thanks."

Susie waved good-bye from the stoop, as Ed and I walked down the block. He stopped beside his blue coupé and opened the door for me. But before I could sit down, he said, "Just a second," grappled a wad of cut-up newspapers off the floor, dusted the front seat with them, and tossed them into the back. "You don't know how dirty construction sites can get."

I gave him Hermione's address, and when we turned south on Second Avenue, I said, "Tell me about Susie's recital hall project."

"It'll be my first chance to use a new kind of reinforced concrete."

"No. I meant: Why do you think people will go to Hell's Kitchen for longhair music?"

"Because Hell's Kitchen itself is changing. It's going to be cleaned up, eventually. That little recital hall is just the beginning."

"Of what?"

"Of something like Times Square, but more cultured. Remember, a couple of years ago, the Metropolitan Opera was supposed to move into Radio City?"

"Sure. But with the Depression on, they couldn't afford to build a new opera house."

"Well, the rumor is: They're still looking to move uptown. And we—Susie and I—we think there could be an opportunity there for us, if we can pick up some property before the prices shoot up. I've got some ideas for that block, even some preliminary designs."

"For a new opera house?"

"For a whole *group* of buildings around a commons, like a college quad. Where the opera moves in, the Philharmonic is sure to follow. You could have ballets, plays, revues, recitals…and each entertainment would have its own home, purpose-built to showcase it."

"Like Wagner's *festspielhaus*, at Bayreuth?"

"That's where I got the idea! But imagine it on a larger scale: a whole campus, with a public square in the middle, with fountains and sculptures, like an Italian *piazza*."

"In Hell's Kitchen?"

"The cultural center of New York is always growing. But it can't move south or east—anything closer to Penn Station or Grand Central, the land is too expensive. And it can't go north without running into Central Park. It has to move west, which means Hell's Kitchen. And we want to be in on the action."

"What if the Met says no?"

He shrugged. "Then I'll build new apartment houses—tall ones."

"Have you approached the property owners?"

"Sure."

"By yourself?"

He grinned. "No. Through a real-estate agent."

"Would that be Erik DeReuter?"

He waited a long moment before saying, "People in Hell's Kitchen might not sell their homes to a…stranger. It makes sense to have a…real-estate professional working for me. Call it: rendering unto Caesar. And—hey, we're here.'"

We'd reached 35th Street. He turned the corner, checked the numbers, and stopped in front of Hermione's building. We shook hands, but before I could let myself out, Ed hopped from his door, trotted around, and opened mine for me.

I smiled at him. I always smile at gentlemen; though, at that moment, I was also grinning at his get-up. Anyhow, he smiled back. He'd make good wherever he went, uptown or downtown. But I had to wonder: How comfortable is it, keeping your feet in two worlds? Where was home? With the patrons of the Met, or the hep-cats on The Stroll?

<center>⊨</center>

East 35th was a quiet street, with a pale green canopy of sycamores whose spring buds were just emerging. Originally, Hermione's building was a townhouse, but it had been cut up into apartments: I could tell by the number of mailboxes in the vestibule.

It wasn't an easy climb up the stairs. My body was still stiff from being dumped in that horrible coal-cellar, and my hands were balky from not having practiced my violin for two days. Kids—and amateurs—complain about the hours they have to practice. But professionals wouldn't trade that time for anything. What you get from practicing, I think, is like what a yogi gets from standing on his head: a sense of purpose, a commitment to an ideal. A girl in a band once told me she liked running scales better than making love. I wouldn't go *that* far. But if I can practice for an hour or two at a stretch, I practically fall into a trance, and don't even notice the El trains outside my window.

I also needed to practice my sax, to get ready for the Copacabana that night. Panchito was one of those bandleaders who put the females in the front row—on display, really. But he deserved the best music I could give him. Did I have enough time today? I checked my watch. It was past three o'clock already. If Madeline showed up at Meyers at six, and I wasn't there to head her off, she'd spill the beans about who I was. And that would squelch any chance I'd have of helping Amalia.

But I wanted to practice, so much! It'd be easy to do: just go home, put on a cotton shift, tune my violin, rosin my bow, flex my arms for a few minutes, and run scales. Then I could get out the sax, trim up a couple of fresh reeds, limber my fingers…and forget my troubles. The manuscript? Must have slipped behind a radiator. Nina? Lost her way in the dark. Iris? A book fell, and hit her on the head. And hello everybody, my name's Shirley Temple; what's *yours*?

"Good afternoon, Miss Green."

I blinked.

Hermione had opened her door, holding a highball glass in her other hand. "Do you know that Miss Rovere is dead?"

"Yes. I heard. I'm sorry."

Raising her glass, she said, " 'Farewell thou child, rest in soft peace,' " and tacked on, "Ben Jonson" when I squinted. "Come in. Would you like a drink?"

She didn't mean lemonade. "It's too early for me, but I'd take soda pop."

"As you may have surmised, I'm what they call a 'night owl.' "

Her tiny kitchenette was right beside the front door. She opened the ice box, handed me a Coke, and I followed her down the hall to the living room. Native drums with African and Polynesian designs hung from two walls, and on a display table there were more rhythm instruments, made of coconut shells and blocks of exotic wood.

"Can you practice here, without being evicted?"

She eased herself into an overstuffed chair and waved me onto a settee covered with floral chintz. "The drums I actually play are at school, where there are no curfews for musicians."

A huge General Electric radio-phonograph, in a polished wooden console, stood opposite the sofa with a stepladder beside it, so she could reach the records—hundreds of records—that filled a wall of shelves all the way up to the ceiling. Even more were stacked, ten-deep, on a side table.

"I bet you have more discs than Theo Levant does."

"We've compared our lists. I have more *in toto*, but of course, he specializes in opera. My tastes are more eclectic. Would you like to hear the band I saw last night at Small's? It's Louis Jordan and his Timpani Five, though Walter Martin—that's the drummer—mostly plays a regular trap-set. *I* think he could cut Krupa." Springing up like a bobbysoxer, and flicking a few strands of soft gray hair out of her hazel eyes, she peered into a teetering stack of discs, pulled one out dexterously, and dropped it onto the turntable.

A small combo laid a swing beat on "Nobody's Sweetheart." I let it play all the way through without opening my mouth, except to say, "Yeah!" after a particularly exciting drum solo.

She sipped her drink. "About Miss Chen…?"

"You said you could help."

She smiled. "Teachers often stick manuscript pages that they've written or copied into whatever is handy, to protect them from the weather. A magazine as large as *The Etude* is as good as a Manila folder, in that way. It certainly didn't occur to me that the Paganini manuscript might be one of the forgeries, until—"

"Forger*ies?*" I almost choked on my soda. *"Plural?"*

"There is a spurious Tartini in the collection, as well."

"What Tartini?"

"Giuseppe Tartini. Italian. Eighteenth century."

"I know that. What piece?"

"His Sonata in G Minor, for violin and piano. The original apparently stolen, and a forgery substituted." (That original must have been what Frank and Tilda had been searching for at Amalia's.) "Mr. Winkler, the appraiser from Beechum's, began looking through the collection yesterday. He found the Tartini copy almost immediately. I'm going to make another gin-and-tonic." She waved her glass. "Can I get you a fresh Coca-Cola?"

I passed her the empty bottle, and she trotted down the hall to the kitchen. When she came back, I said, "Amalia didn't forge the Paganini."

"I agree. There's only one person who stands to gain from substituting forgeries for originals."

"And that would be…?"

"Joseph Meyers, of course. He could have copied and replaced many, perhaps even *all* of the manuscripts in the school's collection by now. With his sister dead, who would know?"

"Why would he do it?"

"For the same reason that the impoverished royal families of Europe do, and have done, for centuries."

"What?"

"They have their priceless works of art copied; then they sell the originals and mount the copies in their great halls."

"You said 'impoverished.' Did you mean that literally?"

Exhaling and closing her eyes, then opening them to stare at me, she said, "I've been teaching at Meyers since 1923, and have kept the books since '36. There's very little in the way of paperwork that hasn't crossed my desk in the past three years. And I have good eyes and ears, besides."

"Okay. How bad off is the school?"

"When this term ends in May, if we haven't had an infusion of capital, we'll have to close down. On any Saturday, there could be a 'pink slip' in our envelopes, as easily as a paycheck. Do you know why I'm telling you this?"

"I hope it's because you feel you can trust me to—"

"I *don't* trust you. Most likely, you're pursuing a sensational story—the more glory for *you*, when it's printed."

"I wasn't going to write about the forgeries!"

"Don't insult me, Miss Green. No reporter would pass up a scandal like this."

"No. Really. I just want to…write about Miss Chen. She's innocent."

"You really believe that?"

"Absolutely. And I'm glad you think so, too. Which reminds me: since you're keeping the books. The school owes her a paycheck, today. Will you—"

"I'll go there, and make sure she gets her money. I wish I could do more for her."

"If Joe Meyers has been forging manuscripts, why did he let Roger Winkler examine them? Why call attention to them? He could have squelched the performance, or substituted some other piece before the broadcast."

"Someone did try to dissuade Miss Chen from playing it."

"Not he?"

"No. It was Miss Rovere." She leaned back in her seat. "On Tuesday, the day before the broadcast, there was a teachers' conference, to go over the plans for the recital. Miss Chen reiterated how keen she was to play the B-Major Paganini, that it was a sort of tribute to Iris Meyers, who had brought her to the school. But Miss Rovere interrupted her, saying it wasn't a good performance piece at all, that it was too complex, that no one in the audience would have heard it before. But it's not un-graspable, you know: it's catchy, and clever."

"It's ice-cream music."

She smiled and lifted her glass. "That's exactly what Miss Chen said!" Then she leaned closer. "It's an old-fashioned expression, going back to my *own* conservatory days. Where did…? Oh. Of

course! You're a musician. And probably *not* a reporter, since you haven't taken any notes. Isn't that right, Miss…what *is* your name?"

"It *is* Katy Green. And I'm not at *The Etude*; I'm in Local 802. Amalia and I have been friends since we were at Rochester together. I'm probably her *only* friend in New York right now. She asked me to help her find the manuscript, when it went missing on Wednesday. And unless I can clear her name, she and her parents will be deported."

There was something about the Tartini sonata that I was trying to remember—something I *should* have remembered, because I have the music for it in one of my books at home, and I know I've played it. There was a connection between the two works—the Paganini quartet and the Tartini sonata—besides both of them being forged—but I couldn't visualize what it was. "So, can I ask you—"

"*May* I."

I raised my eyebrows, but I said, "*May* I ask you about Iris Meyers? Do you think it's possible that she…"

"—was killed? That her death wasn't an accident? That's what I've thought all along. And to your next question, the answer is also: yes. I think that whoever killed her also substituted the forgeries for the originals."

"You're way ahead of me."

"Of course I am, dear. I'm older." She took a sip. "But it's the *sequence* of events that I can't divine. I believe that Iris was examining her manuscript collection that night in January, and spotted the Paganini as a forgery. Perhaps she found even more forgeries, in the cabinet. So she summoned the person whom she believed to be responsible. Iris could be quite brusque—even condescending."

"So I've heard."

"I think the forger took great umbrage at the prospect of being exposed. Unfortunately, the medical examiner established that Iris didn't struggle."

" 'Unfortunately'?"

"I mean—there was no obvious cause of death that would indicate murder. Even if she screamed, no one heard her. And if a tree falls…" She drained her glass and stared out the window at the budding treetops.

"Who do you think she, uh 'summoned'?"

"Well, if it wasn't Joseph Meyers, then it was Miss Rovere, herself."

"What would *she* gain from forgery? I don't think she was supporting champagne tastes."

"It would cast aspersions on Joseph's character."

"Why would she want to do that?"

"They were…they'd been having a love affair. But he ended it recently."

(Well, what do you know! It wasn't a Latin lover who'd jilted her—it was pudgy old *Joe*. I don't know what she saw in him, but I'd never fault a woman for *wanting* to get back at a man who'd ditched her.) "How long had they been…dating?"

She half smiled. "About a year. They had many interests in common. But his affection for her was never ardent. He was always very courteous and considerate, but I never saw him gaze at her with young love in his eyes."

"They're not young, is why."

"You're never too old to flirt! She simply loved him more than he loved her."

"Did they ever…keep company together."

A full smile this time. "Yes. Some mornings, if I arrived a little early, I'd see Miss Rovere coming down the rear staircase from his apartment."

"Well, I'm sorry to hear that Nina was *literally* his 'back-stairs girl.' And that she suffered from unrequited love. But by the time a woman's forty-one, who *hasn't*?"

"Age and experience do not make it easier, when the one you love tells you he's in love with someone else."

"Oh, jeez, I don't believe it! He's in love with Miss *Chen*?"

"No! No!"

"One of the students?"

"Certainly not."

"Well, who's the lucky girl?"

"The 'lucky girl,' if one may put it that way, is Theodore Levant."

⚏

I could have taken the Third Avenue El downtown, but I walked the whole way: I needed time to figure out what to make of a lovers' triangle with Joe Meyers, Nina Rovere, and Theo Levant on the corners.

In show business, most of the man-lovers you meet have to pretend they aren't. So they might ask you out on a date, but it's just to be a "beard," a make-believe girlfriend, to fool other people. You don't want to be disappointed or embarrassed, so you keep your antennae tuned. Maybe Nina couldn't—or wouldn't—read Joe's signals. Maybe she was willing to marry him, even just for show, to stake a claim on the school.

For a moment, I considered the possibility that Hermione had made the whole thing up. The way she carried on, I knew she must have read a lot of mystery books. And she might have a grudge against Joe. Or Theo. Or Nina. Maybe she pushed Nina down those stairs so she could...what? Become librarian herself? Not likely.

But if Hermione had told me the truth, then Nina had a motive for forgery. She could have given Joe an ultimatum: Take me back—marry me, even—or I'll do something terrible.

But embarrassing Joe couldn't make him return to her. My man-lover friends say that, once a fellow acts on his feelings toward other men, he doesn't just turn around and fall for a woman. Maybe Nina felt there was nothing left in life for her, anymore, so she... what? Threw herself down half a flight of stairs? Uh-uh. She'd have

jumped off the roof, or stuck her head in a gas oven. And what did any of this have to do with Iris's sudden death? Was there even a connection?

It was getting harder to think. The sidewalks were crowding up as I got closer to Union Square; I had no room to wave my arms around anymore. (When I'm pondering something tricky, I look like a conductor on a podium.)

More people were walking the same direction I was, and they clotted into a full-size crowd. The Ladies' Garment Workers were holding a rally in Union Square. Music and voices came over a loudspeaker: it was "Sing Me a Song of Social Significance" from *Pins and Needles*. I'd played that revue for three weeks, last year; and hearing it again made me glad, again, that *I'm* in a union. Heaven does *not* protect the working girl from the sons of bitches in this world. Every time the shouting went up, I cheered along with them. But I stayed on the edge of the rally, and kept walking.

The labor crowd merged with the shoppers at S. Klein on the Square. I went down to the bargain basement, elbowed my way through hordes of women, and plunged my hands into the remnant pile.

A dollar and a half later, I was Mary Thornden again. Stuffing my beret in my pocketbook, I had fashioned a turban from a white silk sash, and wrapped myself in a long tan topcoat with a rabbit's-fur collar that was dyed well enough to make someone who wasn't paying attention see mink.

South of Union Square, for five or six blocks down Fourth Avenue, there's a cluster of bookstores, with stalls full of volumes heaped on the sidewalks in front. I went into Slomer's first, where I found a dowdy saleswoman who squinted as she sorted back issues of *The Etude* by publication date.

"Have you any eighteenth- or nineteenth-century scores?" I asked her. "I'm the private secretary to a collector in Syracuse."

"Contemporary or antique?"

"Him? Or the music?" She didn't laugh, so I said, "Antique—and the older the better."

"We don't have much, back beyond a hundred years. Is there a particular composer you have in mind?"

"Paganini." Then I added, "and Tartini, but—"

"Tartini's much too early. Something by Paganini we might have, but only in a modern edition. And probably only anthologies. I don't think we have any individual scores."

"You wouldn't happen to have any autograph works, or manuscripts, would you?"

"Actually, that's my specialty. But we have only a few manuscripts right now. I can show you eight pages from Brahms's Second Symphony: a fragment, unfortunately, and not complete. The price is five hundred and fifty dollars. The oldest piece I have is a complete score for Beethoven's Trio in B flat, Opus eleven. That would be fifteen thousand dollars.

"Oh." She smiled. "I almost forgot. We do have one extraordinary piece in a sealed-bid auction: Arthur Sullivan's two-piano reduction of *The Gondoliers'* overture. It's in his own hand, and there is an accompanying letter, also in his hand, presenting the manuscript to Queen Victoria at a command performance. The Morgan Library has already put in a bid; would you like to submit one, too?"

"Thank you, no. They're very nice people at the Morgan; we're in touch with them, often. But it's more appropriate for their collection than for ours. However, speaking of letters, I'm also sent to inquire about obtaining some Italian writing paper from the early nineteenth century. We're having a reception at the end of June, and we'd like to print up unique invitations. What do you have in stock?"

"Oh, I'm sorry, Miss… Uh…"

"Thornden."

"We had a nice supply, but we sold the entire lot around Christ-

mas time. We'd be happy to locate some more for you. How much would you need?"

(I had no idea.) "When could you have it?"

"Well, there's no getting anything out of Italy now, what with Mussolini, you know. If there's some to be found, it would have to come from a neutral country, like Portugal or Switzerland; and that would take five or six weeks."

"That's too long. Perhaps, if your last customer doesn't need them all, I could make an offer for…thirty sheets. To whom did you sell the paper?"

"I didn't handle the sale. Give me a moment." She went to another desk, removed a ledger, and thumbed to a page. "December twenty-first. Forty sheets to…the Meyers Conservatory of Music, on West Forty-eighth Street."

I suppressed a smile when I said, "Thank you." But I wondered why, if Joe had gone to the trouble of buying the paper, he had done such a poor job with the *forte f*s, and the ink, that Roger Winkler could spot the forgery right away. Hadn't Joe read his own sister's monograph?

The saleswoman cleared her throat. "While I hate to send you to a competitor, I suggest you try Fogarty and Cornelius, in the next block. They also have a manuscript department."

At Fogarty & Cornelius, I was directed to a plump young man in a corduroy jacket. I recognized him from the film of the recital, but pretended not to.

"Do we have a Paganini?" he repeated my question, pulling his horn-rimmed glasses down his nose and leaning back in his chair—it groaned ominously from his weight. "I haven't had a Paganini for years. But it's funny you should ask. There's one coming up for sale very shortly."

(I doubted there could be *another*.) "When do you think it will come on the market?"

"Would your society be interested in acquiring it?"

(On the way over from Slomer's, I'd puffed up Mary Thornden's *résumé*: she was now—as I had told him—the managing director, and daughter of the founder, of the Thornden Society for the Preservation of Musical Heritage.) "We're hoping to mount an exhibition representing violin *virtuosi*."

"Ye-es." His dry voice and the creaky chair made almost the same sound. "I think the Paganini would suit your needs very well. Can you come back on Monday?"

"No. I'm sorry, Mr. Fogarty—"

"I'm Cornelius. Michael Cornelius."

"Oh. Are you *the* Michael Cornelius, the patron of the Meyers Conservatory? You're highly spoken-of there."

"Am I? Well…"

"Unfortunately, I won't be here on Monday. I'm returning to Syracuse, late tomorrow evening."

He pulled a gold watch from his vest pocket. "I could make a telephone call. A Sunday afternoon sale might be possible."

"Who is the seller? You don't have to tell me, specifically," I added. "I won't cut you out of your commission."

"Please don't think me rude, Miss Thornden, but it's *I* who must ask *you* questions. Are you empowered to act on your own, or must you get prior approval from your society?"

I fluffed the "mink" around my throat. "I have full authority."

"So, if something were available on short notice, you could—"

"Yes, I could." I patted my pocketbook.

"And what's your budget? Forgive me, but I'd hate to start the wheels rolling, only to find that we were working at cross-purposes."

"I understand. Our founder—my late father—endowed the society with an annuity. It has enabled us to pay fourteen thousand for Beethoven's B-flat Trio, Opus eleven."

"Recently?"

"*Quite* recently." I glanced toward the door, in the general direction of Slomer's. He took the hint, but I larded even more on. "By

contrast, we spent less than three hundred for an eight-page frag-ment of Brahms's Second Symphony. So for a single page of some-thing by Paganini, I don't think we would go over five hundred. On the other hand, if we should happen to be talking about, oh, say, the complete score of a chamber piece, especially if it's in good con-dition, we could go to twenty or twenty-five thousand."

He grinned. "You're certainly up on current prices. If we do, in fact, do business together, I hope you'll allow me to act as your ex-clusive agent in the future."

"Get me that Paganini, and you could be fixed for life."

"Miss Thornden, as long as you're here, might you be interested in something a little older? Also violin, but from the *eighteenth* century."

"What do you have?"

"An autograph manuscript—the very first draft, I'm sure—of Tartini's G-Minor Sonata."

"Here? May I see it?"

"Certainly." He boosted himself from the chair by rocking back first, and then forward, using the energy of the rebound to stand up. Pulling a drawer from a tall oak filing cabinet, he thumbed through Manila folders, saying, "It's in remarkably good condition for its age, although, of course, there are quite a few flaws. You might want to jot this down. We are selling it *as is*."

I fished through my pocketbook, pulled out the sheet of statio-nery I'd taken from Iris Meyers's desk, tore it in half, and started scratching with a pencil-end. "All right."

"There is a stain on the first page—there's no title page, by the way; Tartini didn't name it until much later. Pages three and five have tears that were repaired with sticky tape, and not expertly, I re-gret to say, but what can one do?"

By then, he'd found the folder, and passed the manuscript to me gingerly. It was discolored in patches, and blotted where notes were crossed out and corrected. If the one in the Meyers library was a

forgery, according to Roger Winkler, then this must be the original. I was starting to "play" the notes in my head, when I heard a sound that wasn't in the score. It was more like the little bell on the radio, on that quiz program "Information, Please," when a contestant gets the right answer.

"The manuscript is on consignment," he went on, leaning over my shoulder, "so I can't take the price down, but…" Staring at the list I'd written, he reached over and picked up the stationery. He sniffed it, held it at arm's length close to the bulb in his desk lamp, squinted at it over his glasses, and concluded, "I would accept some of *this* in trade."

"What?"

"I'll give you ten dollars a sheet, against the price of the manuscript. You treated it so cavalierly, you must have a great quantity. Give me two hundred sheets, and I'll take two thousand dollars off the price. Is that a fair exchange?"

"For this?"

"How much of it do you have?" He held it up to the lamp again. "See the watermark? Italian rag paper; first half of the last century. People ask for this sort of thing all the time. And I really could have used it, last Christmas. I was out of stock. I had to send one of my best customers down the street to—" he grinned "—to *you-know-where*." He sighed. "And now she's gone: she passed away, sitting at her own desk, in January."

The word fugue is derived from the Latin fuga, *meaning flight or chase. Chase is the rarer translation, yet it is by far the better, for a fugue is really a chase and not a flight.*

—Isaac Goldberg,
Music for Everyman

9. Really a Chase

It was quarter to six by the time I got to the conservatory, and Saturday classes were over. I had left "Mary Thornden's" turban and topcoat on the subway, where someone was sure to make further use of them, and put on my beret—checking the angle, and my makeup, in the mirror of a gum machine in the Times Square station.

Upstairs in the dormitory building, I knocked on 3B and waited a moment, grateful that there was no answer, before I twisted the doorknob and slipped inside. Closing the door behind me quietly, I pushed the light button on and looked around.

Two Bibles lay open on Rebecca's dresser. The old one, its bookmark dangling, was opened to the verse—underscored in red ink—that I'd only glimpsed before: *"Be sober, be vigilant,"* it read, *"because your adversary the devil, as a roaring lion, walketh about, seeking whom he may devour."*

I thumbed through her newer Bible, too—the one in which

someone had written "Remember James" on the flyleaf—and turned to the Book of James. Verse 4:7 was also underlined in red ink: *"Resist the devil and he will flee from you."*

Then I went to the photographs on her mirror, just to be sure. Handwritten on the back of the sailor's picture was*: Rebecca— Remember: "Lest Satan should get an advantage of us; for we are not ignorant of his devices." 2 Corinthians 2:11—Your brother, Van.*

Where Rebecca comes from, around Dayton, Tennessee, people believe in the devil, but not in evolution—Dayton is where they held that famous "monkey-trial" fourteen years ago. And I bet some folks there still call a violin "the devil's instrument." Maybe Rebecca didn't believe that was *literally* true, until she read about Paganini. I tried to imagine her shock, to learn that even Goethe, the leading intellectual of his day, believed Paganini had sold his soul to the devil.

And there, in the school library, was a clear example of Paganini's demonic posession: a first edition of *Le Streghe*—"The Witches' Dance"—with *him* on the cover, surrounded by goblins. And the B-Major Quartet, written in his own hand—well, that might as well have been written in *blood*!

But Paganini wasn't the only damned soul in the collection. What about Tartini? That G-Minor Sonata is the one everybody calls "The Devil's Trill." Tartini was alleged to have been inspired by a dream in which he sold his soul in exchange for a command performance by the devil. Talk about sin!

Rebecca would have gone to warn—no, to *challenge*—Iris, to rebuke the devil and the blasphemers. She went to the library, back in January, knowing Iris worked nights at her desk.

And Iris was there. She'd discovered the mistake she'd made in her forgery, and was adding those *forte f*s with ink dissolved in ether. I don't suppose I'll ever know—the police, either—what it was, exactly, that killed her: whether it was a heart attack, or something else; maybe she was overcome, inhaling too much of that

ether. And there must still be some ether left, in that brown, stop-
pered bottle I'd seen in the desk drawer. Either way, Rebecca was
too late. She got there, ready for a confrontation, and only found a
corpse.

But to Rebecca, it must have seemed like a miracle out of the
Bible. There was Iris, with the blasphemer's own pages scattered
about like rose-petals, all around her, struck dead by—what else?—
the hand of God.

Rebecca would have stepped closer, and leaned over, to be
sure...and smelled the ether. She'd have taken up the bottle, and
held it to her nose. Ether's pretty strong stuff: a couple of good
whiffs can knock you out. In Rebecca, who didn't drink liquor, it
must have produced...well, what could she possibly think? *Rap-
ture.* Maybe she even fainted. At the very least, she was disoriented.

And then, someone else came into the library—someone
Rebecca knew. She explained what she believed had happened to
Iris, at God's hand. But the visitor, who had come to steal the
manuscript and sell it, took advantage of her, and played upon her
naïveté, convincing her that—together—they could purge the
school of its blasphemy by taking away the manuscript, and...well,
destroying it, probably.

So Rebecca must have been dumbfounded, last weekend, when
Amalia gave her the manuscript, and possibly even terrified at hav-
ing to touch it, read it, and copy it. After the reception, she must
have seen Amalia put it in her cello case, followed her upstairs, and
swiped it. But why did she—?

Behind me, the latch clicked, and the door opened.

"*You,* again? Get out!" Rebecca demanded. She was wearing a
plain black dress with a round white collar.

The thief came in behind her, carrying the *third* Bible—the one
I'd seen before, on Rebecca's dresser: the one with the brown paste-
board covers. But since I'd seen him last, he'd changed into a sober
black suit with narrow lapels, a plain white shirt, and a dark blue

tie—dressed, of course, to please the person with whom he was doing business.

He struck the book with his fist. "Oh, hell!"

"Don't say that, darlin'. It's blasphemy!"

I was amazed. *"Darling'?"* I said. "Is it *Ed* you're engaged to?"

"I told you, Miss Green, a man's color don't mean nothin' to me, as long as he's a good man."

"Are you sure he's so good? What do you think he was doing in the library, the night you found Iris Meyers dead?"

"He was doin' the Lord's work, same as me." She thrust her face close to mine. "We burned up those ungodly pages in the purifying fire."

"And didn't it make so beautiful a flame," Ed chimed in, inflecting his voice with an almost musical cadence, "going straight to heaven like lightning?"

"Applesauce!" I chided. "Whatever you burned, it wasn't the manuscript. Rebecca, how can you play Paganini's music, if you think he's such a sinner?"

"Oh, but Miss Green, God says to love the sinner, and hate the sin. It's the fruit of his sin that we burned up, in a heavenly, pale blue flame, the color of the sky!"

"The color of *ether*, poured on, to help it burn." I looked around. "Where's that bottle now, anyway?"

"The devil's gone out from the school, now," Ed declared, "and Miss Meyers's soul is—"

"Is that how they preach in the church you're going to, now? You've got a Bible there, from the Assembly of God." I pointed to it, in his hand. "Kind of a research project, going to church there, wasn't it, Ed? Learning the right words to say, so Rebecca would believe that you—"

"Don' pay her no mind, Ed. Miss Green's nothin' but a sneak-thief."

"We know who's the *real* thief, don't we, Ed? *You* took the

manuscript from Iris's desk, that night, and brought it to Michael Cornelius. He'd handled manuscripts from Iris before—like the Tartini. He knows his stuff, and must have spotted it as a forgery right away, and turned it down. So you snuck the forgery back into the library the next day, when the case was open, and went on looking for the original. You've got construction permits: you can go anywhere in all three buildings, you can even open up the walls, if you have to, and if anybody asked, you'd say you were…checking the wiring. You've been stringing Rebecca along, because you thought she might have seen Iris put the real manuscript away, without realizing what it was. So, she might say something that would point to the hiding-place. But now Rebecca's learned a little about forgeries, too. She's read Iris's monograph—she even underlined whole paragraphs in red ink, the way she does in her Bibles. That made Nina mad as hell. Sorry, Rebecca; it's just a figure of speech."

"Are you through?"

"I guess so. But you'll both have to turn yourselves in, at the Sixteenth Precinct."

"We didn't *do* anything."

"Lying's a sin, Ed. Didn't you know?"

Rebecca sighed: "Miss Green, you are the Devil's *own*!"

"Do you—do *either* of you—really believe there's a devil?"

"If there is a God," Ed said, in a reverent tone, "then there is a devil."

"'Course there's a God! 's why there's *got* to be a Devil! Even that Gur-tuh fella said Paganini sold his soul. And you can't put somethin' in a book if it ain't so!"

"Especially the Bible," Ed intoned, again, eyes closed, and head tilted back.

I turned to Rebecca. "Didn't you tell Nina where you saw Iris hide the manuscript?"

"What?" Ed took a step closer to her.

I kept looking at her. "Isn't that why Nina was taking down that old photograph from the stair-landing?"

Ed took another big step, but this time toward *me*.

I glanced at him. "No roughhousing!"

"Oh, yeah? Why not?" He dropped the Bible, stretched out his hands, and leaped at my throat. I stepped aside, just enough to make him miss by an inch, and tripped him with my foot. He extended his arms to break the fall, and sprang back up in a hurry.

From the pocket of his jacket, though, a brown bottle tumbled out. Rebecca snatched it up. I tensed my arms, in case Ed launched another assault.

Surprisingly, though, he edged away, with a shrug and a half smile. Keeping watch on Rebecca—not me—he backed up against the door, reached behind, and turned the knob.

"Where you goin'?" Rebecca called.

" 'To open their eyes and to turn them from darkness to light.' " He pulled the door open.

"Don't you believe it, Rebecca. He's going off to commit another sin: the one called 'Thou shalt not steal.' He's going to grab the manuscript, and get out before the cops arrest him."

"For what?" she demanded.

"For Nina's death."

"I didn't kill her! I was right here in this room. When Rebecca came back from the library..."

I looked at Rebecca."

"Aww, it was an accident. I only *slapped* her. I didn't think she'd break her neck, fallin' down the stairs."

"You two work this out. I've got to go." Ed ducked out the door, and pulled it shut behind him.

Rebecca leaned her back against the door, glaring at me. Then she thumbed the cork out of the ether bottle and took a sniff. " 'I'll fly away, oh glory! I'll fly away, in the mornin'—' " She may have thought she was singing, but the melody wandered badly.

"Now I know why, when people hear you sing, they think you're drunk."

Her eyelids fluttered. "'s not liquor! Drinkin's a sin. I—oh, but hush, now. I feel the presence of God comin' on, right here, comin' on to me!"

"I guess you were high on ether on Wednesday, too, when Amalia and I showed up at your room. You tried to cover the smell by lighting a cigarette, but you set your hair on fire, instead. And Ed couldn't help you, because as soon as he heard us coming, he hid in that closet."

"He wasn't—"

"Yes, he was. He left his Bible on your dresser: the one from the Assembly of God. *This* one, that he didn't bother to pick up off the floor." I touched its pebbly brown cover with my toe. "Come on. Let's go see Dean Meyers. If it really *was* an accident, with Miss Rovere, then it's not murder in th—"

"'What have I to do with thee? Art thou come hither to torment me before the time?'"

"Calm down, Rebecca, I—"

"You're *damned*, Miss Green!" she screamed. "And 'Vengeance is mine; I will *repay*, saith the Lord.'" She brought the ether bottle up to her nostrils, again, and took another deep whiff.

"Rebecca! Stop!"

"'They brought unto him many that were possessed with devils: and he cast out the spirits with his word.'" She reached her other hand into her night stand's drawer, and pulled a hunting knife from its leather sheath. "'Doest thou renounce the Devil and all his works, so that thou will not follow nor be led by them?'"

"By whom? What's that a quote from?" I took a step toward her, my eye on the knife. She held it at arm's length, tracking my face with the point, and grinning from the effects of the fumes. I didn't want to grab her, or the knife, until I was sure I'd have the advantage. When you're hopped up on ether, you don't feel pain.

" 'There met him *two* possessed with devils, comin' out of the tombs.' "

"Are you seeing double now?" I took a step closer.

"The devils besought him, sayin', 'If thou cast us out, suffer us to away into the herd o' swine.' "

"I know all about swine, Rebecca. I play in a lot of bands. Now, give me the knife, please."

I was expecting her to lunge at me with it. But she flung the bottle at my face. It struck my eyebrow. Ether—icy cold—ran down my cheek and soaked into my woolen sweater. The bottle hit the floor and spilled onto the Bible. I blew air out so I wouldn't breathe in any of the ether that had gotten on me, but a little came through, anyway, and I had to hold on to the closet door to steady myself.

Rebecca snatched up a matchbook from her dresser, bent a match over the front with her thumb, and struck it. " 'Fire came down from God out of heaven and devoured them.' "

She thrust the flame toward me. I dodged. Drenched in ether, I'd be burned a lot worse than Theo.

But she forgot to let go of the matchbook before the flame ignited the other matches, all at once, in a white flare and smoky hiss. Numbed by the ether, she stared at the fireball in her hand for three or four seconds, until—with a gasp—she dropped the matchbook. The Bible, damp with ether, too, caught fire right away. She stared at the flame for a few more seconds, then flung open the door and ran out into the hall.

I grabbed the blanket off her bed and beat down the flames until there was only a smoky black ring on the floor, and charred paper around it. People had come out into the hall, by now, saying, "What's happening?" and "I smell smoke," and—to me—"Who're *you?*"

I heard running feet on the floor above, and Guy's voice, saying, "Hey, Rebecca, where're you off to?"

"Go to the Devil!" she screeched at him, and kept running.

I bumped into somebody, mumbled an apology, and took the stairs two at a time. "Did she run into your room?" I yelled to Guy.

"No." He pointed to the last flight of stairs. "She went up on the roof."

I couldn't take the time to explain; if Guy was half as smart as he thought he was, he'd find the dean and tell him what was happening.

Up inside the little shelter that enclosed the top of the stairwell, I was taking each step slowly, one hand on the railing, the other arm cocked to catch her, in case she raced back down toward me. But the sliding bolts were unlatched when I got to the top, and the door opened when I pushed it.

I heard her before I saw her, gravel crunching under her feet, as she ran to the edge of the roof. I stepped out into the breeze, just as she leaped over the low wall and onto the roof of the adjacent class-room building. There, she grabbed the knob of the door to the stairs, but it was latched and wouldn't open.

She spun around, and glared at me as I approached. "Keep away! You're posessed by the Devil."

"Don't you think *you* might be the one who's possessed?"

"I am not!" She ran to the western edge of the roof, stepped up on the parapet wall and started to sway, turning around in place, arms up, as if she were doing an "umbrella-step" in the game of Mother, May I.

"Come on downstairs with me," I said, inching closer.

"'Behold, they ran violently down a steep place into the sea, and perished in the waters.'"

"Don't dive into the water just yet, okay? I'm going to take your hand." I was about a foot away.

She was still turning in circles. "'And devils also came out of them, crying out, and saying, 'Thou art'—'"

"Got you!"

I seized her sleeve and pulled the two of us together, wrapping both my arms around her as fast as I could.

She wriggled almost free. But I lifted my right foot and brought it back in on an angle, as if I were crossing my legs. That caught the back of her knees and forced them to bend. She stopped squirming as she fell, but I lost my balance too. I tried to pull her down close to me, and slide my arms behind hers, to put her in a hammerlock hold. But Rebecca got one arm free and swung back at my ribs with her elbow, hard enough to make me let go. She scrambled a couple of steps. I reached my arms out and tackled her. We rolled around on the roof. The tar was sticky—it clung to my skirt and shoes. And the gravel was sharp, scratching my bare knees and elbows.

"Hey!" somebody yelled. "Lady wrasslers!"

"It's *her* again!" another voice declared.

I looked up. Barely a hundred feet away, on the roof of their garage in the middle of the block, the three Dusters were pointing at us.

"I'll help yuh down off o' the roof, honey," yelled the one in the plaid shirt. "You an' me got a *date*, remember?"

His buddies guffawed. Only three roofs separated us.

Rebecca was still squirming as the Dusters ran toward us, leaping over ventilators and shinnying around chimneys. It distracted me, and gave Rebecca an opening. She wriggled free, sprang off, and ran to the parapet again.

The Dusters were stopped, just one building away, by a gap of four feet or so. Two of them looked around, saw some planks, dragged them over, and began to lay down a crude bridge. The other one pulled a slingshot gun out of his belt, slid a red slice of linoleum into the breech, and took aim.

K-chuff! The shard whizzed past my head, just as one of the bridge-builders put his toe, gingerly, onto the boards that his pal was holding steady. There was no more time. Either the Dusters

would come across and grab us, or they'd shoot at us until we were cut and bleeding.

I made a last grab for Rebecca, stumbled, and bumped into her sideways. By now, intoxication had exhausted her, the ether's effects had worn off, and she was too weak to do more than clutch at my sleeve. Wrapping my arms around her, I leaned both of us up against the parapet wall for support. I'd almost caught my breath, when what was hard against my side turned suddenly soft. The bricks came apart. The parapet collapsed. Nothing was holding us up, and we fell together, over the edge.

<p style="text-align:center">⯗</p>

"Speak of the devil!"

It was a woman's voice. And I smelled smoke. For a fraction of a second, I feared the worst. Then I opened my eyes.

Cigarette smoke. From Madeline Roark's long holder. "It's after six, Katy," she said. "I thought you'd never get here."

Something touched my neck. I flinched. But another woman's voice said, "Lie still, dear." Hermione had been feeling for a pulse. She took both my hands in hers, and rubbed them warm.

I looked around, then up. I was on the table in Joe's office. The glass and the frame of the skylight had broken our fall. But we'd crashed through it. Or had we? Where was Rebecca? In midair, I'd let her go, splaying out my arms and lifting my head, so my shoulders and thighs would absorb the shock—which they had. And now they *hurt*! My elbows and knees stung, too, from the roof gravel. I flexed my hands and fingers—*they* were okay. I touched my mouth: it wasn't cut. I could still play violin and sax. (*Sax!* I had a gig to play that night!)

Someone was gasping. I rolled onto my side and looked down. Rebecca was on the floor. She'd had the wind knocked out of her, and—mouth open—was trying to suck in air. Hermione took a seat-cushion off a chair, and put it under Rebecca's head for a pillow.

I looked up again. Glass panes dangled overhead like a mobile sculpture, tethered by the skylight's wire mesh. The Dusters were peering down at me through the frame. I raised one arm to point. They ducked aside and ran away, back across the rooftops.

I looked around the room. Joe was there. And Roger Winkler. Amalia, too. Guy, and Susie. I saw concern, as well as surprise, on their faces. But Roger said, "Miss Roark says you *don't* write for *The Etude*, after all."

Madeline said, "I don't appreciate being inconvenienced by your cock-and-bull, Katy. I could have picked up my car, and been halfway out to Long Island by now."

"You were always heartless!" Amalia scolded her. "Can't you see she's hurt?"

"Are you all right?" Guy asked me.

"I think so."

Joe dialed the telephone. For a moment, I thought he was calling the cops to have me arrested—for breaking his skylight, at least. But he told Roosevelt Hospital to send an ambulance.

I swung my legs over the edge of the table, and sat up. My sweater was torn at the sleeve seam. My shoes were badly scuffed. I touched my head. The beret had come off; it lay on the table, sprinkled with glass.

Hermione brushed it off and held it out to me, saying, "You shouldn't move, Miss Green," while I put it on.

"I'm okay. I just... I'll be black-and-blue, tomorrow."

"Please clear this up, Katy," said Amalia. "Tell them I didn't steal the—"

"What the hell have you been *do*ing here, anyway?" Joe demanded.

"Just trying to get my friend out of a jam."

"My arm's broke. I can't feel nothin' in it." Rebecca was trying to sit up, using only her left hand for support while her right arm dangled. "Did somebody call a...ambulance? I thought I heard—"

Joe said, "They're coming."

"Takin' their sweet time, ain't they?" She lay back, again, closing her eyes.

"What happened with Miss Rovere?" I called down to her.

Rebecca took a couple of breaths and opened her eyes again, but didn't sit up. "She called me a thief to my face, but—" She looked straight at Joe. "I am not a thief. I am a soldier of the Lord, and I am engaged in the greatest war that a soldier can ever—"

"Wait till the *real* war starts!" Guy sneered.

"You and that war-talk, Guy Carson! Go on and moan all you want to 'bout Mr. Hitler, but the real enemy's the Devil hisself."

Guy glanced around at the rest of us. "What've I been saying, all along? She's loony! I don't need to hear anymore. I've got an audition to practice for." He strode out the door. I'd have to phone him later, to see if he still wanted to keep our date for the following night.

"What happened on the stairway this morning, Rebecca?" I persisted.

"It wasn't my fault! Miss Rovere called me some names I didn't understand. I only slapped her, is all. But she kinda jumped back, and...and fell down the stairs. I thought she was just knocked out, so I ran off. I didn't know she got killed, till a policeman came to my room. I didn' mean for her to die, really. But she's damned to Hell, now—she wasn't never *saved*, you know."

Roger walked over and stood above her. "Where's the manuscript? The *real* one."

"*It's* saved!" Rebecca laughed out loud.

"That's a relief! Where is it?"

"'s up in Heaven!"

"What?"

"Ed 'n' me, we burned that evil thing in the purifyin' flames."

Susie yelled, *"Ed?"* and Joe yelled, *"Burned?"* simultaneously.

I hoisted myself off the edge of the table, but held on while I got

steady on my feet. "It's safe. Don't worry. It was never burned. Ed went to get it, but—"

"Where *is* Ed?" Susie asked.

"Probably on his way home. You ought to phone him. Tell him not to leave town."

She looked down. "What's he done *now*?"

"Where's the manuscript?" Roger demanded. "Do *you* know, Miss Green?"

"I told him it was in back of the picture, on the landing—"

Joe gasped, "Of course!" and trotted out the door. I heard him go down the steps to the landing, but he came back a moment later. "It's gone! Ed must have taken it with him."

"You didn't let me finish, Joe!" I coughed, and had to clear my throat. "I told Ed it was there, so he'd run out to get it, and I wouldn't have to fight the *two* of them. But Iris wouldn't have hidden it in the stairwell, where anybody might bump into the picture and knock it down. She'd have kept it close. Why don't you check her portrait? No—not the old one upstairs! The one in the library, that Mr. Winkler painted."

Joe dashed out again.

Madeline had been looking around the room at the statuary, evidently bored. "Where is the ladies' room, please?"

Hermione pointed. "Dormitory building, next door."

Madeline looked over her shoulder as she left. "Katy, meet me outside when you're through in here. I need to talk to you."

"Dead a hundred years," Hermione reflected, "and Paganini's still making trouble for musicians."

That struck Rebecca as funny, and she laughed out loud again, but subsided after a few seconds. "He's damned, for sure! Purifyin' flames."

"Why is she saying it was burned?" Hermione asked me.

"I *seen* it burnin'!"

Joe stepped through the door, holding the portrait. He turned it

over, slid his hand under the corner where the backing had pulled away, and a few dozen old tea-brown pages fluttered out.

Rebecca said, weakly, "But Ed lit it up! We watched the flame."

"What Ed burned," I told her, "was those newspapers he keeps in his car."

Amalia sniffed. "The *Daily Mirror*, I hope."

Susie shook her head. "If Ed *didn't* take the manuscript, and burn it, then what's he done that's so terrible?"

"He hired the Dusters to harass Theo, so he could buy the corner building. If Theo sold, Joe would probably sell the school, too. Then you could have your recital hall, and he could start building his...*festspielhaus*."

There was a quiet moment, during which Rebecca struck up a tuneless song—"I'm on my way to Heaven...to Heaven...to Heaven"—but was interrupted by a siren from 48th Street below the window.

Joe sighed and picked up the phone. "I guess I should call the police, too, and tell them about th—"

"Wait until tomorrow," I said. "Rebecca can't run away. And I think Ed *will* turn himself in, if Susie asks him. I'll come back tomorrow, too, and give the cops a statement. Oh, but you can get your Tartini sonata, tonight: 'The Devil's Trill'—the real one."

"Where is it?" He put the phone down.

"At Fogarty and Cornelius. You and Mr. Winkler had better keep looking through the collection, here: I bet Iris made a few more forgeries."

"Iris?" Joe said it, but everyone looked up at me.

"She's the only one who had the skill, and the time, late at night in the library, to do it. She'd consign the originals to Michael Cornelius, to sell. So his 'donations,' as a patron of the school, were really the proceeds from the sales—oh! *Finally*."

Three medics had run up the stairs. One of them went straight to Rebecca, and a moment later called out, "Right arm broken,

possible concussion," to his colleagues, who unfolded a stretcher. They picked Rebecca up on it, and eased her down the stairs. Meanwhile, the first medic felt my bruises and decided they weren't threatening my life. He swabbed away the bits of gravel from my knees and elbows, dabbed iodine, and taped them with squares of gauze. Then he dashed down the stairs to the ambulance.

"How about a glass of wine, Miss Green?" Joe asked. "I want to hear the whole story."

"I'll tell you tomorrow. I've got a gig to play tonight."

I limped downstairs, while Amalia retrieved my pocketbook from Rebecca's room. Beside the front door, at the top of the stoop, we embraced.

"I don't know how to thank you, Katy. I didn't think that Iris's death had anything to do with the stolen manuscript."

"They weren't *directly* connected."

"Yes, but if you hadn't tried to *make* a connection, you wouldn't have found it. Are you hungry? Let's go have dinner."

"No. I've still got to wait for Madeline; we have…unfinished business. Then I've got to go home and change, and get my sax, and be down at the Copa by nine."

"How about tomorrow night?"

"Actually, I have—I *hope* I have—a date tomorrow night. Let's get together next week. Give my regards to your parents."

"Okay. And…and…thanks again." She gave me one more hug, then she walked down the stoop, and away toward the subway.

Madeline came out, lighting a fresh Régie. "You shouldn't have told me a lie, Katy."

"I didn't think it'd turn into such a big deal."

"And if Mr. Cornelius is involved in this…manuscript business, then he's not going to help me with the story I was going to write, this week, about his buying that publishing house."

"Madeline! Look what you've got, *now*. You can sell this to *Colliers* or—"

"I don't like murder mysteries."

"Well, this is one murder mystery without a murderer."

"They told me two people are dead."

"But nobody actually *killed* them. You can look up the effects of ether, though, and see if—"

"Forget it, Katy. I don't want to write the story. I don't even want to *know* what happened. I just want to get out to Long Island, and rest."

"Think of it as a fugue, with a dozen voices in counterpoint, all—"

"Stop! I *hate* music theory. I told you, the whole business is too complicated for me. And the devil's in the details."

"There's your headline!"

"You're *mad*, Katy, d'you know that?" She waved me away with her cigarette holder.

I shrugged and looked at my watch. If she didn't want the scoop, there was still time to phone Josh, before the *Mirror* went to press. And I'd make sure Dingall got on the line, so *he'd* get the straight dope, too. In fact, a night at Eddie Condon's, on 52nd Street with wholesome Josh Forman—but in the audience, for a change—suddenly seemed like a very nice change of pace. He might even be a good comeback to Mother's inevitable third question. Oh, he was no Guy Carson in the looks department, but—

"Katy! You're daydreaming."

"I'm sorry, Madeline. What were you saying?"

"I said: What's with Miss Pierce? While I was waiting there for you to show up, she went on and on about recital space, and a *piazza* with a symphony hall and an opera house—supposed to be built all the way over here on the West Side! That's crazy! Who in their right mind would come to Hell's Kitchen to hear the Philharmonic? Or the *Met*! Which reminds me—" she leaned in close and whispered "—tell me about Mr. Carson. What's *his* story? I ran

into him on the stairs just now, and we had a little chat. He's going up for an audition at the Met next week."

"He might get it, too."

"Now, *that's* the kind of story I do like to write."

"Huh?"

"An up-and-coming young musician, about to land his first important job, the job that'll launch his career. It's a great angle: very exciting, don't you think?"

"He's certainly talented...in many ways." Before she could ask what I meant, exactly, I added, "He probably won't get that gig at the Met, though, unless he practices all weekend for his audition. He'll be distracted by cops and reporters barging in and out."

"My thought, exactly! So I'm going to help him get that job. I have a nice, quiet place on Long Island, and I told him he can practice there all he likes. My car's just around the corner. He's upstairs, packing a bag right now. Ordinarily, I would offer you a ride home, Katy. But it's getting late, and you live uptown, which is really out of our way. So I hope you don't mind if—"

"No, that's fine. I was going to take the El anyway. But you'll need *this*." I pulled the red claim stub out of my pocketbook, and thrust it into her gloved hand. "Your Packard's up in Columbus Circle."

Afterword

It is still possible today to glimpse the New York of 1939. The Empire State Building, and much of Chinatown, are essentially unchanged. Strivers' Row, in Harlem, is still a prosperous block of townhouses. "Beechum's" is fictional, but Madison Avenue, on the Upper East Side, remains home to the city's elegant auction galleries.

The youth gangs are gone from Hell's Kitchen, but it's still mostly a working-class neighborhood. Many pre-war streetscapes of brownstone houses and walkup "tenement" apartment buildings are intact—though inside, most homes have been updated. Among the New Yorkers who live in Hell's Kitchen now, quite a few are performers and musicians who work in the nearby Broadway and Off-Broadway theaters, or in clubs and cabarets. Katy's union, the American Federation of Musicians, Local 802, which was on Sixth Avenue in 1939, is now headquartered in Hell's Kitchen, on West 48th Street.

Fifth Avenue's double-decker buses are gone; but some tour companies run double-decker sightseeing buses. The Ninth Avenue elevated train line that ran through Hell's Kitchen, and up Columbus Avenue past Katy's apartment, was abandoned in June of 1940, and dismantled for scrap-metal during World War II. But there are working El lines in the Bronx, Queens, and Brooklyn.

The pioneering discount department store officially called S. Klein on the Square is defunct, but most of the shops on the 14th Street side of Union Square specialize in cheap merchandise.

Of the venerable back-date bookstores, south of the Square, only one survives: the Strand, on Broadway at 12th Street.

The authoritative "Stratton biography" is *Niccolò Paganini: His Life and Work* by Stephen S. Stratton, published in 1907. And while Hannah Dobryn's epigraphs explaining the art of the fugue (and the art of the mystery) do come from the cited vintage reference books, they are not necessarily direct quotations: some have been edited to cover elisions and transitions.

In 1939, *The Etude* was a real magazine for classical music professionals; and the *Daily Mirror* was a real tabloid, whose tone was notoriously lurid and jingoistic. However, *The Etude*'s local correspondent did not work on Times Square; and the *Mirror*—which (here) Katy reads in the morning—was, in fact, an afternoon paper. Also, it's no longer possible to perform the "one-handed matchbook trick," since the striker has since been moved to the *back*.

New York continues to be a world-class venue for classical performers, attracting ambitious students from around the world, although "Meyers Conservatory" is only imagined. It was inspired by the Mannes College of Music, in whose original East Side home I once worked as assistant librarian.

Of course, a huge, formal campus of opera, symphony, and theater buildings around a *piazza* did ultimately rise on the West Side of Manhattan; but (both street-wise and decade-wise) in the Sixties, not the Forties. If it seems that Ed and Susie were prescient, anticipating such an entertainment complex, it must be remembered that I created them, and Katy—and Hannah, too—long after Lincoln Center was built.

—Hal Glatzer

Kathy Frankovic

ABOUT THE AUTHOR

Although Hal Glatzer once worked as a librarian in a music college, he has been a journalist and novelist for more than thirty years. He is the author of several innovative mysteries, including the current Katy Green series. Classically trained, Glatzer plays swing guitar, and composed three songs for the award-winning audio-play of *Too Dead To Swing*. He and his wife are Art Deco enthusiasts and frequent travelers, with homes in San Francisco in the Haight-Ashbury district, and in Manhattan in (where else?) Hell's Kitchen. Glatzer welcomes visitors and e-mail at www.fugue-mystery.com.

MORE MYSTERIES
🕷 FROM PERSEVERANCE PRESS 🕷
For the New Golden Age

Available now—

The Affair of the Incognito Tenant, A Mystery With Sherlock Holmes
by Lora Roberts
ISBN 1-880284-67-7
In 1903 in a Sussex village, a young, widowed housekeeper welcomes the mysterious Mr. Sigerson to the manor house in her charge—and unknowingly opens the door to theft, bloody terror, and murder.

Silence Is Golden, **A Connor Westphal Mystery**
by Penny Warner
ISBN 1-880284-66-9
When the folks of Flat Skunk rediscover gold in them thar hills, the modern-day stampede brings money-hungry miners to the Gold Country town, and headlines for deaf reporter Connor Westphal's newspaper—not to mention murder.

The Beastly Bloodline, **A Delilah Doolittle Pet Detective Mystery**
by Patricia Guiver
ISBN 1-880284-69-3
Wild horses ordinarily couldn't drag British expatriate Delilah to a dude ranch. But when a wealthy client asks her to solve the mysterious death of a valuable show horse, she runs into some rude dudes trying to cut her out of the herd— and finds herself on a trail ride to murder.

Death, Bones, and Stately Homes, **A Tori Miracle Pennsylvania Dutch Mystery**
by Valerie S. Malmont
ISBN 1-880284-65-0
Finding a tuxedo-clad skeleton, Tori Miracle fears it could halt Lickin Creek's annual house tour. While dealing with disappearing and reappearing bodies, a stalker, and an escaped convict, Tori unravels the secrets of the Bride's House and Morgan Manor, which the townsfolk wish to hide.

Slippery Slopes and Other Deadly Things, **A Carrie Carlin Biofeedback Mystery**
by Nancy Tesler
ISBN 1-880284-64-2
Biofeedback practitioner/single mom/amateur sleuth Carrie Carlin is up to her neck in snow, sex, and strangulation when her stress management convention is interrupted by murder on the slopes of a Vermont ski resort.

REFERENCE/MYSTERY WRITING
How To Write Killer Fiction: **The Funhouse of Mystery
& the Roller Coaster of Suspense
by Carolyn Wheat**
ISBN 1-880284-62-6
The highly regarded author of the Cass Jameson legal mysteries explains the difference between mysteries (the art of the whodunit) and novels of suspense (the hero's journey) and offers tips and inspiration for writing in either genre. Wheat shows how to make your book work, from the first word to the final revision.

Another Fine Mess, **A Bridget Montrose Mystery
by Lora Roberts**
ISBN 1-880284-54-5
Bridget Montrose wrote a surprise bestseller, but now her publisher wants another one. A writers' retreat seems the perfect opportunity to work in the rarefied company of other authors...except that one of them has a different ending in mind.

Flash Point, **A Susan Kim Delancey Mystery
by Nancy Baker Jacobs**
ISBN 1-880284-56-1
A serial arsonist is killing young mothers in the Bay Area. Now Susan Kim Delancey, California's newly appointed chief arson investigator, is in a race against time to catch the murderer and find the dead women's missing babies—before more lives end in flames.

Open Season on Lawyers, **A Novel of Suspense
by Taffy Cannon**
ISBN 1-880284-51-0
Somebody is killing the sleazy attorneys of Los Angeles. LAPD Detective Joanna Davis matches wits with a killer who tailors each murder to a specific abuse of legal practice. They call him The Atterminator—and he likes it.

Too Dead To Swing, **A Katy Green Mystery
by Hal Glatzer**
ISBN 1-880284-53-7
It's 1940, and musician Katy Green joins an all-female swing band touring California by train—but she soon discovers that somebody's out for blood. First book publication of the award-winning audio-play. Cast of characters, illustrations, and map included.

The Tumbleweed Murders, **A Claire Sharples Botanical Mystery
by Rebecca Rothenberg, completed by Taffy Cannon**
ISBN 1-880284-43-X

Keepers, A Port Silva Mystery
by Janet LaPierre
Shamus Award nominee, *Best Paperback Original 2001*
ISBN 1-880284-44-8

Blind Side, A Connor Westphal Mystery
by Penny Warner
ISBN 1-880284-42-1

The Kidnapping of Rosie Dawn, A Joe Barley Mystery
by Eric Wright
Barry Award, *Best Paperback Original 2000.* Edgar, Ellis, and Anthony Award
nominee
ISBN 1-880284-40-5

Guns and Roses, An Irish Eyes Travel Mystery
by Taffy Cannon
Agatha and Macavity Award nominee, *Best Novel 2000*
ISBN 1-880284-34-0

Royal Flush, A Jake Samson & Rosie Vicente Mystery
by Shelley Singer
ISBN 1-880284-33-2

Baby Mine, A Port Silva Mystery
by Janet LaPierre
ISBN 1-880284-32-4

Forthcoming—

Tropic of Murder, A Nick Hoffman Mystery
by Lev Raphael
Professor Nick Hoffman flees mounting chaos at the State University of Michigan
for a Caribbean getaway, but his winter paradise turns into a nightmare of deceit,
danger, and revenge.

Death Duties, A Port Silva Mystery
by Janet LaPierre
The mother-and-daughter private investigative team introduced in *Keepers,* Pa-
tience and Verity Mackellar, take on a challenging new case. A visitor to Port Silva
hires them to clear her grandfather of anonymous charges that caused his suicide
there thirty years earlier.